The Raven's Tail

"The rich wrap themselves up sometimes in white blankets, manufactured in the country, from the wool of the wild sheep, which is as soft and fine as the Spanish merino. These blankets are embroidered with square fringes, and figures with black and yellow tassels. Some of them are so curiously worked on one side with the fur of the sea otter, that they appear as if lined by it, and are very handsome."

Iurii Fedorovich Lisianskii,
Sitka Sound, 1805

Over two hundred years ago, when Europeans first visited the Northwest Coast of North America, the weavers of the area were making robes of exquisite beauty to adorn the wealthiest of their noble class. Patterened in bold black and white designs streaked with scintillating dashes of yellow, these robes predate the better-known Chilkat Blankets from the same area.

Today only eleven robes exist, three of them as fragments. Another two are shown in Russian historical paintings by Mikhail Tikhanov. The only other known robes are found in an archival photograph and in two sketches by Pavel Mikhailof.

To produce this book, Cheryl Samuel travelled to Leningrad, Copenhagen, and London to examine the six robes in Europe. She also studied the robes housed in museums in Canada and the United States. Using this research material she was able to reconstruct Chief Kotlean's robe. In the process she resurrected an old weaving style no longer in use by the native people on the northern coast. In this book Samuel presents the known historical data on the robes along with an analysis of the materials used and a description of the nine twining techniques.

The Raven's Tail makes an important contribution to the knowledge of early Indian weaving, and will be of interest to those in native studies as well as weavers.

CHERYL SAMUEL is an expert weaver living in Victoria, British Columbia. Her first book, *The Dancing Blanket,* revealed the mysteries of Chilkat weaving.

The Raven's Tail

Cheryl Samuel

The University of British Columbia Press
Vancouver 1987

Reprinted 1989

Reprinted 1992

This book has been published with the help of grants from the B.C.
Heritage Trust and the Canada Council.

Canadian Cataloguing in Publication Data

Samuel, Cheryl, 1944-
 The raven's tail

Bibliography: p.
ISBN 0-7748-0296-0 (bound). — ISBN
0-7748-0224-3 (pbk.)

1. Indians of North America - Northwest Coast of North America -
Textile industry and fabrics. 2. Indians of North America
-Northwest Coast of North America -Art. 3. Hand weaving -
Northwest Coast of North America. I. Title.
E78.N78S34 1987 746.1'4'08997 C87-091420-0

International Standard Book Number
0-7748-0224-3 (softcover)
0-7748-0296-0 (hardcover)

Designed by Fiona MacGregor

Printed in Canada

With great honour and respect
I dedicate these words to

Jenny Thlunaut, Chilkat Blanket Weaver
and Selina Peratrovich, Haida Basket Weaver

Two women, two weavers,
who danced the Perfect Circle
with their hands

Prelude

A tale told by Cowee, principal chief of the Aukqwan Tlingit, translated by G.T. Emmons in 1886

Before the coming of the white man, when the natives had no iron, the Chilkat and Hoon-ah made long canoe trips each summer to Yakutat, to trade with the Thlar-har-yeek for copper, which was fashioned into knives, spears, ornaments, and tinneh [coppers] and which again were exchanged with the more southern tribes for cedar canoes, chests, food boxes and dishes.

One spring a large party of Thluke-nah-hut-tees from the great village of Kook-noo-ow on Icy Straits, started north, under the leadership of three chiefs—Chart-as-sixh, Lth-kah-teech, and Yan-yoosh-tick.

In entering Lituya, four canoes were swallowed by the waves and Chart-ah-sixh was drowned. The survivors made camp and mourned for their lost companions. While these ceremonies were being enacted, two ships came into the bay. The people did not know what they were, but believed them to be great black birds with far reaching white wings, and, as their bird creator, Yehlh, often assumed the form of a raven, they thought that in this guise he had returned to earth, so in their fright they fled to the forest and hid. Finding after a while that no harm came to them, they crept to the shore and, gathering leaves of the skunk cabbage, they rolled them into rude telescopes and looked through them, for to see Yehlh with the naked eye was to be turned to stone.

As the sails came in and the sailors climbed the rigging and ran out on the yards, in their imagination they saw but the great birds folding their wings and flocks of small black messengers rising from their bodies and flying about. These latter they believed to be crows, and again in fear they sought the shelter of the woods.

One family of warriors, bolder than the rest, put on their heavy coats of hide, the wooden collar and fighting head-dress, and, armed with the copper knife, spear, and bow, launched a war canoe. But scarcely had they cleared the beach when a cloud of smoke rose from the strange apparition followed by a voice of thunder, which so demoralized them that the canoe was overturned and the occupants scrambled to shore as best they could.

Now one nearly blind old warrior gathered the people together, and said that his life was far behind him and for the common good he would see if Yehlh would turn his children to stone, so he told his slaves to prepare his canoe, and, putting on a robe of the sea otter, he embarked and paddled seaward. But as he approached the ships the slaves lost heart and would turn back, and all deserted him save two, who finally placed him alongside. He climbed on board, but being hardly able to distinguish objects, the many black forms moving about still appeared as crows, and the cooked rice that they set before him to eat looked like worms, and he feared to touch it. He exchanged his coat of fur for a tin pan and with presents of food he returned to the shore. When he landed the people crowded about surprised to see him alive, and they touched him and smelled of him to see if it were really he, but they could not be pursuaded to eat the strange food that he had brought to them.

After much thought the old man was convinced that it was not Yehlh that he had gone to and that the black figures must be people, so the natives, profiting by his experience, visited the ships and exchanged their furs for many strange articles (Emmons 1911: 297-98).

Jean-François de la Pérouse was the captain of the vessel which anchored in Lituya Bay in 1786, one hundred years before the tale was recounted to Emmons. In his journals of the voyage, la Pérouse says "The Americans of Port de Français [his name for the bay] . . . spin the hair of various animals, and, with a needle, form of that wool a manufacture similar to our tapestry. With this web they mingle strips of the otter skins, which makes their cloaks resemble the finest silk shag. In no other part of the world are straw hats and baskets more skillfully made" (la Pérouse 1786: 163).

Contents

Introduction

The Gathering of the Robes

Patterns speaking of women and men . . . patterns recording the movement through time of the great clans . . . patterns telling the tale of transition. . . . When I first met the patterns of the Raven's Tail robes, my heart quickened and my soul danced. I wondered "why?" When I shared them with others through lectures, I felt an instant response, a recognition. I wondered, "why?" Neither I, nor the global audiences I spoke to, had ever seen these robes. They were not a part of "our" heritage, nor were they familiar through the vast body of the world's literature. Why, then, was it so easy to make an audience enthusiastic about them? Why, when we finally had a real robe to dance with, did the people who wore it always speak of its Power? Why did those who saw it dance, stand spellbound?

These questions have followed me through the last seven years. As I have wandered the world following the trail of the robes, I have pondered the impact they have had on me and on others.

The odyssey of the gathering of the robes has been touched with magic. It seems almost as if the robes themselves wished to come forth and be counted. The saga started in New York in 1980 at the American Museum of Natural History. I was totally involved with the Chilkat Dancing Blankets, speaking to the weavers through the products of their hands. Dr. Phillip Gifford came one morning with a box full of what looked like scraps of yarn. "You might be interested in this," he said, and left me. To my amazement, the box yielded remnants of half of a robe such as I had never seen before. It was twined; it was *not* Chilkat. Techniques were hidden in its structure which were completely new to me. I spent the next three days puzzling its border; by day I would prod the disintegrated threads, by night I would weave on a sample loom. Finally I figured it out. The difference between knowing something intellectually and actually being able to do it never ceases to astonish me.

In New York I also made another discovery which was to prove important. Prior to arriving there I had been in Ottawa, where I had studied a tunic which had been fashioned from one half of an old robe. On it, blocks of Chilkat design units were placed on a black and white background. I had treated it as a Chilkat robe, for I knew no better. At the Heye Foundation, having "done" the storage rooms, I was prowling through the public display when I spotted a legging which I did not recognize. Also a piece once cut up in potlatch, the patterns were identical to those on the Ottawa Tunic. Questions produced the mate to this legging, and suddenly I had two more sections of what I now recognize as the Lynn Canal Robe.

After New York my next destination was the Harvard Peabody Museum and the famous Swift Robe. Arrangements had been made for me to see it, but when I got there I discovered that "seeing it" meant looking at the front of the robe through a display case. Not only was the case wired with a burglar alarm system, but also decades of dutiful decorators had painted the glass to the frame. Un-daunted, I asked if the robe could be removed, and miraculously workmen appeared to scrape away the paint, unwire the case, and free the robe. The gallery was roped off and I was left to live with that exquisite garment "as long as I wished." Perhaps they thought I would leave at closing time, but in the wee hours of the night I could still hear the footsteps of the guard doing his round. I left the robe when my eyes would no longer focus.

That journey was only the beginning. At home, I received a box in the mail addressed to me from Carolyn Osborne. I knew of her by reputation, but I had not paid much attention to her writings. At that time my work was on the Chilkat robes, and she had written on another of those mysterious "geometric Chilkats." Hearing of my investigations, she had quite independently felt inspired to pile all of

the material she had into a box and post it to me. I was, and still am, extremely moved by the generosity of this woman. Initially I did all my research on the Knight Island Robe from Osborne's notes. When I found that I would be doing a workshop in Philadelphia the following year, I wrote to the University Museum requesting permission to view its remains. My arrival was uncomfortable for the staff had not been able to locate the fragments. I was there for five days, and on the morning of the fourth I received an ecstatic call from the museum curator saying they had at last discovered their whereabouts. No one had asked for them since the 1950's when Osborne had placed them in a small box. The fragments themselves held a curiosity. Little, round sticks appeared to be twined into the weft segments. Why were they there? I had never seen anything like it, and perplexed by a technique which would include sticks in the twining, I told the people around me, "I don't want to know about this." At dinner that night I was pondering the problem when my hostess, who had been with me at the museum, said "I saw a box on the top shelf in the office which was labeled 'ASK de LAGUNA.' Here's the phone—why don't you call her?" The answer came quickly; the small sticks were rootlets grown into the fabric during the years in the grave. I *didn't* need to know about them.

In that same year, a visit to a good friend, Dr. Giovanni Costigan, Professor Emeritus of History at the University of Washington, was to catapult me into a Russian adventure. Over tea served in cups of delicate bone china, I shared with him and his wife Amne my newborn enthusiasm for the "pre-Chilkat" robes. How I rued the fact that the largest number of them were in Russia where I would never be able to see them. "Go to Russia!" was their astonishing reaction. Me? Go to Russia? Impossible! But the seed was planted, and in time it grew and bore fruit. With no institution behind me, but merely as an individual with recommendations from Bill Holm and George MacDonald, I initiated a seemingly endless monologue with Soviet officialdom. I sent letter after letter and wondered at my audacity in writing *so much* in English. Ten months later, in the small village of Woodstock, England, where I was living

with my family on an academic exchange, *the* letter arrived. At 6:30 a.m. it fell through the slot in the front door which served as our mail box. Addressed to Cheryl Samuel, the contents were written all in Russian. The hours seemed innumerable between then and the opening of the Bodleian Library, when I could finally request a translation from a Slavic scholar. North American enthusiasm flooded my body when I heard that my request to study in Leningrad had been granted. I literally had to sit on my hands to keep from hugging that staid and learned Englishman.

The trip to the Soviet Union was extraordinary. I was treated with immense respect, given an office and the freedom to come and go whenever I pleased. Four precious robes were in my constant possession, and I was not only allowed to photograph them outside in the natural light, but also a museum staff member put them on so that I could get a real sense of the incredible impact of their designs. The graciousness of Madame Rosa Lyapunova was unbounded; she expressed only two concerns. One was that I take time from the robes to see their beautiful city, and the other was that I see the "most important piece in the museum's collection." I did indeed tour the Hermitage and journey to the Summer Palace of the Czars on the shore of the Baltic sea, and in the final hours of my visit I stood for twenty minutes dutifully staring into a darkened display case at the small etched markings on a Rongo-rongo board from Easter Island. "Some day you will know why you were to see it," she told me.

The trail goes on, weaving a fascinating tale of adventure throughout the major cities of Europe. In Vienna with my daughter Alena Samuel, I met the Vienna Robe with its tantalizing taste of transition. In Dublin, my son Dean Samuel puzzled the mock two-strand twining technique with me; during our breaks we stood in awe over the intricate interlacings in the Book of Kells. Back in England, perched high in the bow of a double decker bus, I slalomed through the streets of London to meet the Diamonds Robe.

There, I met another robe, one with brown zig-zag patterns and yellow eyes. "A cedar bark robe" I wrote in my notes, and it

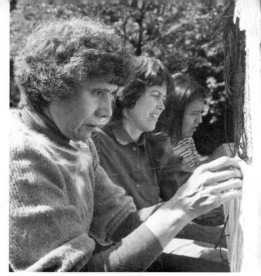

From left to right, Delores Churchill, Cheryl Samuel, and Ernestine Glessing work on the Kotlean Robe

took me nearly a week to erase that sentence. The robe showed no visible signs of mountain goat wool in its warp, but the presence of wool in the strands underneath the bands of design was peculiar. For a while I tried to work out how to spin strands of warp with wool at only one place in them . . . Jonathan King came to my rescue with a magnifying glass which relieved my technical trauma; the entire warp originally included mountain goat wool. It is curious how long it takes to undo knowledge gained from books and an initial visual impression.

While I was in Leningrad I had known of the existence of sketches by Mikhail Tikhanov which showed Raven's Tail robes being worn, but I had been unable to obtain permission to see them. The sketches had been published in the *Alaska Journal*, printed in black and white. I had

The Kotlean Robe in progress

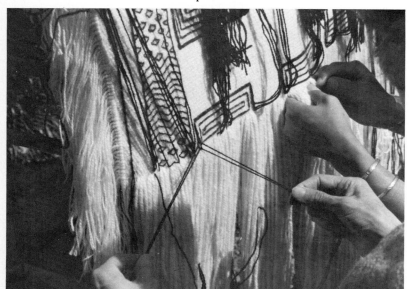

assumed that the originals were the same. In 1982, I was invited by Ron Senungetuk to lecture at the University of Alaska, Fairbanks. While there, I learned that the prints from the *Alaska Journal* article were housed in the archives. Unknown to me, archivist Marvin Falk overheard my request to see them. Disappearing behind the stacks, he emerged again carefully carrying a handful of newly acquired transparencies. "Could these be what you are looking for?" The University had just received colour transparencies from the Leonid Shur collection, and among them were pictures of the two paintings I wanted. It was an overwhelming experience to see them in colour, to see the detail in Tikhanov's work, and to be given duplicates before I left town.

To accept the challenge of fully understanding the techniques of Raven's Tail weaving, it seemed mandatory to weave a complete robe. Three choices presented themselves: design a new robe based on the traditional style, recreate one of the existing robes, or weave one of the robes seen in the Tikhanov paintings. The last option seemed best, for this way a robe which once lived on this coast would return to its place and its people. I chose the robe worn by Kotlean; at the time I did not know that the descendants of this Chief still lived in the land of their noble ancestor. I set out to weave, and after completing the upper borders and the first row of figures, I found myself longing for help. Each row starts on the left and ends on the right; I could easily hand my wefts over to a companion sitting next to me. She could weave on while I began a new row.

My wish came true when two weavers arrived from Alaska to apprentice with me in Chilkat weaving. Delores Churchill, a Haida from Ketchikan, and Ernestine Glessing, a Tlingit from Hoonah, were well versed in twined basketry techniques, but neither had worked in wool. During the first two months of their apprenticeship while they were spinning Chilkat warp yarns, I would sit with them for an hour each morning and we would work on the black and white robe. They learned to handle wool, and I got the chance to see if three weavers could work together on one robe. Each of us wove slightly differently; to keep the tension even, we

changed places every day. The part was measuring the space be... weft rows and keeping them para... heading. Each of us had a different concept of measuring. Eventually we r... three tiny, identical templates of yellow cedar bark which measured exactly the distance between the rows. Working in this way we completed the next two patterns, learning how to move the spiral wefts efficiently, learning a lot about each other, laughing together. When I was left to work alone, I continued our method by starting up to six consecutive rows at one time before moving to the next position. The experience of creating this robe gave body to the technical knowledge I had been gathering; when it finally danced we felt the impact of a Raven's Tail robe in motion.

Another four years would pass before I discovered that another sketch of a robe existed, one drawn by a different Russian artist. Bill Holm told me about seeing it while he was on a trip to the Soviet Union, but he had been unable to photograph it. In the spring of 1986 Thor Heyerdahl paid an unexpected visit to Lester B. Pearson College where I work. I was terribly busy preparing for a show, and when I was asked if I would like to meet him at the seaplane I almost turned the invitation down. My husband Edgar had important business to discuss with Dr. Heyerdahl, and when I finally decided to go, I vowed to myself that I would sit silently, enjoying their conversation. It didn't happen. Within minutes of our greeting, Thor was talking about his days in Bella Coola, and I was asking about that mysterious Rongo-rongo board in Leningrad, so like the ones he had described in *Aku-Aku*. On the way to the college we stopped to show him the reproduction of the Kotlean Robe, which was freshly off the loom, and as I waxed enthusiastic about the collection of fourteen robes, I sorrowed at my inability to see the fifteenth. "Why is that?" he queried. "It's in Russia, and I can't go again." Thor Heyerdahl is an honourary member of the Moscow Academy of Sciences, and he offered to write to Academician Julian Bromley requesting that the sketch be photographed. That very evening, after a day of visiting our international student body, Dr. Heyerdahl whisked me away to the guest suite where he immediately composed the promised

... Coast
...er, models the
... Robe

letter. "If you can type, bring it the morning and I'll sign it; here, some of my letterhead." Ten month... and two months before this manuscrip... went to the press, I received the photograph of the last robe.

Journeys such as this one never end. The robes gathered here speak of a bygone time shrouded in symbolic mist. Why are their designs so moving? Like the magic that stirs in our hearts when we stand in awe at the rim of a sunset, their patterns speak to us. Perhaps they play with our memories across cultures and continents, back through the centuries to the dawn of symbolic perception. Now, with intimate knowledge of each of the Raven's Tail robes, I still ponder the question of their strength.

Women, weavers of another time, responded to the human impulse to create. Through their weaving, they wrapped the bodies of the people in patterns of power. These patterns flowed easily from their fingers, from a perfect marriage of design and technique. Laughter lifted from the looms as a robe, conceived in the depths of human experience, grew through the hands of the weavers. This I know, for I have touched the children of these weaver's minds, and I have felt the power of the robes.

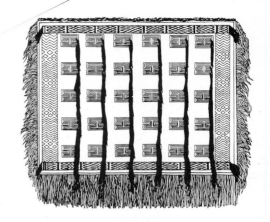

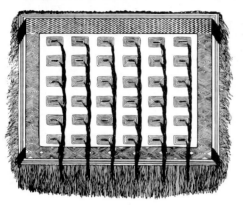

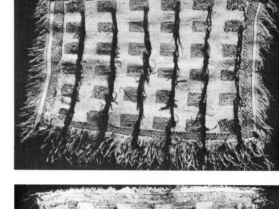

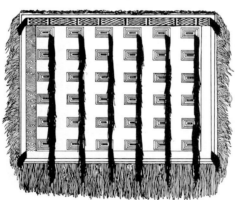

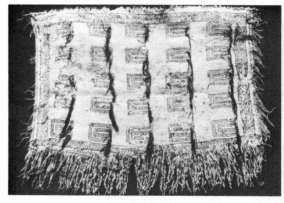

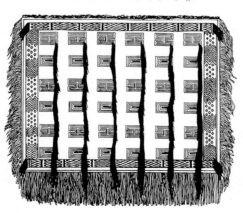

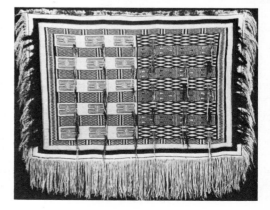

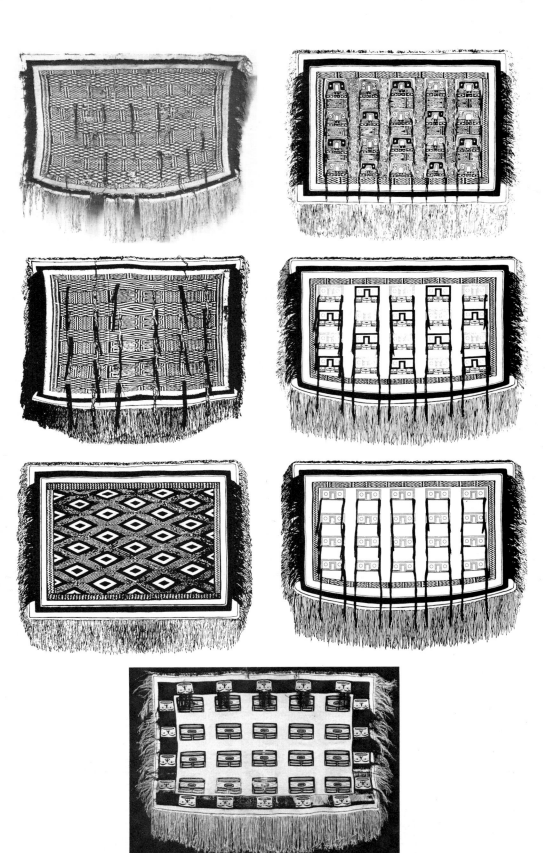

The Raven's Tail

Two hundred years ago, on the Northwest Coast of North America, native weavers created robes of exquisite beauty to adorn the wealthiest of their noble class. These robes, patterned in bold black and white designs streaked with scintillating dashes of yellow, predate the better known Chilkat Dancing Blankets which originate from the same area. The robes come from the time before Chilkat weaving, a time when women who were expert basket makers turned their talents to working with wool. "From the testimony of those best informed, the first woven blanket was known as tan or 'thlaok klee' ('worked-together blanket'), a combination of twisted cedar-bark and the wool of the mountain-goat, showing a plain white field. Then followed the introduction of color in geometric design, in which longitudinal stripes of the herring-bone pattern appeared on the white field. This was named Yel-ku uu [Yeil Koowu] ('the raven's tail') from the resemblance it bore to the vanes of the tail-feather of that bird" (Emmons 1911: 332).

From which tribe, or tribes, the weavers came is difficult to say. There is little recognition of this style of weaving among the native people of the northern coast today, and no memory of its manufacture. The patterns and weaving techniques which are shared with the basket weavers are familiar, but knowledge or practice of their use in wool is unknown. Published accounts of European voyages on the coast in the 1700's and early 1800's reveal that the robes were worn by the Tlingit, the Haida, and by the Pacific Eskimo inhabitants of Prince William Sound, the Chugach (Holm 1982: 40). It cannot be assumed, however, that their distribution was limited to these peoples for active trading took place amongst all the separate tribes of the coast.

Only eleven of these historic robes remain. They are housed in major museum collections around the world. Six of them are in Europe: four in the Museum of Anthropology and Ethnography in Leningrad, one in the National Museum in Copenhagen, and one in the British Museum in London. Of the five robes in North America, only two are complete. One of these is in the Harvard Peabody Museum and the other in the Royal Ontario Museum, in Toronto. Storage rooms in the Museum of Civilization in Ottawa, the American Museum of Natural History and the Museum of the American Indian in New York, and the University Museum in Philadelphia shelter fragments of the other three.

This meagre material record is greatly enhanced by the work of Russian artists. Mikhail Tikhanov was the official artist on board the sloop *Kamchatka*, which sailed into the northwest coastal waters in 1818. Tikhanov made watercolour sketches of the area and the people, and in two of them he depicted chiefs wearing pattern-twined woollen robes. One of them portrays the Tlingit Chief Kotlean; Fort Sitka appears in the background. The reconstruction of the Kotlean Robe was completed in 1985, increasing the number of actual robes to twelve. A second drawing by Tikhanov is a portrait of a man called Aichunk wearing a Raven's Tail robe. Another Russian, Pavel Mikhailov, sailed as ship's artist aboard the sloop *Moller* in the latter half of the 1820's. In one of his sketches he also illustrates a robe of this style. The addition of an archival photograph makes fifteen the total number of robes in this collection.

How does it happen that so many of the Raven's Tail robes are in European collections? In the late 1700's and early 1800's, explorers and traders plied the coastal waters of North America, making contact with the native population. Descriptions in the journals of the early European mariners make clear that the native people were loathe to part with their finest garments. The five excellent examples of these robes obtained by the Russians are of major importance to our knowledge of this unique style of weaving.

The collection history of the Leningrad robes is confused. In 1978 Dr. Adrienne Kaeppler published *Cook Voyage Artifacts*, an account of the items collected on the Pacific voyages of Captain James Cook. In this record she mentions all of the Raven's Tail robes in Leningrad. However, recent research by Dr. Kaeppler shows that the Russian records of the Cook material acquired by Behm in Kamchatka do not mention any woollen weavings. Therefore, she feels that the Leningrad blankets cannot be dated from the Cook voyage (personal communication).

Of the five robes in North America, only two are complete. One called the Swift Robe is the most remarkable example of Raven's Tail twining in existence. The other complete robe, from Gitlaxdamks village, is transitional: its designs are Chilkat, but its construction remains in the Raven's Tail tradition. Three robes which exist as fragments are the only weavings with any data concerning their place of origin. These come from Lynn Canal, Knight Island, and Kruzof Island, all areas in the Tlingit tribal homeland.

Raven's Tail Robes and Chilkat Dancing Blankets

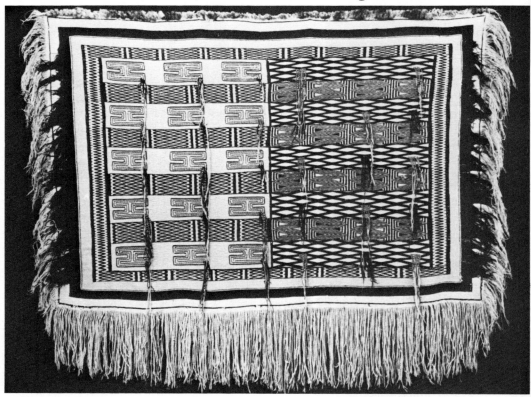

The Raven's Tail robe known as the Swift Robe

The Raven's Tail robes must not be confused with the famous robes twined by the Tlingit known as the Chilkat Dancing Blankets. The two styles differ greatly in execution and design. The rectangular Raven's Tail robes are marked by strong linear black and white patterns and sport thick, long tassels which hang pendant from the central design field. In contrast, the five-sided Chilkat Dancing Blankets are decorated entirely with black, yellow, white and blue curvilinear designs in the totemic genre.

Technically, the weaving styles differ greatly. Both use mountain goat wool for the weft yarns; only Chilkat weaving incorporates yellow cedar bark in the warp yarns. As many as nine variations of the basic two- and three-strand twining techniques are used to produce a Raven's Tail robe, while Chilkat weaving uses only three. The production of a Raven's Tail robe is extremely clean. The weaving is worked from top to bottom and in individual rows from left to right. Each horizontal row builds, geometrically, the pattern established in the designer's mind. Each row is complete; there are no ends to work in

when the twining is finished since the total length of every strand of yarn is utilized in the design. In Chilkat weaving, no row between the heading and footing is continuous border to border. There, the weaving is separated into small design areas, and each section of the pattern is developed individually, the whole emerging as a sum of its parts. Because of the bas relief simulation achieved with the Chilkat technique, there are innumerable ends to be worked in as each section is completed.

The determining difference between the two styles of weaving is the design. Raven's Tail robes demand a row by row solution to their development, and their designs are closely related to the structure of the weaves. In the curvilinear motifs of the Chilkat Dancing Blankets, wool is forced to act in a painterly mode and techniques become servant to design. The beauty of each of these styles rests on its own merits; each is a response to the challenge of design. That Chilkat weaving evolved, partially, from Raven's Tail weaving can be shown. That it became something quite different and unique is obvious.

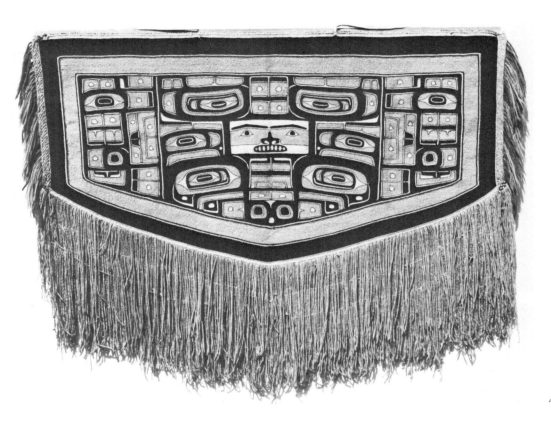

A Chilkat Dancing Blanket

Yeil Koowu

The designs on Raven's Tail robes bear a close relationship to those on twined baskets. Both were women's art, and unlike the tradition in Chilkat weaving where a male artist designed a painting which would be transformed by a female weaver into wool, the women used their own patterns and sense of balance and design in creating these robes. Until the inclusion of formline figures, all of these patterns were composed of linear motifs.

The art of basket-weaving had already reached perfection when the European explorers first made contact with the peoples of the coast. Early accounts and illustrations proclaim an art form well established in design and in workmanship. The weavers of the Northwest Coast were superb basketmakers. Containers fashioned from the roots of spruce trees, the bark of cedar trees, and the stems of many plants and grasses were used for a multiplicity of purposes. Expert fingers coaxed these woody materials into large baskets for carrying clams and tiny ones for drinking cups.

In *Spruce Root Basketry of the Alaska Tlingit*, Frances Paul states that traditionally the Tlingit people "believed that a spirit . . . lived in inanimate objects. It is not surprising that the names of the decorative motives in basketry should be based upon the natural objects of [their] environment" (p. 46). The designs on the baskets were woven expressions of forms seen in the world around them, and they were given such names as "the mouthtrack of the woodworm," "wave pattern," and "tattoo."

17

The Legendary Origin of Basketry

"It happened in those mysterious times when Raven still walked among men, exercising the cunning of his mind in bringing good to his creatures by ways strange and inexplicable to mankind. Already his greatest works had been accomplished. He had stolen the Sun, Moon and Stars from his grandfather, the great Raven-who-lived-above-the-Nass River, Nass-shah-kee-yalhl, and thus divided the night from day. He had set the tides in order. He had filled the streams with fresh water and had scattered abroad the eggs of the salmon and trout so that the Tlingit might have food. But not yet had Raven disappeared into the unknown, taking with him the power of the spirit world to mingle with mankind.

"In those days a certain woman who lived in a cloud village had a beautiful daughter of marriageable age. She was greatly desired by all mortals and many came seeking to mate with her. But their wooing was in vain. At last it chanced that the eyes of the Sun rested with desire upon the maiden, and at the end of his day's travel across the sky he took upon himself the form of a man and sought her for his wife.

"Long years they lived together in the Sky-land and many children came to them. But these children were of the Earth-world like their mother and not of the Spirit-world of their father, Ga-gahn. One day as the mother sat watching her children frolicking in the fields of the Sun-land, her mind filled with anxiety over

their future, she plucked some roots and began idly to plait them together in the shape of a basket. Her husband, the Sun, had divined her fears and perplexities. So he took the basket which she had unknowingly made and increased its size until it was large enough to hold the mother and her eight children. In it they were lowered to their homeland, the Earth. Their great basket settled near Yakutat on the Alsek River, and that is the reason that the first baskets in southeastern Alaska were made by the Yakutat women.

Thus out of their folk memories have the Tlingit created the story of the origin of basketry'' (Paul 1944: 9).

By Sara Porter

The Patterns

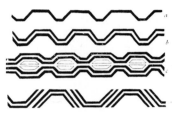

In his 1903 monograph *The Basketry of the Tlingit* Lieutenant George T. Emmons describes forty-nine different patterns, with variations, used by the Tlingit weavers in composing the designs on their baskets. Following this description he illustrates a number of baskets, showing the use of the various designs alone and in combination with each other. A number of these patterns can be seen in the Raven's Tail robes. It is interesting to note that many of these are described as being "very old" and some of them have connections with the Haida nation.

The following list of patterns consists of the nineteen Tlingit basketry designs which are similar to the patterns found in Raven's Tail robes. Each entry is accompanied by descriptions directly quoted from Emmons. The Tlingit names for the designs are included parenthetically; native weavers will be able to feel the rhythm of a pattern through its sounds. The spellings have not been taken from Emmons; instead they come from translations by Nora Florendo Dauenhauer, a native Tlingit speaker, which are presented in a 1981 Appendix to Frances Paul's book. While it cannot be proved that the designs and their symbolic meanings were intentionally copied by the weavers of wool, the patterns in the robes certainly echo the designs of Tlingit basketry. It is also possible, because of the shape of the robes, that some of the designs which are oriented horizontally in the baskets may have been arranged vertically in the robes.

The mouth-track of the woodworm (tl'ukx x'a.eeti) is shown by a continuous zig-zag, wide-spread and low, horizontally arranged, and graphically illustrating the irregular, halting course of the worm as it eats its way through dead wood. . . . a design in the decorative zone of the larger berry-baskets (p. 263).

The intestine of the sooty song-sparrow (ts'itsku naasi) is copied from a drawing found among a number of basketry designs in the possession of an old woman at Sitka. She and others assured me that in the past this served as a border-decoration. It differs from the preceding figure in the closeness of the lines, forming a double series of acute angles. It was always placed singly in a horizontal band (p. 264).

Butterfly (tleilu, translated as "moth" by Dauenhauer) is one of best-defined and most uniform motives. The only element of doubt is what special feature of the insect is expressed. Some explain it as referring to the many-colored markings of the wings; others, as indicative of its halting, uncertain flight. As the name is simply "butterfly," it would seem that the outline of the insect with expanded wings was pictured I believe it is one of the oldest, as it is one of the most universal, of motives (p. 264).

The footprint of the brown bear (xoots x'us.eeti) is fairly realistic, considering its expression by means of straight lines and angles. It is usually arranged in one or more horizontal bands encircling the basket, thus representing the trail of the bear. It illustrates the instinctive habit of this sagacious animal in following in the old, deep-worn tracks on its way to and from accustomed feeding-grounds. In the diagonal bisection of a rectangle, this figure and its complement form reversals (p. 265).

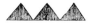

The tooth of the larger tropical shark (shakdak ooxu). These large teeth have always been highly esteemed by the coast people for ear-ornaments, and are said to have been obtained in trade from tribe to tribe, through a stretch of one or two thousand miles of coast, long before the arrival of Europeans. The shape of the tooth is clearly defined and in many instances the serration of the edges is indicated in color. The greater axis is always in a horizontal plane, and the figure is placed singly with several complementary forms in the same decorative section. The Tlingit, having no personal knowledge of the fish itself, make no attempt to picture the succession of teeth as they occur in nature (p. 265).

The teeth of the killer-whale (keet ooxu) represents truthfully the saw-like jaw of this voracious animal; but its use is limited, as it appears only as the complement of the "tree-shadow" or the lozenge when arranged in a vertical series; and by many it is recognized only as an ornament, and not as a character proper (p. 268).

The hood of the raven (possibly yeil t'oogu, translated as Raven's Cradle by Dauenhauer). [This design] is an ornamentation in the skip-stitch in the natural root, found more frequently on the rim of the conical hat and in the ornamental border-band of the Chilkat basket than as a design in straw and color (p. 268).

The tail of the snow-tail (dleit aa koowu, translated by Dauenhauer as "the white one's tail"). The forked tail of the Arctic tern is a characteristic feature of this noisy little fellow, that darts hither and thither, following with ceaseless chatter the fisherman in his canoe. The open jaws are placed horizontally. The figure is always used with one or two other angular forms, which go to make up a rectangular section in the ornamental field (p. 266).

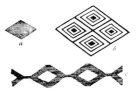

One straight, or the cross-piece of the fish drying frame, on which rest the small rods which carry the split fish (tleikatan or tleiyeidei katan) . . . is a simple continuous, horizontal line in straw or color, paralleled by others for decorative effect. It is the plainest of ornaments, and occurs as a line of separation, on borders, or on the little double basket (p. 269).

An eye (atuwaagi, translated as "the eye within it" by Dauenhauer). The lozenge is of indeterminate significance, and is given different interpretations according to its size and to locality. Any small lozenge, either solid or in outline, is known to the coast tribes from Icy Strait to the Copper River as "an eye" from its shape. . . . When arranged in outline one within another it is called (deegaa), "the scoop-net used in the taking of the candle-fish" (p. 271).

The echo of the spirit-voice of the tree reflected in shadow (aasak'w ayahaayak'u). The Tlingit endows all nature with spirit-life, which manifests itself in various ways. The master of the tides, hidden away in the caverns of the sea, rears his head suddenly in anger, and sweeps through the narrow rocky channels in the resistless bore or swift swirl, carrying destruction in his wake, and silently disappears. The voice of the glacier is many times given back from the mountain-side, until it loses itself far up the valley in the heart of the great ice-spirit. The brilliant scintillations of the aurora, chasing each other through the northern skies, are but the warriors greeting their friends from the blessed abodes of rest. And so the graceful tree-life comes forth in the evening, to rest upon the quiet waters until driven home by the ruthless storm-spirit, which is the enemy of shadow-life. The idea is the unconscious expression of the poetry of primitive life.

[The extended form of this figure] as a vertical zigzag . . . truthfully pictures a water reflection distorted and broken by the tremulous rippling surface. This motive is among the oldest and best-recognized throughout the area of spruce-root basketry (p. 268).

The peculiar flake-like appearance of the flesh of a fish cut along the line of the greater axis, or *fish flesh pattern* (xaat x'uxu) is represented by convergent lines serially placed. These, in the original design, were narrow strips of color, separated by broad intervals of straw; but in later work these more natural proportions have not been preserved, and now the difference in color alone distinguishes them. Like other angular figures, this is known to the Yakutat as "the outside of the tent-shell" (the Limpet), while many connect it with the "tree shadow." . . . It is generally associated in the same ornamental section with the "shark's tooth" and the "tern's tail," the three forming a most pleasing combination in outline and color (p. 267).

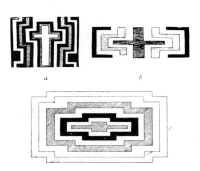

The tail of the raven (yeil koowu), a regular and intricate design made up of crosses, half-crosses, and open arms enclosing each other, is universal. In the minds of the people it is not connected with the [Christian cross]. It seems to be purely symbolic in character, and bears no trace of resemblance to the natural object. . . . It seems perfectly natural that the raven should be represented in basketry, as it is the most prominent figure in every other branch of art; and, aside from superstitious and religious motives, no picture of native life is complete without these familiar birds dancing over the house-top or collected on the shore in groups, full of individuality in form and pose, and offering numberless suggestions to the artist (p. 272).

The leaves of the fireweed (lool kayaani) is an excellent example of plant conventionalism. The symmetry of the lanceolate leaves, and their parallelism standing out diagonally from the stalk, are well expressed in the successive rhomboid figures horizontally placed. . . . The plant is of common occurrence, covering old village sites and clearings along the beach, and in its midsummer bloom presents a sea of color which could not fail to have attracted canoe-travellers as they skirted the shore (p. 266).

The outside of the smaller scallop-shell, or, as translated by Paul, *the outside of the cockle clam* (p. 57) (yalooleit). In this case the ribbed appearance of the exterior is due to the use of two woof-strands of different colors, which by one skip-stitch in every circumference of weave produces vertical lines of alternating color. It is in general use on mats and basket-covers, often in combination with the strawberry weave. Thus both appear to great advantage, the variegated effect of the one being in strong contrast with the regularity of the other. These two characters in combination are recognized all along the coast, and occur also in old specimens of Haida work from the Queen Charlotte Islands (p. 270).

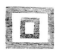

One within another (woosh kinaadei adi) is an ornamentation that I once saw on an old basket. It may have been copied, or it might readily have been suggested by the piling of one chest or box on top of another, as is often done for economy in storage (p. 276).

Double around the cross, translated by Paul as "cross cemented together" (p. 61) (woosh daaganyaa kaneisdi) . . . a nest of rectangular figures open at one end (p. 273).

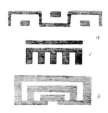

Wave pattern (galaku), a word from the tongue of an older race that descended the Copper River and peopled these shores before the coming of the Tlingit, is a [very popular design]. It is equally old and well distributed. It refers to the flow of the tide in its wave-like motion and indicates either a floating object which appears and disappears successively, or the irregular, winding line of drift and seaweed along a flat shore, left by the receding waters. This is the Yakutat explanation of the pattern, while to the other Tlingit it is known as sarh-shar tootsee (literally, "the labret of the woman's root hat"), the continuous line representing the hat, and the small enclosed parallelogram or square the "labret" or crown of the hat. This design is represented as a single line or is backed by several others. Sometimes it is divided into single figures arranged in horizontal sections. It is always placed horizontally (p. 274).

Tattoo pattern, literally "old-person-hand-back-of-tattooed" (kaa jikool kajoolani) is possibly the most interesting, as it is one of the most ornamental and widely used characters in basketry. It illustrates an old custom of the Tlingit. . . . Tattooing . . . was a mark of position, and was little used by the common people. It does not seem to have had any totemic significance. Only the back of the hand and the adjoining part of the fore-arm were tattooed. The design was tattooed on the back of the hand, (a) being placed on the metacarpals of the fingers . . . (b) being placed on the metacarpal of the thumb. Besides this, there were three lines across the wrist, resembling a bracelet. Above these, rows of sixteen dots were arranged on the fore-arm, running from wrist to elbow-joint. . . . The origin of these figures is wholly forgotten by the present generation, who know them only as basket designs (p. 273)

The Materials

The Wool and the Dyes

The primary fibre used in all Raven's Tail robes was obtained from the fleece of the mountain goat, *Oreamnos americanus*. The coat of these animals consists of long white guard hairs covering soft downy wool. To remove the wool and hair from a hide, the skin side was wetted and then rolled and left to sit. In time, the roots of the fibres would loosen, and the fleece would slip from the hide in batts which would be set aside to dry.

The soft wool, which was used primarily for weft yarns, then had to be separated from the long, stiff guard hairs. This was done by teasing the hair from the wool while the batts remained intact. The hair would be set aside for use in spinning the warp yarns. The remaining downy wool would be eased into long thin roving strands in preparation for spinning. It is possible that the weft yarns were spun on a small spindle such as the ones collected by Emmons from the Tlingit people. Finished weft yarns were about two millimetres in diameter, S singles, two-ply Z, and very evenly spun.

The warp yarns were made of the wool and the hair of the goat, spun together to produce a thick, strong strand which was also S singles, two-ply Z. The heading cords were either all mountain goat hair or a combination of hair or wool with sinew. If the warp ends were thin, they may have been produced on a spindle; if they were thick, they were most likely thigh spun. The all-hair cords, and those with an inclusion of sinew, indicate a tradition of thigh spinning because it is more difficult to spin these materials on a spindle.

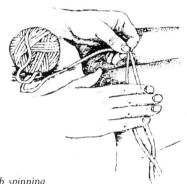

Thigh spinning

The three main colours found in Raven's Tail robes are white, black and yellow. The white is the natural colour of the mountain goat wool. The black is a very rich, reddish black, often faded to a reddish brown. Experiments show that it was obtained from two dyes: an initial bath of spring hemlock bark boiled in old urine and iron, with an overdye bath of old urine in which copper had oxidized to form a blue-green liquid. If the weft yarns used are a reddish brown colour, with no sign of black, it is likely that this latter bath was omitted.

The yellow yarns could have been dyed with the chartreuse lichen *Evernia vulpina*, commonly called "wolf moss," which was used to produce the yellow in the Chilkat Dancing Blankets. This lichen is found on the boughs of pine trees which grow east of the coastal mountain ranges. It was obtained in trade from the tribes of the interior. Dye was produced by boiling the lichen in fresh urine for about an hour. Wool placed in this liquid and heated for ten minutes turns a vivid yellow colour.

The lichen Evernia vulpina *or "wolf moss"*

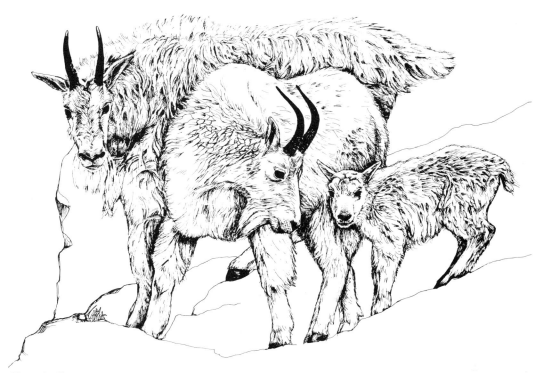

Mountain Goats

Recently, the question has arisen whether tree lichens indigenous to the coast and used by the basket weavers were also used for dyeing wool. This certainly can be done, and the colour produced is very similar to the renowned "Chilkat yellow." Tradition, and collections, however, tell us that wolf moss was used by the Tlingit; perhaps the abundance of this lichen, in comparison to that of the local tree lichens, made it a more popular dyestuff.

Some of the Raven's Tail robes sport units of Chilkat design in their composition. In these units, a fourth colour was used, the yellow-green of the oldest Chilkat weavings. It was obtained from boiling the wool in an initial dye bath of copper and urine with a quick overdye in the wolf moss yellow solution.

Fur

Another material used in the production of Raven's Tail robes is thin strips of fur, which were wound around the heading cord to finish the upper edge of all the robes. Fur strips were also used as warp ends in two of the robes. The fur on these strips is light, golden brown, very soft, and about 2.5 to 3 centimetres in length. It has been assumed that this fur is sea otter (Kaeppler 1978: 10, and Gunther 1972: 200); but none has been tested, and it is also possible that it is winter marten.

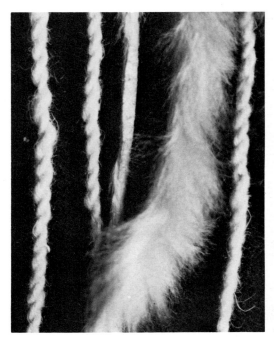

Fur and wool warp ends

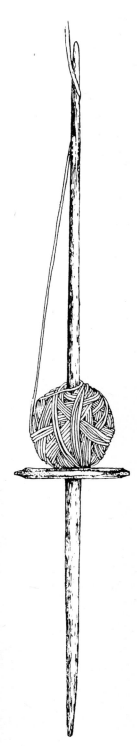

A Tlingit spindle

25

The Techniques of Twining

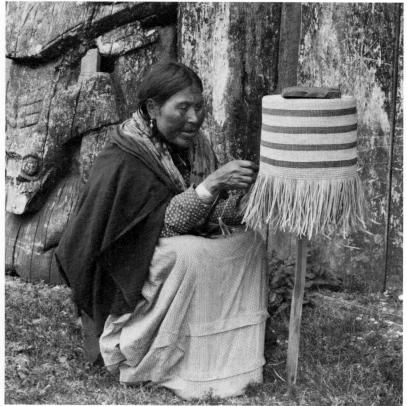

Fig. 1. A Haida basket weaver working on a suspended warp

The ceremonial robes which came from the hands of these weavers echo their basketry both in design and in technique. In twined basketry the warp strands, or splines, are not held under tension. Instead, two wefts are used to encircle each warp end, and the weaving process is accomplished entirely by finger manipulation. The basket can be held so that the weft twining is pushed down on the warp ends, as in Tlingit basketry, or up on the warp ends, as in the suspended twined basketry of the Haida.

When twining, a basket weaver works in only one direction, the weft strands spiralling in a circular fashion from bottom to rim. If a basket were to be cut in half and laid out flat, each row would start on one side and finish on the other with no row returning in the opposite direction. In the Raven's Tail robes, the twining is done in this manner; the rows are not continuous, and they are always worked from left to right. One row starts at the left selvage, twines across to the right selvage, and is then tied off in a knot, its tails becoming side fringe. Each succeeding row follows this same path and is separate from the rows directly above and below it.

Fig. 3. The cylinder of a basket, cut up and laid out flat

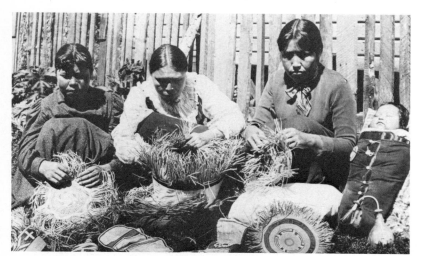

Fig. 2. Tlingit basket weavers working with the warp ends up

26

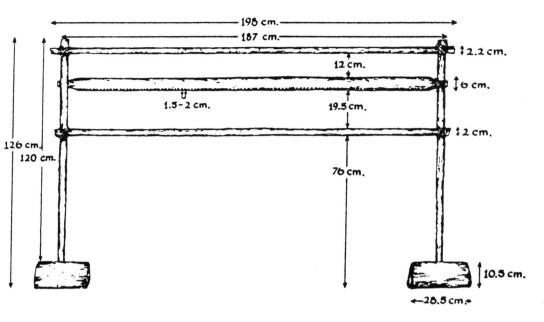

Fig. 4. A single bar loom

The Loom

In weaving the Raven's Tail ceremonial robes, the desired shape is not cylindrical; instead, a robe is a flat, two-dimensional rectangle which takes on three dimensions when it surrounds a person's body. To facilitate weaving, the warp ends must be held in place along a horizontal line. This is done by hanging them on a cord which is laced to a long bar. When twining, the weaver pushes the weft up on the warp ends in the style of the Haida basket makers; therefore, the bar must be suspended between two posts. The posts are placed in shoes, made of half-rounds of logs, to hold them upright. A thin slat is placed across the top of the loom to help stabilize it, and another might be tied across the weaving to help organize the pattern wefts. In order to keep the warp ends clean and untangled during the weaving process, groups were bundled and slipped into gut bags. It must be emphasized that these bags were *not* weights; there is no need for tension in these twining techniques. This type of loom, called a "single bar loom," is used to twine the Chilkat Dancing Blankets. Most likely it was also used in twining the Raven's Tail robes.

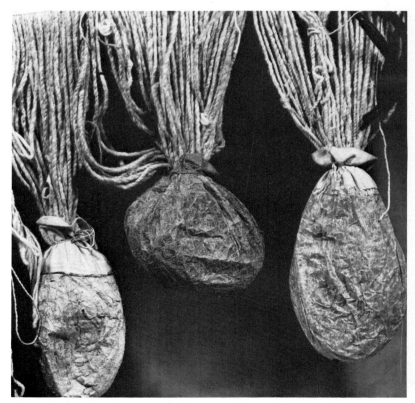

Fig. 5. Gut bags keep the warp ends clean

27

Fig. 7. Slip knots are placed at the ends of a strand of yarn

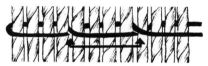

Fig. 6. Slip knots

Preparation of the Wefts

Because each row of twining is completely separate from the rows above and below it, the wefts can be measured and cut prior to weaving. The width of the robe plus the desired length of the right side fringe is measured, and approximately one-quarter of this length is added for take-up. The total length is then doubled in order to create one two-strand weft. Slip knots were probably used to shorten the tails of the wefts since it would be tremendously time-consuming and hard on the yarn to pull the length of the weft through the warp every few stitches. Slip knots are easily inserted in a doubled two-strand weft by placing the first knot near the cut end of each strand and working each succeeding knot snuggly down to the one before it. The individual knots are placed about three hand widths apart on the weft strands; this distance is reduced to nothing when the knot is formed. Prepared in this way, the knots pull out from the bottom up, rather than the top down, and therefore do not come out during the twining process. To lengthen the wefts while twining, the slip knot nearest the fell of the weaving is removed by grasping the bundle of slip knots just below it and gently pulling. Removal of one slip knot releases just enough weft for comfortable twining.

Twining

Two types of twining are used to create the designs, and each displays a number of variations in its basic structure. These twining techniques are called two-strand twining and three-strand twining. Another weave structure, the spiral weft technique, is used in six of the robes.

Two-strand twining

Two-strand twining is a weave structure in which two weft strands cross each other as they move to enclose successive groups of warp ends. The weft strand in front of the warp passes underneath the weft strand from the back, producing the Z angle of twist most commonly used in Raven's Tail robes. The length of weft strands between each twist is called a weft segment.

Fig. 8. Two-strand twining over four warp ends. The arrow indicates one warp segment

Fig. 9. Two-strand twining over two warp ends. The arrow indicates one warp segment

If all succeeding rows of two-strand twining are pushed up directly beneath the rows above them allowing none of the warp yarn to show, the technique is called *compact twining*. If the succeeding rows of compact twining are worked over the same warp ends, the designation paired compact twining is used. Two-strand twining which encircles two or four warp ends in one row and divides these in the middle in the succeeding two is called alternate two-strand twining. Multiple rows worked in this manner and packed closely together are termed alternate compact twining.

Fig. 10. Paired compact twining

Fig. 11. Alternate compact twining

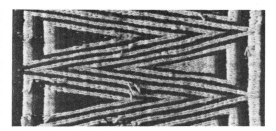

Fig. 12. Two-colour twining is used to form the diagonals

Black and white or black and yellow pairs of two-strand wefts are used to produce bold diagonal lines and vertical bars. When worked in combination with alternate compact twining, enclosing four warp ends in each weft segment, the technique will be called *two-colour twining*. If diagonal lines are desired, the wefts travel over a four warp end group in one row and split this group in the middle in the succeeding row. If bars or vertical lines are called for, the wefts travel over the same warp group every row. A double twist is used between the warp groups if the same colour is needed in adjacent segments. The wefts are twisted twice in order to bring the same colour to the pattern surface.

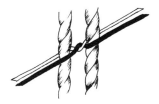

Fig. 13. A double twist

If succeeding rows of two-strand twining are worked so that a small amount of warp shows between them, the technique is called *spaced twining*. Spaced twining over alternate warp pairs forms the basis for the white background in many of the robes; in this context it will be called *ground twining*.

Fig. 14. Ground twining

A chevron effect is accomplished in two-colour twining by changing the direction of the slant of twining in the second of two rows. This is referred to as *counter twining*.

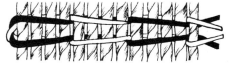

Fig. 15. Chevron twining

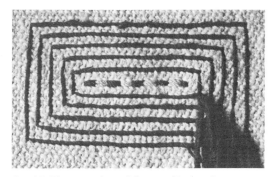

Fig. 16. The centre line of this motif is done in chevron twining

Skip-stitch twining is a beautifully rich and subtle technique which enables a weaver to decorate a surface without changing weft colours. It is accomplished by varying the number of warp ends encircled in successive weft segments. The basis of this technique is compact two-strand twining over paired warp ends, the same pairs being used every row. The twill design is effected by "skipping" a stitch and enclosing four warp ends in one weft segment when a diagonal line is desired. In succeeding rows, skip stitches will split the preceding four warp end segment to the right or to the left, as dictated by the angle of the diagonal line being produced.

Fig. 17 Skip-stitch twining

29

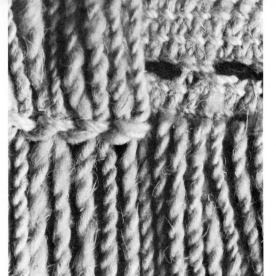

Fig. 18. Fringe twining

Three-strand twining

Within the design field of a robe, a technique called *three-strand twining* may be used for outlines or to create pattern figures. Rows of twining done in this technique travel either horizontally or vertically. In this weave structure one of three wefts, called the working strand, passes around its mates as it moves to enclose a warp group or weft row. When moving horizontally from left to right, the working strand travels behind its two weft mates, over four warp ends and under two warp ends. This action produces the S angle of twist which was most commonly found in Raven's Tail robes.

The bottom fringe of a robe is an extension of the warp. The last row of twining includes a special treatment of the warp fringes to secure them tightly and produce a finished appearance. *Fringe twining* is done with a pair of white two-strand wefts. After twining a segment of four warp ends, the two warp ends which lie on the right side of the segment are raised and included in the next weft segment. This second segment will now include six warp ends. The two warp ends which were raised into the second segment are then left to fold down over the weft twining stitch. This process is repeated across the entire width of the warp.

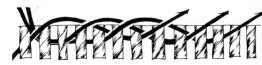

Fig. 22. Horizontal three-strand twining

When travelling vertically, the working strand moves to the right of its two mates and behind the appropriate weft row, enclosing it in the twining. This movement shows on the back of the robe as a line composed of single weft segments.

Fig. 19. 1st stitch: Twine weft around first four warp ends
2nd stitch: Twine around the next four warp ends, leaving the front strand loose

Fig. 20. Move two warp ends from the first stitch to the second stitch, under the front weft strand. The second stitch will now enclose six warp ends

Fig. 21. Finish the second stitch, enclose the next four warp ends of the third stitch with the weft strands, move the two warp ends from the second stitch to the third stitch underneath the front weft and twine. Continue this process until the row is finished, then knot the twining off

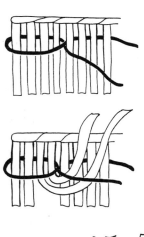

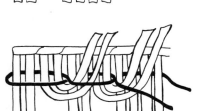

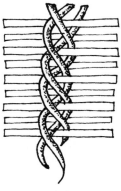

Fig. 23. Vertical three-strand twining

To prepare the wefts for a three-strand twining row, the entire distance the yarns have to travel is measured. In the case of concentric figures, the length of the tassels which hang from the corners of these figures must be included. One-third of the twined length is added to the total for yarn take-up, and the strand is then doubled. Slip-knots are placed on both sides. Three wefts prepared in this manner are then middled and inserted between two warp ends at the upper left hand corner of the figure to be twined. Half of each strand will be behind the warp, and half will be in front. The three front strands will work to the right, across the top of the figure. Next, all strands are then worked vertically until the sides are completed. A figure is finished by moving the strands from the lower left corner across to the lower right corner to meet the right hand vertical strands where they are locked together in tassel braids.

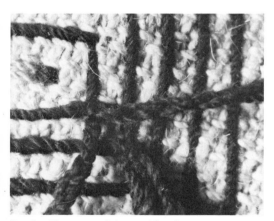

Fig. 24. The corner of the tassel braids

To work the tassel braids, the strand furthest to the right of the horizontal braid is first exchanged with the lowest strand of the vertical braid. The horizontal strands are then plaited together as a three-strand braid for the required distance and then tied off with a single-strand hitch. This horizontal braid is then placed between the two lower vertical strands, and they are braided and knotted off. The vertical braid is therefore linked with the horizontal braid, both through the exchange of weft ends and through insertion. This type of linkage allows the weaver to create a square corner.

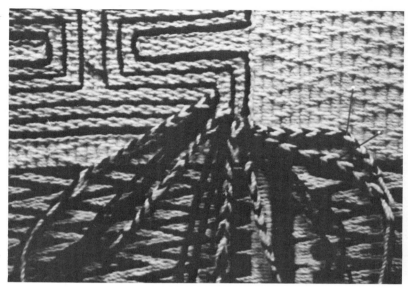

Fig. 25. Chevron braided tassels

If a four-strand braid is desired at this junction, one strand from a horizontal row of three-strand twining is chosen, along with one from a vertical row. An additional strand is then added by middling it and wrapping it around these two strands close to where they meet. The four strands are plaited together as if they were three, the single strands moving over one strand from the left and two strands from the right. If the added strand is of a different colour, the braid is always worked in a chevron pattern starting with one strand of each colour in each hand and always working the same colour consecutively. Black is followed by black, then white by white, repeatedly. Chevron braids are also worked in this manner using all four strands of the two-colour twining rows in the centre lines of some concentric figures.

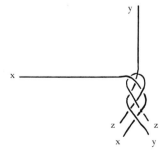

Fig. 26. A four-strand braid. The outermost row of white three-strand twining is divided and used with black three-strand wefts to form chevron braids

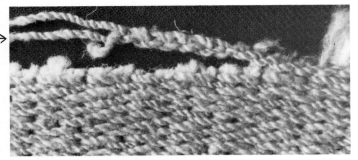

Fig. 27. A fragment of a braided twining row

Braided twining is a variation of three-strand twining. In this technique, the three wefts interweave with each other before they twine with the warp. Horizontally, each weft travels between the other two wefts, over four warp ends, and then under two warp ends. The interweaving of the wefts among themselves is, in fact, three-strand braiding. On the back side of the weaving, the weft strands travel over two warp ends and lie at an angle which is in opposition to the slant of the strands on the front.

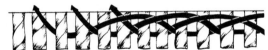

Fig. 28. Horizontal three-strand braided twining

In Chilkat weaving, the vertical movement of three-strand braided twining does not enclose the weft row; instead, the working strand of the braided twining row is sandwiched between the wefts of the underlying two-strand twining row. In such a case, the vertical twining does not appear on the back of the weaving. In a small number of the Raven's Tail robes this technique is used to outline the borders.

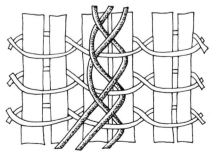

Fig. 29. Vertical three-strand braided twining

There are three techniques which appear on the surface of the fabric to be two-stranded twining but which are, in fact, worked with three strands.

Rigid weft twining is a technique in which one weft strand, or "rigid" weft, remains behind the warp while two pattern weft strands interlock with it from the front surface. The appearance on the front of the weaving is of compact two-strand twining over alternate warp groups. The back weft strand is called a "rigid weft" because it does not move around the warp ends but rather stays to the back, anchoring the two travelling wefts. On the back side of the robe, the weaving appears as a series of dots which are actually the point where the pattern wefts encircle the rigid weft. Sometimes these dots align vertically, sometimes they are off-set, depending on the sequence of the two travelling wefts on the front. Occasionally solid lines of colour intersperse with these dots; these lines are two-strand twining rows.

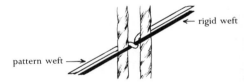

Fig. 30. Rigid weft twining, side of the weaving

Fig. 31. Rigid weft twining seen from the back of the weaving

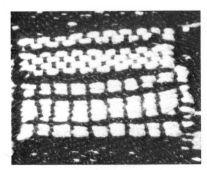

Fig. 32. Rigid weft "dots"

32

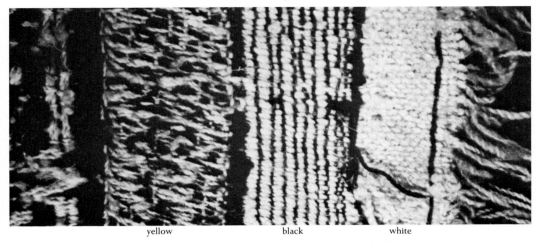

yellow black white

Fig. 33. Rigid weft twining as it appears on the back of the black and yellow side borders

The rigid wefts are always a different colour from the pattern wefts. In the top and bottom borders of a robe, the white weft strands from the selvage band become the rigid wefts. When used in the side borders, this technique serves as a method of moving unused weft strands horizontally behind the warp until they are needed on the surface. In this case, the rigid weft may be composed of two different coloured strands.

To work rigid weft twining, each of the travelling pattern wefts is moved over four warp ends before it is interlocked with the back weft. Since there are two pattern wefts being used around one rigid weft, they form a top and bottom row, the bottom weft splitting the warp ends used by the top weft. In some instances, the pattern wefts travel over two rather than four warp ends, producing a tighter weave.

Rigid weft twining can appear on the front surface of the robe as skip-stitch twining. Here, the travelling pattern wefts work over paired warp ends for the ground pattern and four warp ends for the diagonal designs while the rigid weft is maintained on the back. This technique is called *rigid weft skip-stitch twining.*

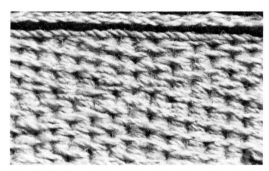

Fig. 36. Rigid weft skip-stitch twining in a yellow border

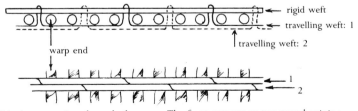

Fig. 34. A cross-section through the warp. The front appears as two-strand twining

Fig. 35. The pattern of rigid weft skip-stitch twining

In another form of three-stranded two-strand twining, each of the wefts travels over four warp ends on the front of the weaving and behind two on the back, creating two rows of twining in one action. This process would produce three-strand twining except that the working weft strands alternate between splitting their mates in one move and working around them in the next. Consequently, each weft strand moves from the first row to the second row and back again as it travels along its path. This type of twining has been called *mock two-strand*.

Fig. 37. *A mock two-strand twining heading seen from the front of the robe*

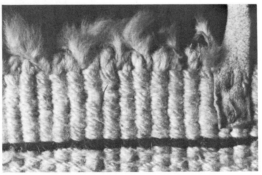

Fig. 38. *The reverse side of the mock two-strand twining heading in Fig. 37*

Fig. 42. *To start a row of mock two-strand twining:*

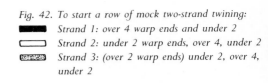

Strand 1: over 4 warp ends and under 2
Strand 2: under 2 warp ends, over 4, under 2
Strand 3: (over 2 warp ends) under 2, over 4, under 2

Fig. 43. *To work the row: If the strand closest to the left side of the weaving lies under the weft segment A, below, then this strand goes under the next two weft strands while it travels over 4 warp ends and under 2 warp ends*

Fig. 44. *If the strand closest to the left side of the weaving lies over the weft segment B, below, then this strand goes over the nearest weft strand and under the next weft strand while it travels over 4 warp ends and under 2*

← row 1
← row 2

Fig. 39. *Mock two-strand twining: front view*

← row 1
← row 2

Fig. 40. *Mock two-strand twining: schematic diagram*

O = warp end

Fig. 41. *Mock two-strand twining: plan view*

Spiral weft technique

The *spiral weft technique* produces a design which displays multiple diagonal lines on a white background. It is a two-sided pattern, showing on both surfaces of the fabric. In its simplest form, it is accomplished by vertically spiralling one pattern weft around one group of warp ends while the warps are tied down with two-strand ground twining. The number of warp ends encircled by the spiralling weft varies.

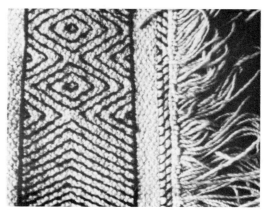

Fig. 45. A spiral weft pattern

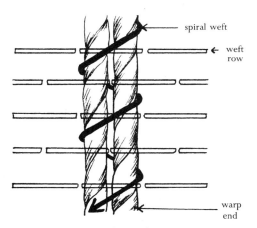

Fig. 46. One spiral weft strand

spiral weft

weft row

warp end

When working a spiral weft design, the weaver first places coloured weft strands in position by inserting them, at their midpoints, between the warp ends. One weft will serve for two pattern lines.

Fig. 47. Each doubled strand serves for two pattern lines

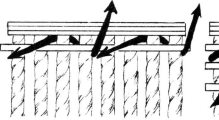 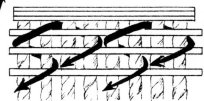

Fig. 48. The first movement of the spiral weft strands

Fig. 49. The process is repeated until the pattern is completed

A row of two-strand ground twining is worked across the pattern area. When this row is completed, the spiral weft strands at the back of the warp move diagonally behind a warp unit and emerge to the front of the weaving, underneath the ground-twining row and between two warp ends. The number of warp ends in a unit depends on the pattern, as does the direction of the diagonal move. When all the spiral wefts from the back have been moved to the front, the original front pattern wefts are moved to the back, diagonally, over the ground-twining row and a warp unit. There is a special reason for this sequence. Since all the spiral weft strands are on the front surface after the first move, it is much easier to see the strands in front of the warp and move the appropriate ones to the back than it is to do so if all the pattern strands have been moved behind the warp. A row of ground twining follows each exchange of the spiral wefts, locking them in position.

If a spiral weft strand is placed between two warp ends and worked so that the back strand moves to the right, under the ground-twining row and to the front, while the front strand moves to the left, over the ground-twining row and to the back, diagonal lines will form.

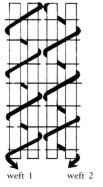

weft 1 weft 2 visual pattern

Fig. 50. Two spiral wefts forming a diagonal line

Fig. 51. The visual pattern created by the wefts in Fig. 50

In order to change the visual direction of the angle of patterning, two adjacent spiralling wefts must change warp groups.

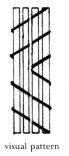 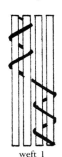 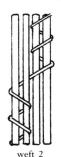 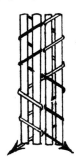

visual pattern weft 1 weft 2

Fig. 52. Adjacent spiral wefts change warp groups

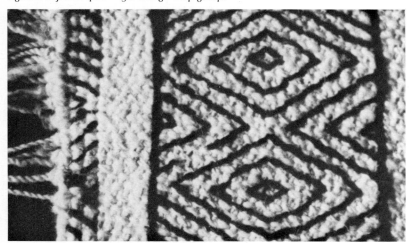

Fig. 53. Diamonds created by a change in the angle of the spiral wefts

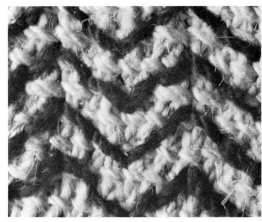

Fig. 54. A spiral weft zig-zag

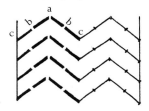

Fig. 55. The points of entry in a spiral weft zig-zag

To work the horizontal zig-zag lines shown (Fig. 54), four spiral weft strands are used. Two pattern wefts are placed between the warp ends at points (a) (Fig. 55). A ground-twining row is worked, and then the two front strands which emerge from points (a) move diagonally, in opposite directions, and slip behind the warp (Fig. 56). The back strands move in the same direction as the front strands, emerging in front of the warp at points (b). After the next ground row, the front strands from points (b) will move towards each other and disappear at (c), while the back strands at points (b) also move towards each other and emerge again in the (a) column.

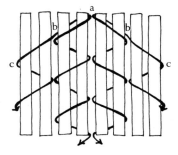

Fig. 56. The movement of the spiral weft strands to form one section of a zig-zag

36

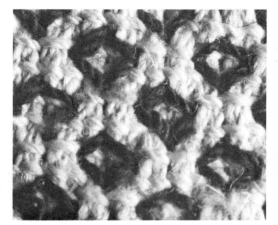

Fig. 57. The "eye" pattern

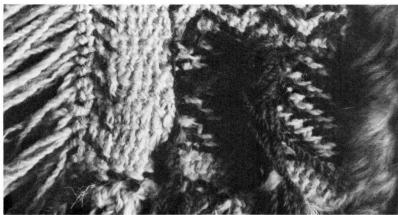

Fig. 59. Spiral weft strands end in a tassel on the back of the robe

To work the "eye" pattern, groups consisting of four spiral weft strands and eight warp ends are used. These groups are repeated to create the number of eyes desired. In Fig. 58, each spiral weft travels around four warp ends, weft (1) changing places with weft (2) on one group of four warp ends, and weft (3) changing places with weft (4) on an adjacent group of four warp ends.

When the spiral weft border design is completed, all of the pattern strands are gathered together on the inside of the robe and braided or knotted together before the bottom two-colour border is twined.

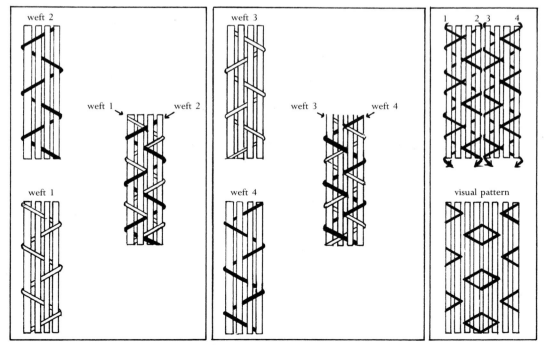

Fig. 58. The path of the spiral wefts used to form an "eye" pattern

Joins

Four different types of joins are used to connect weft yarns between different coloured pattern areas. Two of them, the drawstring join and the dovetail join, appear only when Chilkat motifs are used.

The addition of a new colour of weft yarn is usually done with a black looped join on the left side of the robe. At the point in the design where there is either a black border or the commencement of two-colour twining, a doubled black weft is inserted behind both strands of the existing two-strand weft, leaving a loop on the front of the weaving which is approximately ten centimetres long. Each entry of this loop will be covered by a row of vertical three-stranded twining. Once the looped fringe is inserted, one half of the doubled black weft is coupled with one of the existing two-strand wefts, and the two are worked together across the design area. The remaining black strand is then coupled with the remaining two-strand weft, and these two work the succeeding row of the design. When the black wefts are no longer needed, they are dropped immediately after a row of vertical three-strand twining on the right side of the robe and are trimmed about ten centimetres long to complement the looped fringe on the left.

On occasion a rigid weft interlock is used instead of the looped join. In this case, the new pattern wefts are middled around the rigid weft and then worked in rigid weft twining. A vertical three-strand outline row will cover the join.

In some instances the Chilkat units on the outer edges of a robe are attached to the side borders with an interlock join. This join is also used almost exclusively within the formline unit itself and occasionally to connect certain of the bands in the side borders. An interlock join takes place between two warp ends. The two adjoining weft colours are twined towards each other until they meet. The front strand of the weft on the left side of the join then encircles the back strand of the weft on the right side, makes a weft turn, and then resumes twining in the opposite direction. The weft on the right side also turns and continues its path across the weaving.

Fig. 61. The interlock join

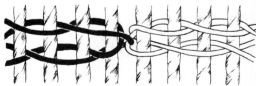

Fig. 62. Diagram of an interlock join

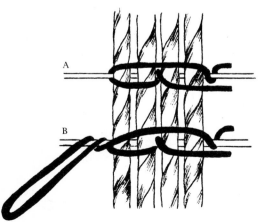

Fig. 60. A: The rigid weft interlock. B: A looped join

The dovetail join may also be found connecting the vertical solid-colour borders of a robe. In this join, the two adjacent weft colours advance and retreat within the space of two or three warp ends, forming a geometric pattern. One weft turn, or two at the most, may be taken around each warp end.

Fig. 63. Diagram of a dovetail join

Fig. 64. The dovetail join

Rectangular units of Chilkat weaving are found in the design field of some of the robes. Drawstring joins are the main method used to connect these units to the surrounding field. The drawstring is a separate yarn, usually spun sinew, which is dropped along the outer vertical edges of a design unit. As the unit is twined, this "string" is woven into every other weft turn at the edge of the unit. When the units are completed, the adjacent field is twined to the units, drawing out the uppermost loop of the drawstring and including it every other weft turn. This method allows the weaver to work the design units separately from the field and yet have them very securely attached when the twining is completed.

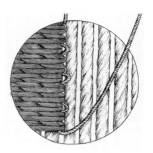

Fig. 65. A drawstring is dropped alongside the area to be woven. As the twining progresses, the drawstring is included with the edge warp end for two turns, and then left out for one turn

Fig. 66. When weaving the adjacent side, a loop of the drawstring is pulled out. Four rows are twined to advance the weaving to the point where the loop emerges

Fig. 67. In the next weft turn, one of the two weft strands is inserted in the drawstring loop and the twining proceeds from left to right

Fig. 68. The drawstring loop is pulled tight by tugging gently on the bottom of the drawstring or by pulling out the next free loop

39

The Parts of a Robe

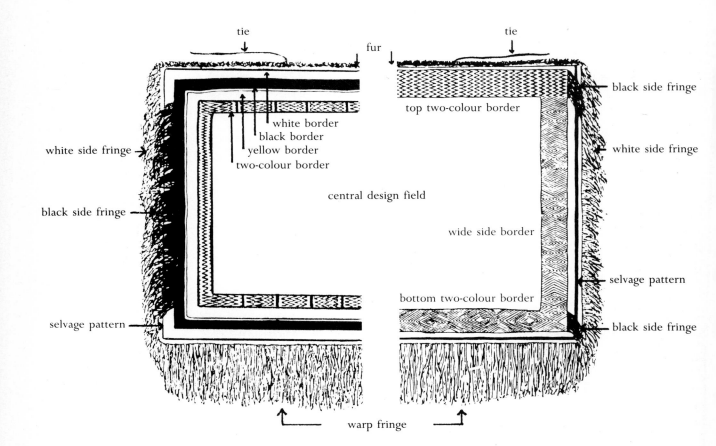

tie

fur

tie

white border
black border
yellow border
two-colour border

white side fringe →

black side fringe —

selvage pattern —

central design field

top two-colour border

wide side border

bottom two-colour border

warp fringe

black side fringe

white side fringe

selvage pattern

black side fringe

Fig. 69. The organization of the borders and fringes in the two major styles of design

Weaving a Robe: Technique and Design

The Heading and Selvage Pattern

The heading cord may consist of one or two warp ends or of special strands spun with a sinew core. It is laced along the single bar of the loom; often both ends on both sides extend down the length of the warp and become side cords. Once the warp ends are hung, the first row of twining begins. It starts on the left side of the robe with a weft yarn folded around the side cords. The two tails of this weft are worked in two-strand twining over paired warp ends to the right side of the robe where they are tied off in an overhand knot to become the right side fringe. The weaver then returns to the left selvage to start the next row with a new pair of wefts.

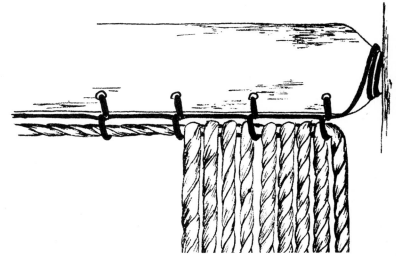

Fig. 71. The warp ends are hung from a cord attached to the main beam

Fig. 70. Two different placements of the lark's head fringe

Before she begins to twine, the weaver inserts a short strand of weft yarn around the side cords and first weft row with a lark's head knot. This strand becomes the left side fringe. In some cases, this fringe is inserted underneath the weft row, rather than around it. The fringes are measured prior to weaving by winding white weft yarn many times around a short, wide board called a "fringe winder." A string is tied around the middle of the strands on one side of the board and cut on the opposite side near the centre.

The first row of twining establishes the sett of the warp. The sett is the number of warp ends which will lie comfortably in each centimetre of twining. The heading is a narrow band of white two-strand twining measuring between 2 and 4 centimetres in width; the number of rows depends on the sett and the size of the weft yarns. Following the first row of twining, the heading is usually worked in ground twining.

The experience of weaving a complete robe has shown that it is impractical to complete each row before starting the next one. To do this, one would have to move back and forth in front of the robe, wasting time and energy. Because each row is separate from the rows above and below, it is logical to weave as far as one can comfortably reach and then drop the wefts and start a new row. This row is twined to within a few weft segments of the preceding row, and then it too is dropped. When as many as six or eight rows have been worked, the weaver shifts to a new position and then twines each of the rows, in succession, another comfortable distance. It is possible to complete eight rows in this manner, moving three times. As mentioned in the Introduction, it is possible that two or three weavers could have worked together, passing the wefts from one to another in this same way.

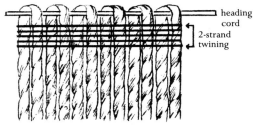

heading cord

2-strand twining

Fig. 72. The heading

41

Serious technical problems arise from the fact that each of the rows must lie parallel to the heading cord. If the line of weaving drops on one side, even imperceptibly, the error is compounded in each succeeding row and eventually the entire weaving becomes unbalanced. A straight line is most difficult to maintain in ground twining, where the space left between the rows must always be equal. It is useful to make a small template to gauge this distance and to check it periodically as each row progresses. The problem is simpler to manage in compact twining, where each row is pushed up directly beneath the one above it. However, the juxtaposition of bars and diagonal lines in some of the designs causes the fell of the weaving to become uneven. Rows pack more tightly together in the diagonal twill than they do in paired twining; the weaver therefore has to adjust her beat to the type of stitch being used.

The first design element in a robe is the selvage pattern, a thin line of design which travels around the periphery of the robe. It can be composed as a series of diagonal lines or as one or more straight black lines.

Fig. 74. A diagonal line selvage pattern

If the design of the selvage pattern is diagonal lines, it is worked in two-colour twining along the top of a robe and spiral weft technique along the sides. Across the top, the yellow or white two-colour twining wefts are measured so that they are only long enough to work the top selvage pattern. In contrast, the black wefts will be long enough to work across the top of

Fig. 73. Winding yarn on a fringe winder. By Sara Porter.

42

the robe, down the side, plus an additional one-third of this length for yarn take-up. Selvage patterns in two-colour twining always consist of two rows. When the pattern is completed across the top of the robe, the two yellow or white wefts are knotted together to form a side fringe, while the black wefts drop down to be used for the spiral weft work of the right side selvage pattern.

The black wefts for the side selvage pattern on the left side of the robe are entered directly beneath the top selvage pattern. Their tails will be long enough to travel down the left side of the robe and across the bottom, plus one-third of this length for yarn take-up. They are used for the two-colour twining of the bottom selvage pattern, meeting the wefts of the right side selvage pattern at the lower right corner of the robe, where they are locked together in a small braid.

Fig. 75. A straight line selvage pattern

A straight line selvage pattern consists of one or more rows of black three-strand twining. The wefts for these rows are long enough to travel around the entire periphery of the robe, plus the usual one-third take-up. This length is doubled, slip knots are placed in both sides, and then they are entered at their mid-point at the top left corner of the robe. The strands which move to the right are worked across the top of the robe in three-strand twining. After this row, the three-strand wefts turn the corners on both sides of the robe and travel vertically down the sides. Owing to the middling of the black weft strands and their entry at the top left side of the robe, the strands on the right will be shorter than those on the left. The bottom line of the selvage pattern is therefore worked from left to right, using these three-strand wefts from the left side of the robe. They work across to the right and join the strands on the right in a small tassel.

The Borders

All of the robes feature one or more borders lying inside the selvage pattern and surrounding the central design field. These borders can be worked either in a single colour or in a variety of two-colour twining designs and/or spiral weft patterns. They are always outlined in rows of three-strand twining in the colour of the border itself. These three-strand rows are measured and inserted in the same manner as the straight-line selvage pattern. If the border is a two-colour design, it is always outlined with a black three-strand twining row.

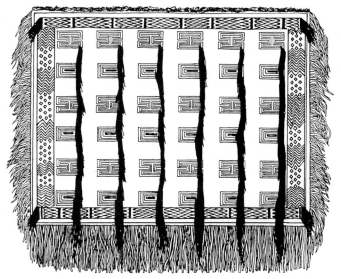

Fig. 76. A single border surrounds the central design field

When there is a single border surrounding the central design field, it is worked at the top in a two-colour twining pattern outlined by black three-strand twining rows. Its black wefts enter with a looped join, forming a looped fringe on the left and a cut fringe on the right. The side borders are worked in the spiral weft technique edged by black three-strand outlines. The pattern strands are inserted directly underneath the two-colour twining of the top border. They are worked for the length of the border and are then braided or knotted together on the back of the robe directly above the bottom border. This border is twined in a two-colour pattern, usually different from the one used at the top. It is edged by black fringes and outlined by black three-strand twining rows.

43

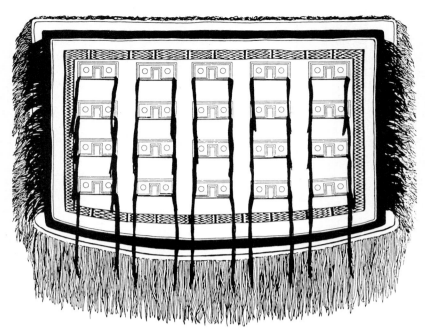

Fig. 77. Multiple borders surround the central design field

If the central design field is surrounded by multiple borders, the wefts of the top white border will start on the left and end on the right as fringes. For the top solid black border, the black weft strands join the white wefts in a rigid-weft interlock. The black strands are then worked as pattern wefts across the top of the robe with the white strands as rigid wefts. At the right, the black wefts are either dropped as a short fringe on the *inside* of the robe or worked into the weaving alongside the warp ends. The white wefts from two rows of rigid weft twining join each other and continue to the edge of the robe in the ground-twining technique.

A solid yellow border lies inside the black border. On some robes, a white line is placed between the three-strand outlines of the black and yellow borders. This line is worked as two rows of three-strand twining. For the border itself, the yellow wefts join the black and the white wefts in a rigid-weft interlock. The yellow border is then woven in rigid weft twining with yellow wefts on the front and the white wefts from the selvage working behind them as rigid wefts. For the width of the top yellow border, the black wefts return in two-strand twining to the left sides of the black borders.

With the exception of one robe, the black side fringes start with the beginning of the two-colour border. These fringes are not placed adjacent to the top black and yellow borders because the black weft would not be needed for the entire length of the yellow border. Fringes could be present next to the top black border, but presumably the gap produced by the absence of fringes for the width of the yellow border was considered undesirable.

The pattern of the two-colour border is worked with the weft yarns from the adjacent borders on the left. When the weaver starts to twine the border, the black weft yarns enter the black side border as a looped join rather than as an interlock join. These black weft yarns are used as a rigid weft behind the yellow border along with the white wefts from the selvage. When the two-colour border starts, the weaver uses either the black and white or black and yellow weft yarns, depending on the pattern she is weaving. Upon completion of two rows of pattern, the black wefts work once again as rigid wefts behind the right yellow border, are used as pattern wefts in the black border, and then are dropped at the outside edge of the black border to become side fringes. The white or yellow wefts which were mated with them twine across to the right side selvage and are tied off as weft fringe.

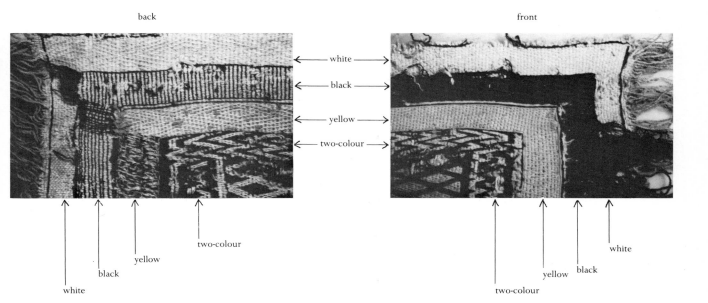

back front

←— white —→
←— black —→
←— yellow —→
←— two-colour —→

white black yellow two-colour

two-colour yellow black white

Fig. 78. Back and front of the top corner of a robe showing the four borders

The two-colour border is patterned in black and white designs, often with yellow streaks running through at regular intervals. When the yellow streaks appear, the wefts start at the left selvage and work through the white, black, and yellow borders before being used with a black weft in two-colour twining. Because of this, yellow streaks appear in the white ground twining of the selvage bands. On the right side of the robe, these yellow wefts are tied off and become side fringe. The yellow fringes are not balanced on the left by the addition of yellow lark's head fringes; rather, the side fringes on the left are always white.

If the pattern established for the two-colour border is composed of unit designs, a black and white block will always alternate with a white and black one. These units succeed each other across the robe; an extra long unit or two very short ones may be placed on the right side, depending on the total number of warp ends which the border covers. It apparently was not important to adjust the number of warp ends per unit so that they divide evenly into the total. The impact of the design is not impaired by such a discrepancy in unit sizes. This concept also applies to the two-colour unit designs when they are used in the central design field.

Down the sides of a robe, the two-colour border is composed of one continuous black and white pattern. Yellow streaks may course through this design; if they do, they occur in tandem with the yellow in the patterns of the central design field. The black side fringes continue until the completion of the two-colour border at the bottom of the robe, at which point the use of the rigid weft interlock is resumed for the entry of the black wefts. All four bottom borders mirror the arrangement, if not the actual design, of the top borders.

Fig. 79. A black and white unit

Fig. 80. A white and black unit

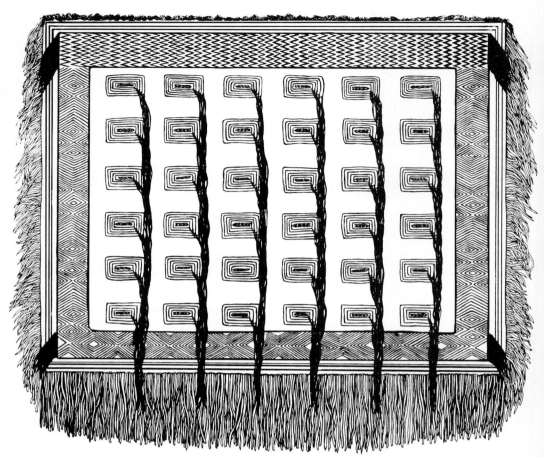

Fig. 81. A robe with a central design field showing rows of concentric figures

The Central Design Field

The central design field lies inside the borders of the robe. Two major styles of patterning are used. One illustrates a plain white surface of ground twining with successive rows of concentric figures worked in three-strand twining. Long black tassels issue, visually and structurally, from the lower corners of each of the figures, giving the overall design of the robes a three-dimensional impact. The other major style shows an elaborately decorated field of black and white patterns worked in two-colour twining. Design units are juxtaposed in a subtle and sophisticated manner. Tassels, all black or black and white, are spaced at regular intervals over the entire field. These tassels are not structurally part of the two-colour patterns; their addition adds the quality of depth to the two-dimensional surface.

Touches of yellow, sparingly placed, give vibrancy to the design fields of both styles of robes. Some robes show a combination of these two major design fields, and a small number of them include formline motifs.

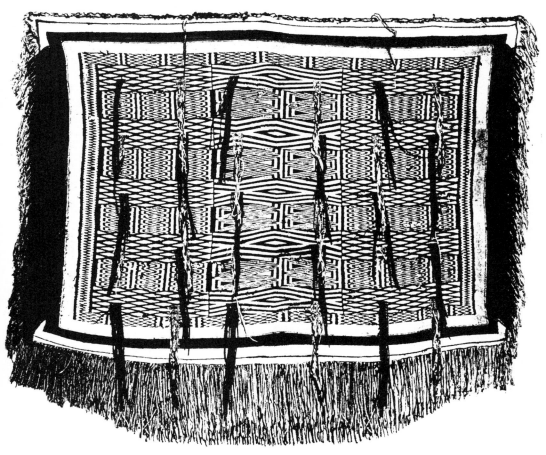

Fig. 82. A robe with a central design field showing elaborate black and white patterns

The Footing and the Fringes

Underneath the bottom borders and the selvage band lie a few rows of ground twining and a final row of fringe twining. These rows, collectively, are called the footing; in echoing the heading they give balance to the framework of the design.

White weft fringes line the sides of the robes, and a white warp fringe hangs from the bottom. Robes with solid colour borders sport secondary black fringes on each side, while robes with a single two-colour border at the top and the bottom have a small amount of black fringe adjacent to these borders.

Fur and Ties

When a robe is completed, a fur strip is wrapped around the heading cord, giving a soft, elegant finish to the neck edge. A thin strip of fur, measuring no more than .5 centimetre, would be inserted from the front side of the robe, under the heading cord and between two warp ends. It was then wound around the top edge of the robe and inserted once again from the front side, moving ahead two or three warp ends. It took the skins of three martens to trim the entire length of the heading cord. The strips would be sewn together as the wrapping progressed since it would be far too cumbersome to pull a very long length of fur through the warp repeatedly. Ties which hold the robe on the wearer's body are sewn to the heading.

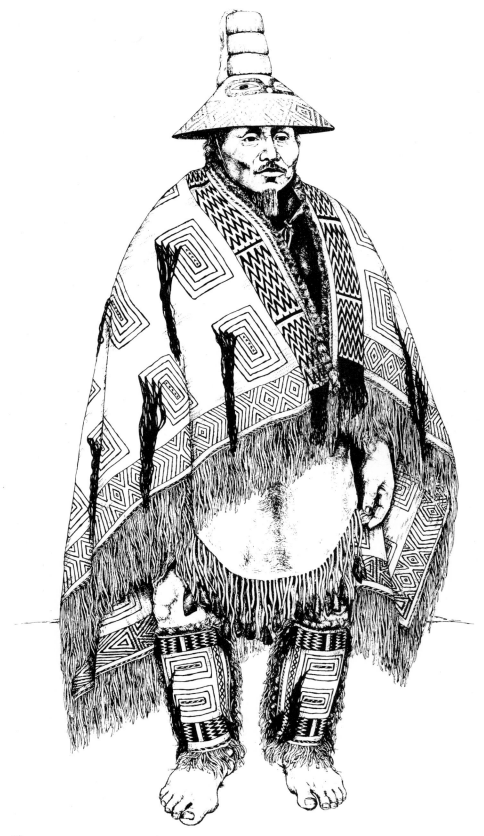

Fig. 83. By Sara Porter

48

Robes I to VII

The rich wrap themselves up sometimes in
white blankets, manufactured in the country,
from the wool of the wild sheep, which is as
soft and fine as the Spanish merino. These
blankets are embroidered with square figures,
and fringed with black and yellow tassels.
Some of them are so curiously worked on one
side with the fur of the sea otter, that they
appear as if lined by it, and are very handsome.

Iurii Fedorovich Lisianskii
Sitka Sound, 1805

The following is a description of each of the fifteen robes. They have been arranged according to the visual complexity of their overall designs, and similarly styled robes have been placed together.

The first seven robes in the collection are rectangular in shape and are woven in white, black, and yellow wool. The white selvage band is decorated with a diagonal pattern in black and yellow or in straight black lines. The border which surrounds the central design field is worked in a two-colour twining pattern at the top and the bottom of the robe and in a spiral weft pattern along the sides. In the central field there are rows of concentric figures with long black tassels pendant from their lower right corners. White side fringes and a warp fringe border three edges of the robes; the top edge is finished with a wrapping of fur. In two of the robes, fur is used as warp along with the wool yarn, covering one surface of the robe in a lush fur pile.

Robes I, VI, and VII are complete weavings; all three of these reside in the Museum of Anthropology and Ethnography in Leningrad. Of these three, two are the only robes with a fur surface in existence today. Robes II and III are fragments of robes found in gravesites. One is in the American Museum of Natural History and the other is in the University Museum in Philadelphia. The other two robes, numbers IV and V, exist only as illustrations. Both were done by Russian artists in the early 19th century, and both are now in museums in Leningrad.

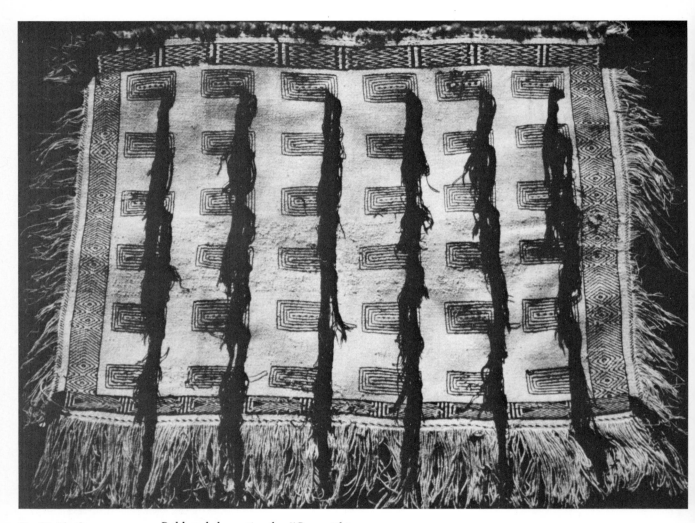

Fig. 84. The front or black tassel side of the "One within Another" Robe

Bold and dramatic, the "One within Another" Robe is the finest example of this style of design in existence. It is in superb condition and therefore speaks strongly of the power held in its designs. Laid out flat, it is an interesting, if static, textile. However, when it encloses the body of a dancer, the three-dimensional quality of its design springs to life. Movement becomes of paramount importance as the tassels and fringes sway to the rhythm of the dance. The impact of the black tassels is startling: cascading from the body of the robe, they seem to create a magic space around the dancer.

50

Robe I

"One within Another" Robe

Collection Data

Present Location: Museum of Anthropology and Ethnography, Leningrad, USSR.
Catalogue Number: 2520-6

Materials and Condition

The robe is in excellent condition; its dyes are still strong, its tassels have not broken away, and it shows little sign of disintegration. The fur is luxurious. Underneath the fur there is evidence of the chalk used to clean the wool.

There is some hair present in the warp yarns; it is not used as a core but is mixed with the wool in the spinning. The white, black, and yellow weft yarns are approximately 1 millimetre in width. Some of the wool, especially in the tassels, is very stiff and brittle. These qualities indicate the presence of iron in the black dye.

Technique and Design

The Heading and the Selvage Pattern

The heading cord is composed of two warp strands laid together. It travels down the sides of the robe, becoming the side cords. A thin strip of fur is wrapped around the heading cord. The warp is sett at five ends per centimetre. The first row of twining in the heading itself lies directly underneath the heading cord and starts over one warp end. Four rows of ground twining follow, with a 2 millimetre space between the rows.

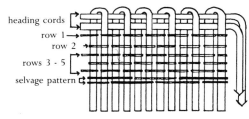

Fig. 85. The heading

Across the top of the robe, the pattern on the selvage band is worked in two-colour twining using black and yellow wefts with diagonal lines moving to the right. Along the sides the pattern consists of a series of diagonal lines in spiral weft technique which encompass four warp ends. These diagonal lines alternate direction, forming half-diamonds at the point of their turn. The visual pattern is inconsistent in the top left corner for 8 centimetres and then becomes regular. Across the bottom of the robe the selvage pattern is worked in two-colour twining using black and white wefts with diagonal lines moving to the left.

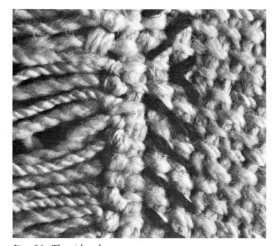

Fig. 86. The side selvage pattern

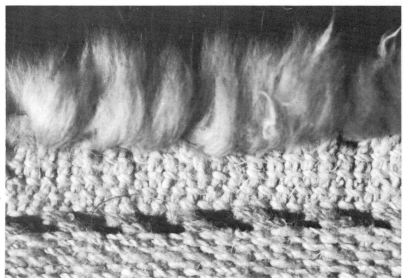

Fig. 87. The fur, the heading, and the top selvage pattern

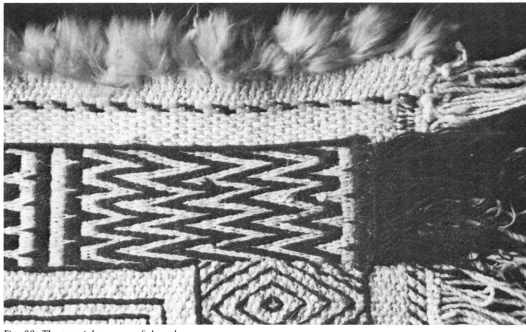

Fig. 88. The top right corner of the robe

The Borders

The top border is worked in two-colour twining in a pattern composed of zig-zag lines and vertical bars. The main pattern is black and white, with a yellow weft used at the points of the zig-zags. Each diagonal line consists of two weft segments in black and two segments in yellow or white, requiring a double twist to maintain the colour in the second segment. The black wefts enter on the left at the edge of this border in a looped join and finish on the right as a cut fringe. The border is outlined in a row of black three-strand twining.

Along the sides of the robe, the border is a spiral weft design outlined on each side by a row of three-strand twining which travels vertically over three weft rows and behind one. The spiral weft pattern consists of two concentric diamond shapes, described by Emmons as a "scoop net" pattern, separated by a column of V's. The number of V's between the diamonds varies along the length of the border. Each spiral weft element is worked over a three-warp unit. Before the bottom border commences, the spiral weft strands are braided together in threes on the inside of the robe.

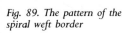

Fig. 89. The pattern of the spiral weft border

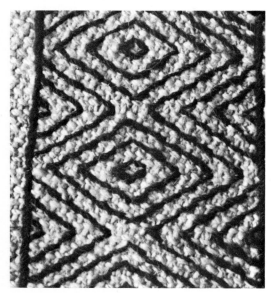

Fig. 90. A detail of the spiral weft wide side border

Fig. 91. A three-warp unit

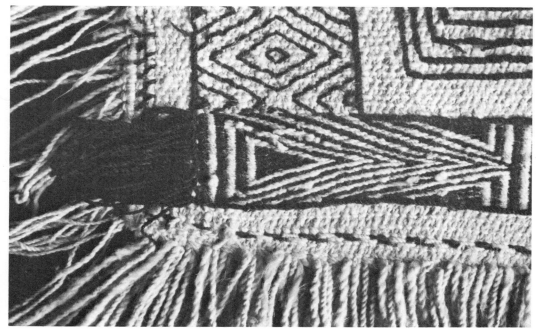

Fig. 92. The bottom left corner of the robe

The bottom border is a two-colour twining design of multiple triangles and zig-zags. It is primarily black and white with black and yellow lines at the top and bottom and through the centre. The bars of the compact two-colour twining pattern are worked over the same two warp ends every row. Each weft segment in the diagonal lines travels over four warp ends, alternating colour with each twist. The black looped fringe and cut fringe of the top border are repeated.

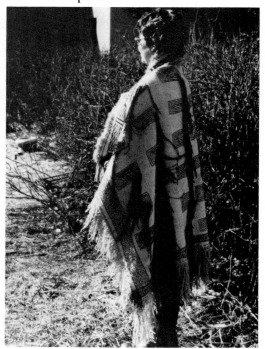

Fig. 93. A back view of the "One within Another" Robe shows the three-dimensional effect of the tassels

Fig. 94. A side view of the robe

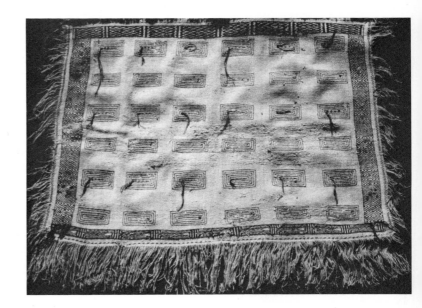

Fig. 95. The back of the robe sports single-strand tassels pendant from the centre line of the concentric rectangles

The Central Design Field

The entire background of the central design field is composed of rows of ground twining. Two variations of the "one within another" motif are placed in rows in the central design field.

The first, third, and fifth rows have black and yellow centre lines worked in alternating black and yellow bars of counter-twining. The weft tails of these lines disappear to the inside of the robe to form a short chevron braided tassel. The second, fourth, and sixth rows have units with a solid black centre line. The tails of this line remain on the front side of the robe as part of the long black tassel. Both types have black tassels 34 centimetres long on the front side of the robe. Eight centimetres of the total length are braided in three-strand braids.

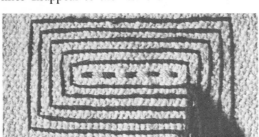

Fig. 96. In this motif, the centre line is a two-row chevron pattern

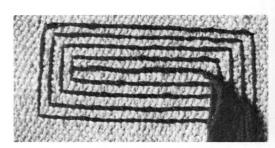

Fig. 98. In this unit the centre line is all black, and its tails join the tassel on the front

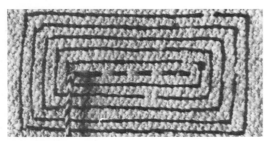

Fig. 97. The back of Fig. 96 shows the single tassel

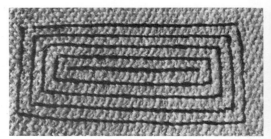

Fig. 99. The reverse of Fig. 98 shows no tassel

54

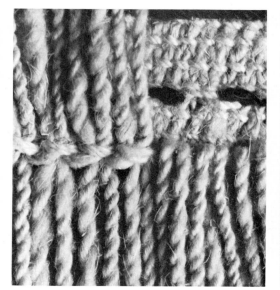

Fig. 100. The bottom selvage pattern, footing, and warp fringe twining

Fig. 101. Fig. 100 seen from the back of the robe

The Footing and the Fringes

The footing is composed of two rows of ground twining which lie underneath the bottom selvage pattern.

White weft fringes line each side of the robe. On the left, two methods are used for entering the weft ground twining rows. The standard method of a lark's head fringe followed by a two-strand twining row is used alternately with a looped and knotted weft twining row. In the latter, the weft is doubled, a 14-centimetre fringe length is measured, and an overhand knot is placed in the yarn. The twining then commences around the side cord. Since separate fringes are not added, the space between the two-strand rows is determined by the knot and the weaver's eye. This method was tried in the centre rows and eventually abandoned as the knots piled up on each other and produced an uneven weave. Furthermore, the selvage edge was not as secure as with the lark's head fringe. The side fringes on the right are the knotted ends of the ground-twining rows and are yellow when this colour is used in the two-colour twining borders.

The warp fringe twining consists of one row of two-strand twining over four warp ends using two white wefts. Of the four warp ends in each segment, two hang down while two are raised and included in the next weft segment and then left to fold down over the twining.

Fig. 102. A looped and knotted weft twining row

Dimensions

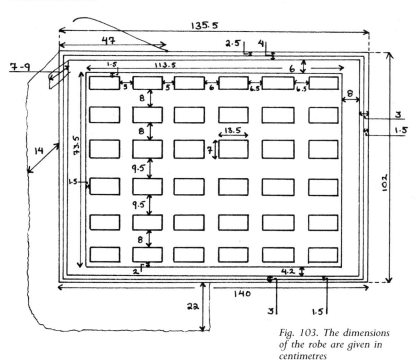

Fig. 103. The dimensions of the robe are given in centimetres

55

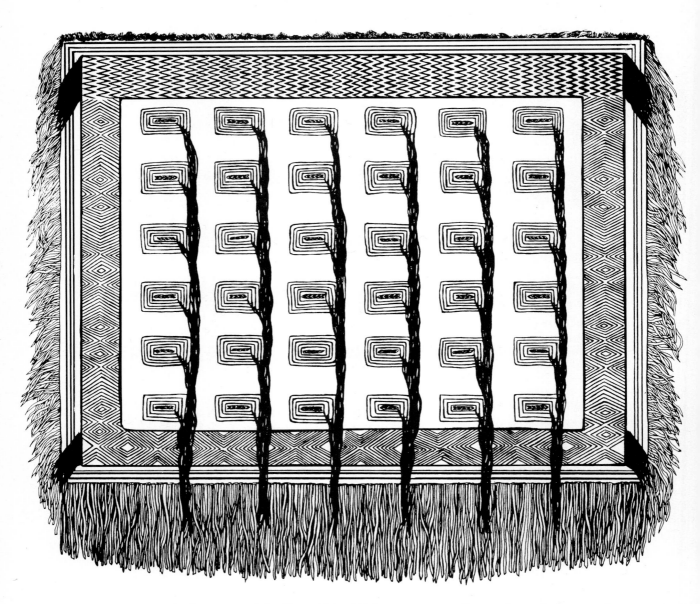

Fig. 104. This drawing reconstructs the Kruzof Island Robe based on information taken from the fragments

The fragments of the Kruzof Island Robe speak to us from the grave. Found first by school children in the depths of a cave and again, years later, in the depths of a museum, they have provided key information on the most unusual weaving technique found in the robes. Owing to the amount of disintegration in the yarns, the spiralling wefts used to create the patterns of the side borders were revealed. The "spiral weft technique" is not common weaver's knowledge. Perhaps the impetus for it came from the spiralling overlay patterns of grasses found in the finest Tlingit baskets.

Robe II

The Kruzof Island Robe

Collection Data

Present Location: American Museum of Natural History, New York, New York, USA.
Catalogue Number: 16.1 932G.

Historical Record: The following information is from the catalogue records at the American Museum of Natural History:
 "Tlingit—Shaman's burial.
 W. Leslie Law, Purchase, 1932-10.
Mr. Law was superintendent of Sheldon Jackson School, Sitka (for orphans) six of whose students turned up the box and mummified head June 10 1931 while on a treasure hunt in a cave facing Crab Bay (?), Kruzof Island, 10 miles from Sitka. The head was found wrapped in a scrap of blanket, supposed to be very old. Emmons claimed that it was a very old style."

Materials and Condition

The fragment is in very poor condition. The surface is brittle and somewhat felted. There is a great amount of fading, discoloration, and disintegration of the fibres. The weft yarns are made of mountain goat wool; the warp is a mixture of wool and hair. The fur has completely disappeared from the hide on the strip which wraps around the heading cord.

Technique and Design

The Heading and the Selvage Pattern
The heading cord is one strand of warp yarn. When the robe was new, a thin strip of fur was wrapped around the cord, entering approximately every four warp ends. The warp sett is established at five ends per centimetre. The heading itself is constructed of six rows of white, compact two-strand twining over alternate warp pairs.

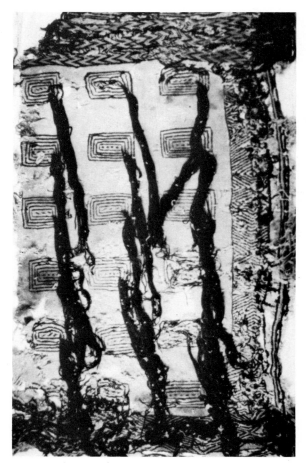

Fig. 105. *The entire fragment*

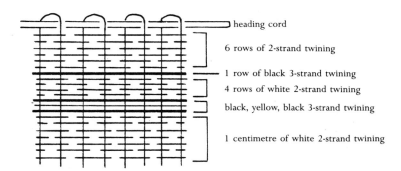

heading cord
6 rows of 2-strand twining
1 row of black 3-strand twining
4 rows of white 2-strand twining
black, yellow, black 3-strand twining
1 centimetre of white 2-strand twining

Fig. 106. *A diagram of the heading and the selvage pattern*

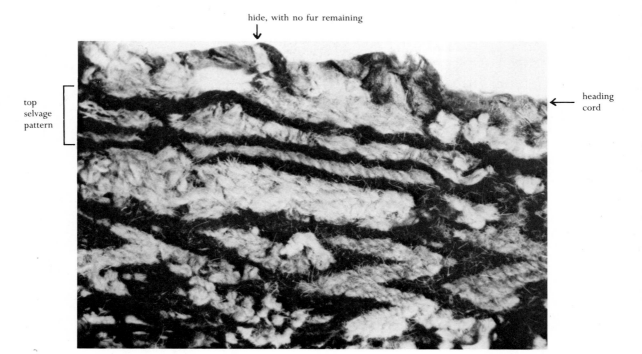

hide, with no fur remaining ↓

top selvage pattern

heading cord

Fig. 107. The top of the robe fragment

The pattern in the selvage band at the top of the robe consists of one row of black three-strand twining and four rows of white two-strand twining, followed by black, yellow, and black three-strand twining rows. Under these rows lies one centimetre of white compact two-strand twining.

Along the sides, the selvage band is patterned in vertical lines which are continuations of the top three-strand twining rows. They turn the top right corner and travel down vertically, maintaining the spacing established along the top of the robe. At the bottom, underneath the two-colour border, there are five rows of ground twining followed by the black and yellow lines. The final black pattern row is missing. (See Fig 112)

The Borders

The top border consists of vertical zig-zag lines worked in black and yellow two-colour twining, reminiscent of the "tree shadow" pattern described by Emmons. Each diagonal line is two weft segments wide. It is difficult to determine whether there is any white weft in this pattern band owing to discoloration and disintegration. The black wefts end on the right side of the border in a short cut fringe. The yellow wefts continue to the right selvage and become side fringe. Black three-strand rows outline the entire border.

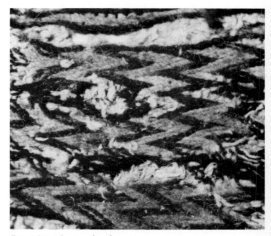

Fig. 109. The top border

Fig. 108. In the top border each weft segment goes over four warp ends

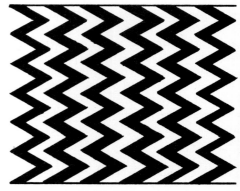

Fig. 110. The patterning of the top border

58

Down the sides of the robe, the border is worked in spiral weft patterns. The design is composed of the diamond "scoop net" pattern separated by upright and inverted V's. Two yellow spiral wefts run down the entire vertical centre of this band. All the spiral wefts wrap around three warp ends, changing places every two weft rows. At the bottom of the band the tails are gathered together on the inside of the robe and tied in one fat knot.

The bottom border of the robe is patterned in diagonal lines with diamond centres. It is worked in two-colour twining, using a double twist in the diamond centres to maintain a yellow weft colour. The diagonal lines, which are one warp end wide, are black and yellow. The black wefts end in cut fringes at the right side of the band while the yellow wefts twine together to the outer edge of the robe where they become side fringe.

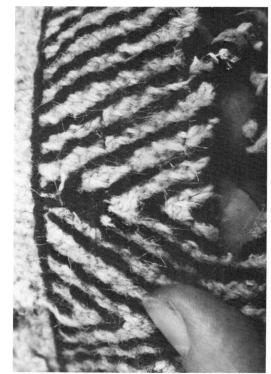

Fig. 111. Half of the spiral weft pattern remains intact

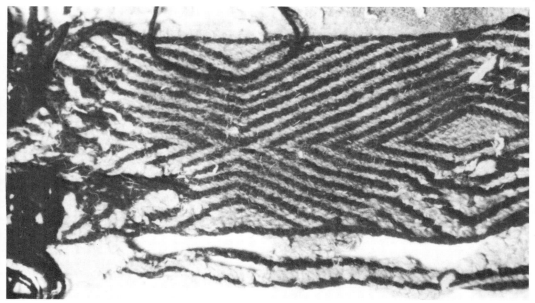

Fig. 112. The bottom border and bottom selvage pattern

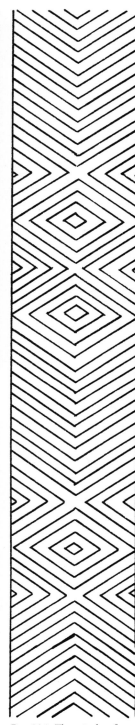

Fig. 114. The spiral weft patterns of the side borders

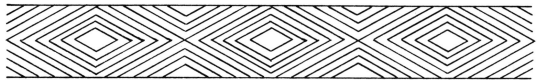

Fig. 113. The patterning of the bottom border

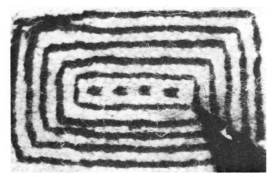

Fig. 115. Centre line A

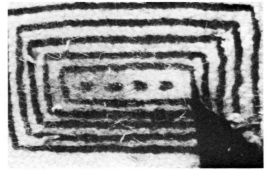

Fig. 116. Centre line B

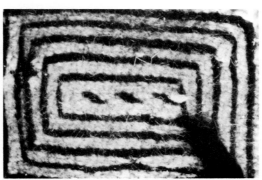

Fig. 117. Centre line C

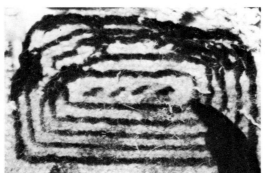

Fig. 118. Centre line D

The Central Design Field

White ground twining serves as the background for the "one within another" concentric figures in the central design field. In the first five rows these figures consist of five concentric rectangles surrounding a centre line. In the sixth row they are composed of four rectangles and a centre line. Four variations of two-colour patterning are used in the centre lines. Two of them contain counter-twined centre lines of black and yellow "arrows," the arrows in one line pointing to the left and in the other to the right. The other two variations contain diagonal lines which angle to the left or to the right. These variations are distributed in the central design field as illustrated in Fig. 119. All of the centre lines are finished on the inside of the robe in four-strand chevron braids.

The tails of the three-strand twining rows which comprise the units are braided on the front of the robe to form long tassels. All six strands from one row may be formed into one braid or into two three-strand braids. The distribution of these two methods is haphazard.

(missing portion)

Fig. 119. The distribution of the centre lines A, B, C and D in the central design field

60

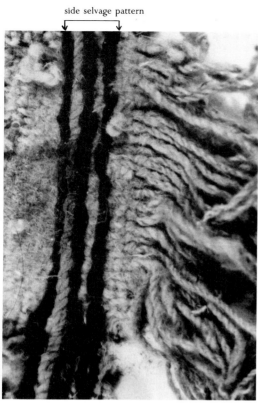

side selvage pattern

Fig. 120. The right selvage pattern and side fringes

The Footing and the Fringes

The final rows of twining are missing from the fragment. Although they are disintegrated, the side fringes on the right are clearly a continuation of the weft rows. The major colour of the side fringes was white, with yellow appearing adjacent to the top and bottom geometric bands. The left side fringes and the warp fringe are missing.

Dimensions

Fig. 121. The dimensions of the robe are given in centimetres

61

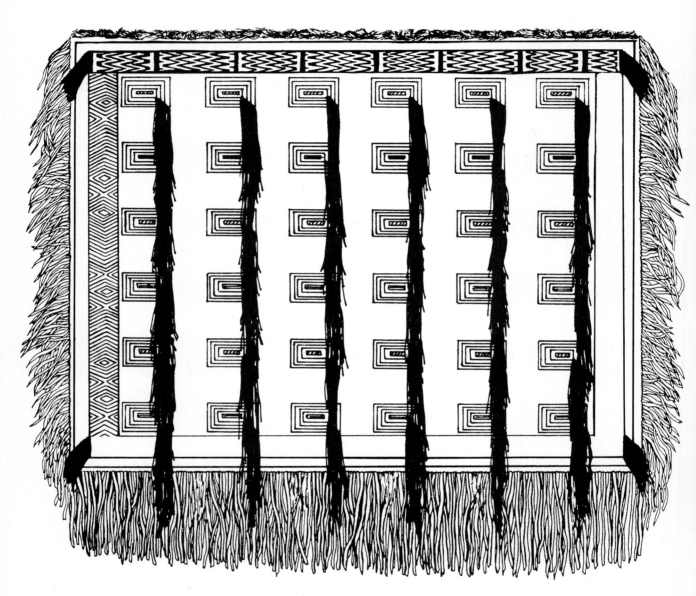

Fig. 122. A drawing of the Knight Island Robe based on information from the fragments. There are no remains of the right or bottom borders

The remains of two of the robes in this collection come from gravesites. The Kruzof Island Robe and the Knight Island Robe speak strongly of ownership; no one can deny their Tlingit roots. The fragments of the Knight Island Robe are miniscule; to gather the facts and discard the irrelevancies was like a detective drama.

The result projects a handsome robe, produced through the combined energies of a fine weaver and an expert spinner and, one feels, a very strong spirit.

Robe III

The Knight Island Robe

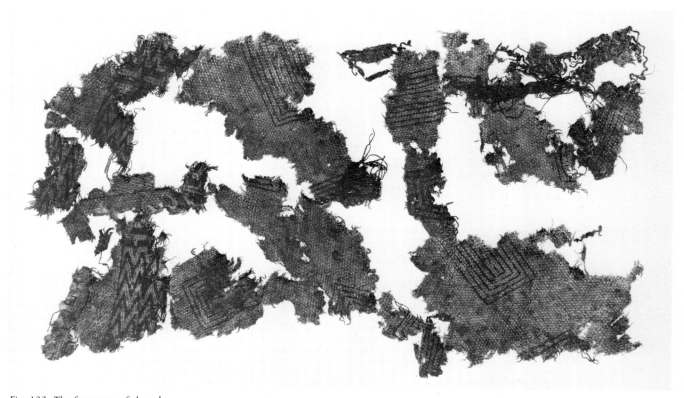

Fig. 123. The fragments of the robe

Collection Data

Present Location: University Museum, University of Pennsylvania, Philadelphia, Pennsylvania, USA.
Catalogue Number: Riddell-de Laguna Blanket.

The fragments of Robe III were collected by Francis A. Riddell and Frederica de Laguna, who conducted archaeological research on Knight Island near Yakutat

Bay between 1949 and 1952. They were found in a post-contact grave of an adult male along with remnants of a wooden coffin, blue and white beads, and an iron pot. In an article entitled "The Yakutat Blanket," Carolyn Osborne gives precise descriptions and measurements of the fragments, and records the conservation work that was done on them.

Materials and Condition

The pieces of this robe consist of five fragments from the top border, four from the side border, four main pieces from the central design field and numerous small bits. The largest fragment measures 26.5 centimetres warpwise by 31.7 centimetres weftwise. The samples of warp yarn show definite discoloration which gives them a gold-beige hue. The weft samples which are not brown are coloured in the same tones. This discoloration and a degree of felting on the surface of the weaving were caused by weathering and the time buried in the grave. Interwoven in the fragment pieces are very small bits of woody materials, which appear to resemble small sticks. These "sticks" can be ignored in analysing the fragments; as Dr. de Laguna has explained, they are rootlets which grew into the fabric during the time the robe was in the grave. Analysis by the Federal Bureau of Investigation confirms that the fibres used to create the robe came from the mountain goat.

Technique and Design

The Heading and the Selvage Pattern
The heading consists of three rows of white two-strand twining over paired warp ends followed by five rows of ground-twining. The sett is approximately five warp ends per centimetre. A fur strip was originally wrapped around the heading cord.

Directly under the heading lies a black three-strand twining row which is the top selvage pattern. This is followed by ten rows of white alternate compact twining over four warp end groups. The black line continues down the left side of the robe as the side selvage pattern, within which there is a space of white ground twining which equals the white band along the top border in width. The bottom selvage pattern is missing.

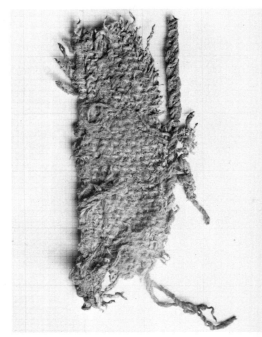

Fig. 125. The side selvage pattern

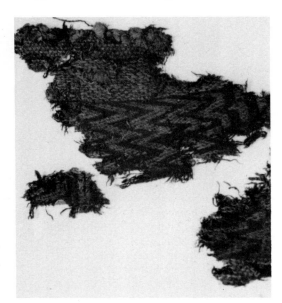

Fig. 124. The heading fragments

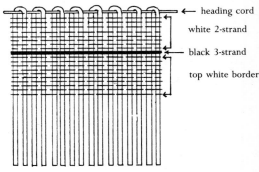

→ heading cord

white 2-strand

black 3-strand

top white border

Fig. 126. The heading, selvage line, and top white border

Fig. 127. A fragment from the top border

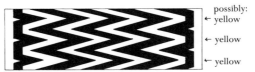

possibly:
← yellow
← yellow
← yellow

Fig. 128. One design unit in the top border

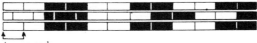

4 warp ends

Fig. 129. A diagram of the twining segments in a portion of the design in Fig. 128

Fig. 130. A fragment from the spiral weft design

The Borders

The top border of the robe is outlined by rows of three-strand twining. The pattern is worked in two-colour twining over four warp ends. The zig-zag stripes are two weft segments wide. The bars are not worked over the same warp groups every row, but instead are twined over four warp ends in one row and split these warp ends in the next. This is a very unusual treatment of the bar design.

One of the fragments indicates that one unit of the top border design appeared as in Fig. 128. The unit was black and white and could have included yellow stripes at the points of the zig-zags. The fact that this fragment includes a portion of the heading confirms that this design comes from the top border.

The side border is patterned in a spiral weft design of the diamond "scoop net" pattern and multiple inverted V's. A small portion of this border exists in one fragment, which gives enough information to determine a possible border design.

There are no existing fragments which give a clue to the patterning of the bottom border.

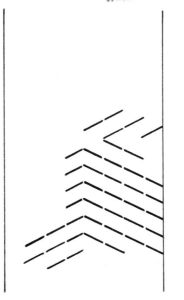

Fig. 131. The pattern in the fragment

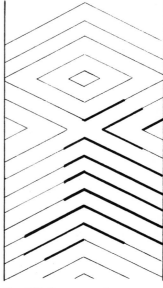

Fig. 132. Reconstructed pattern derived from Fig. 131

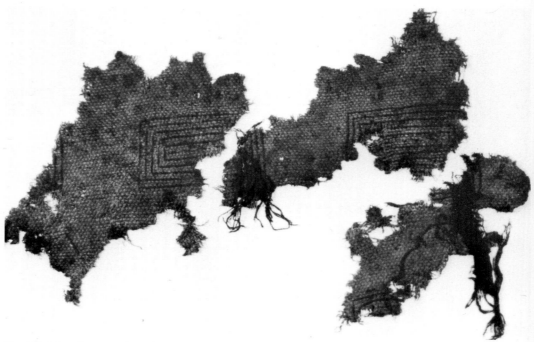

Fig. 133. These fragments from the central design field show two concentric rectangles

The Central Design Field

In the central design field, rows of "one within another" concentric rectangles are worked in black three-strand twining against a white ground-twining background. Each of the rectangles in one unit ends in two tassels which are braided for about 4 centimetres and then knotted. The longest tassel measures approximately 18 centimetres. There are five concentric rectangles in each unit, plus a centre line. The centre line in one unit is designed in diagonal stripes of black and yellow two-colour twining. A loose chevron braid among the fragments confirms the existence of this two-colour style. Another unit displays an all black centre line. Possibly this robe was designed in a fashion similar to Robe I, with alternating rows of units with all black and with diagonal-striped centre lines.

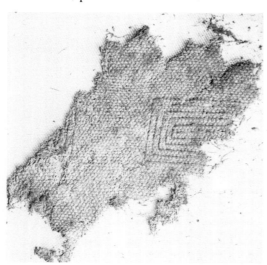

Fig. 134. Close up of concentric rectangle

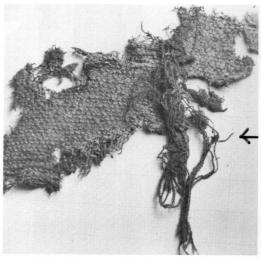

Fig. 135. This fragment shows the remains of a black tassel

The Footing and the Fringes

There is no information about the number of rows in the footing. On one of the fragments, remnants of white side fringes are attached to the side cords with lark's head knots, which indicates that the fragment comes from the left side of the robe. there are no fragments to indicate the techniques used in the right side fringe or warp fringe.

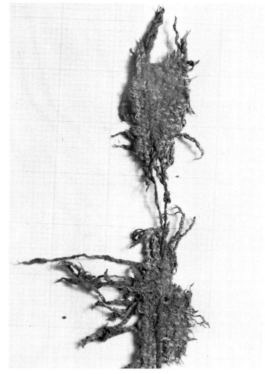

Dimensions

The following dimensions are those actually taken from the fragment pieces.

Fig. 136. Side fringes on the left side of the robe

*Fig. 137. The dimensions
are given in centimetres*

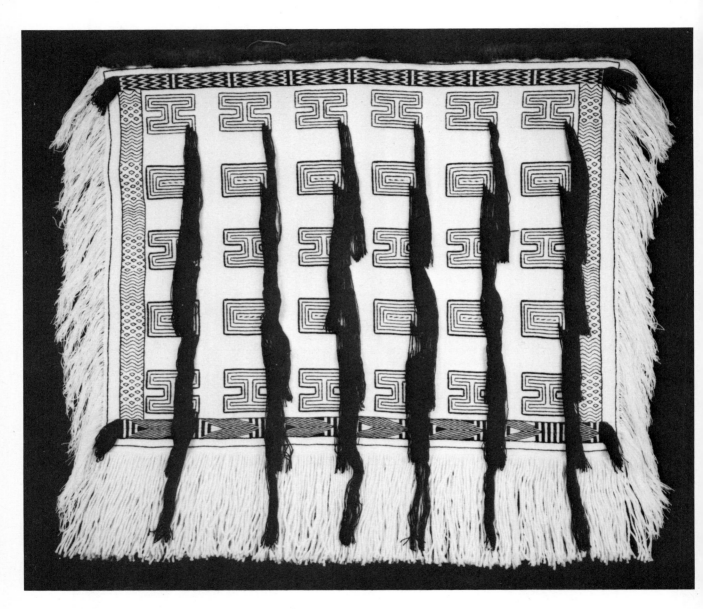

Fig. 138. A woven reconstruction of Kotlean's Robe, from the collection of Dr. Robert White

Chief Kotlean of Sitka, Alaska, was proudly portrayed in a painting by the Russian artist Mikhail Tikhanov. In the portrait, Kotlean wears a robe which has not been found in any of the public collections. Because of the amount of detail in the painting, this robe was chosen for reconstruction so that I could learn the techniques of Raven's Tail weaving and experience more fully the visual impact of the robes. Kotlean's Robe takes on a magical quality when it is worn; draping easily about the body, the richness of the fur strikingly accentuates the features of the wearer, and the black tassels sway dramatically as the robe moves. For the first time in over 150 years, a Raven's Tail robe has danced in the land of its origins.

Robe IV

Kotlean's Robe

Fig. 139. "Kotlean" painted by Mikhail Tikhanov

Collection Data

Present Location:
Original painting: Museum of the Academy
of Art, Leningrad, USSR.
Colour transparency: Leonid Shur Collection,
Archives, University of Alaska,
Fairbanks, Alaska, USA.
Black and white print: *Alaska Journal*
(Winter 1976, p. 43)

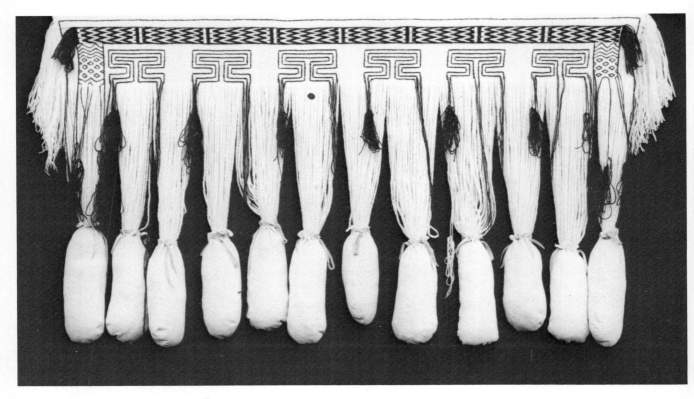

Fig. 140. The concentric shapes are at different stages owing to the progress of successive wefts across the weaving

Historical Record: L. A. Shur and R. A. Pierce co-authored an article "Artists in Russian America: Mikhail Tikhanov" in the *Alaska Journal*. In it, they state that Tikhanov "was born a serf about 1789. His talent was noted, and in 1806, at the age of 17, he was sent to the Academy of Art in St. Petersburg. Freed from his serf status in 1815, he stayed on at the Academy."

"In May 1817, Tikhanov was recommended as an artist to accompany the round-the-world expedition under Golovnin, and August 15, 1817, left Kronshtadt, the port of St. Petersburg, on board the 'Kamchatka.' . . . Following his instructions, the artist painted all aborigines in both full face and profile, which at first makes it seem as if he was painting two individuals. He carefully portrayed clothing, ornamentation and weapons, making these [paintings] a superb ethnographic source" (p. 47).

Technique and Design

The Heading and the Selvage Pattern

To produce the spacing apparent in the painting, a number of ground-twining rows were placed underneath the heading cord which is finished with a fur wrapping.

The pattern on the white selvage band is a black line. This line lies underneath the heading and travels around the periphery of the robe. Typically, such a line is worked as a row of three-strand twining. Inside this pattern line is a band of white. In the reconstruction it is made up of rows of compact two-strand twining at the top and bottom of the robe; along the sides it is worked in ground-twining rows.

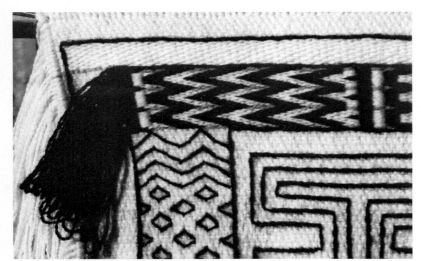

Fig. 141. The top left corner of the robe

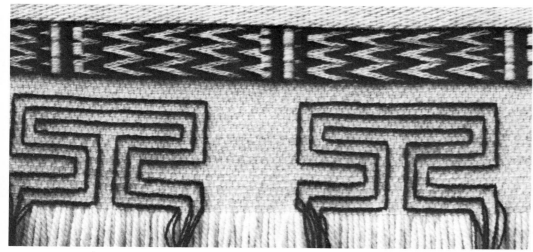

Fig. 142. Two tattoo units in the process of being woven

Fig. 143. A black and white woven unit

Fig. 144. A white and black woven unit

The Borders

The top border of the robe is designed in units of the zig-zag and bars pattern worked in two-colour twining. Two units, one black and white and one white and black, alternate across the length of this border. The long black fringes which appear at the edges indicate that the looped join technique was used on the left and the cut fringe on the right.

Only the left side border is illustrated in the painting. It appears to be designed with horizontal zig-zag lines, called "the mouth track of the woodworm" by Emmons, interspersed with "eye" lozenges. Both of these patterns would have been done in the spiral weft technique.

In the painting, the bottom border is illustrated with zig-zag and bar designs. Since it is very difficult to determine the exact arrangement of these elements, the bottom band of the reconstructed robe is taken from Robe I. There is generally a difference in design between the top and bottom borders of the robes. However, Tikhanov's painting suggests that these two bands were of the same design.

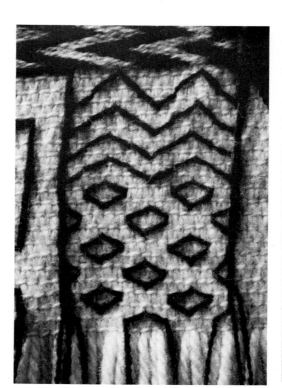

Fig. 145. The zig-zag pattern and "eye" lozenges of the spiral weft border

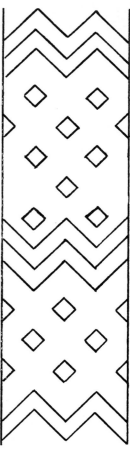

Fig. 146. The pattern of the spiral weft border

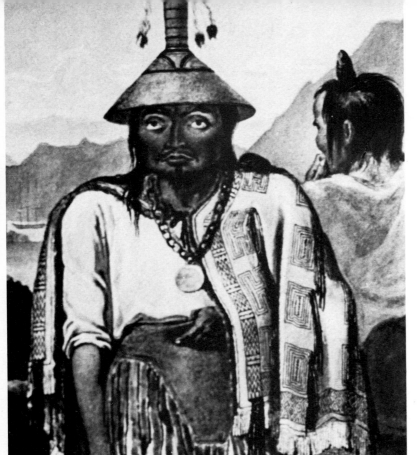

Fig. 147. Two different design units can be seen in the upper portion of the central design field

The Central Design Field

Two different types of concentric units can be seen in the upper portion of the central design field. These are concentric "tattoo" shapes, and the "one within another" concentric rectangles. The tattoo pattern can also be found in Robes V and X, and it is seen on many fine baskets.

It is difficult to determine exactly how many rows of units appeared on the original robe. The painting indicates that there are four tattoo rows and three rectangle rows. However, given the size of the units and the distances between them, such an arrangement would produce a central design field of disproportionately large dimensions. In the reconstructed robe, one row of tattoo shapes has been removed.

Fig. 148. Concentric tattoo shape

Fig. 149. Concentric rectangle

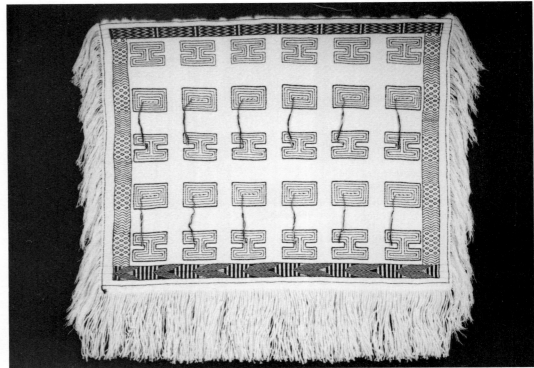

Fig. 150. A back view of the robe

72

The Footing and the Fringes

The white space illustrated as the footing has been woven in rows of ground twining. In the painting, both the side fringes and the warp fringe appear to be much shorter than is traditional.

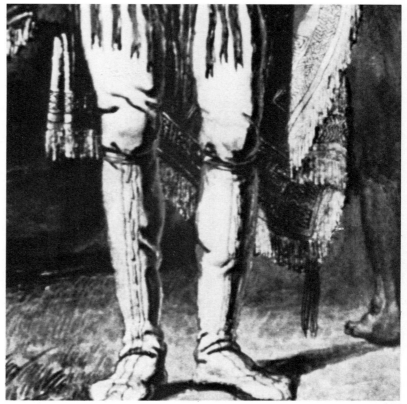

Fig. 151. The lower border and fringes of the robe

Dimensions

If Chief Kotlean was a tall man, seven rows of concentric units might have been necessary to make the robe fit. The size of the reconstructed robe, with the elimination of the final two rows, is appropriate for a person 5'5" (165 cm.).

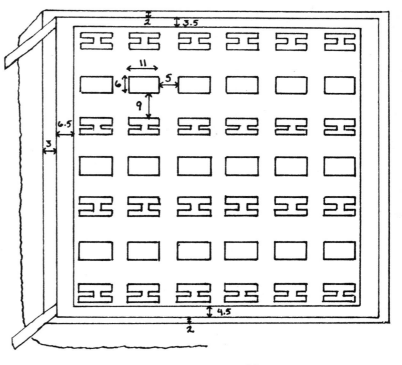

Fig. 152. The dimensions of the robe are given in centimetres

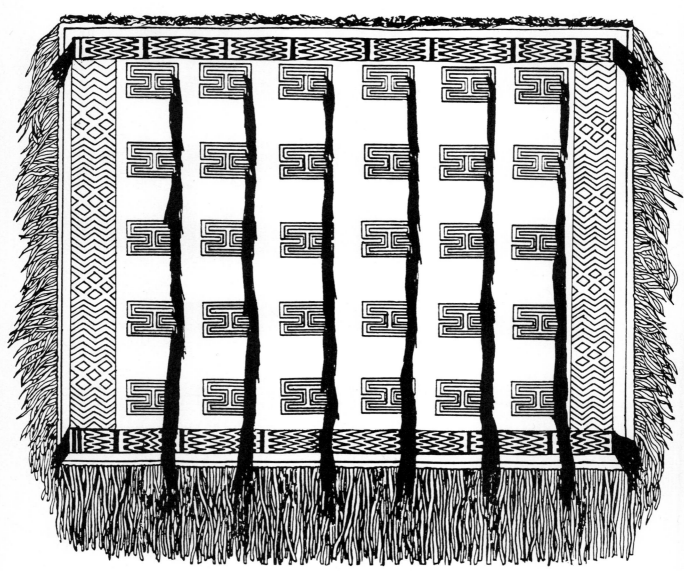

Fig. 153. A drawing of the "Tattoo" Robe based on Pavel Mikhailov's sketch made at Sitka in 1827

Another Russian artist, Pavel Mikhailov, was appointed official artist by the Russian Academy of Art to the round-the-world voyage of the sloop *Moller*. This voyage took place between 1826 and 1829, under the command of M.N. Staniukovich, and visited the North Pacific and Russian America, spending some time in Sitka, Alaska, in September 1827. The sketch of Robe V comes from the collection of works that Mikhailov made during this journey. The whereabouts of the actual robe are not known; record of it only exists in this romantically draped sketch. Mikhailov was under precise instructions to "strive for maximum accuracy; he was not to draw from memory alone; and he was to avoid supplementing or embellishing what he saw. Such rules were not accidental. In those years, before photography, drawings and paintings were the sole

Robe V

"Tattoo" Pattern Robe

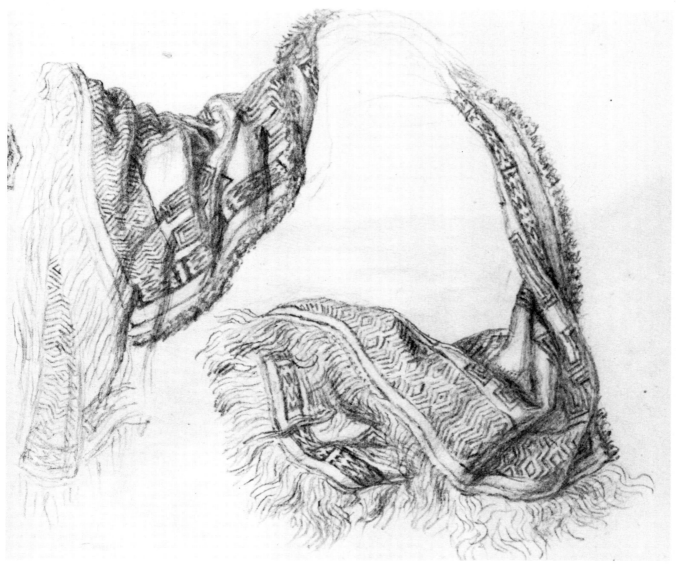

means of recording visual impressions" (Shur and Pierce 1978: 361). His sketch shows a robe draped about an invisible body whose right arm is raised, showing a portion, though upside down, of the front side of the robe. As the robe falls from the left "shoulder," it turns, showing the inside of the spiral weft border, the top two-colour border and a small amount of the central design field.

Collection Data

Present Location: The sketch is in the collection of the State Russian Museum, Leningrad, USSR.
Catalogue number: R-29091.

Fig. 154. Mikhailov's drawing reveals the detail of the robe

Historical Record: No information is known about the robe itself, but an article, written by L.A. Shur and R.A. Pierce, entitled "Pavel Mikhailov, Artist in Russian America" and published by the *Alaska Journal*, Autumn 1978, gives an excellent description of the artist. "Mikhailov was born in 1786 in St. Petersburg. In 1795 his father, a retired actor, placed him in a school in the Academy of Arts. There the youth did well; in 1806 and 1807 he received gold medals for his work. After graduating from the academy, he specialized in portrait and miniature painting. In 1818, his talent earned him a place on the round-the-world voyage of the sloop *Vostok* under command of F. F. Bellingshausen. His many watercolours and sketches are an important part of the record of this well-known expedition, which was crowned by the discovery of Antarctica" (p. 361). His second journey was with the sloop *Moller*. "The greater part of the works of Mikhailov, produced during the round-the-world voyage on the sloop *Vostok* in 1819-1821, were published in 1831 in the atlas accompanying the description of Bellingshausen's voyage. The drawings made by the artist during his second round-the-world voyage in 1826-1829 have never been reproduced, with the exception of several published in recent years. Of particular interest are the watercolours which Mikhailov made in Russian America. Inasmuch as only a few of his works have ever been published, Mikhailov's depictions of Russian America are of great interest as sources in Alaska history and ethnography" (pp. 361-62).

Design

The Selvage Pattern and Borders

The top, or neckline, of the robe is edged in fur, followed by a white selvage band. A black line runs around the periphery as patterning within this selvage band. One border surrounds the central design field. Along the top and bottom of the robe it is composed of units of two-colour design in the zig-zag and bars pattern. These units vary in width; as sketched, some have two and some have three zig-zag lines between the bars. Along both sides of the robe the border is executed in spiral weft technique. Areas of "scoop net" diamonds are separated by the horizontal zig-zag lines called "mouth of the woodworm." These borders appear to be very wide.

Fig. 156. The zig-zag and bar units

Fig. 155. The spiral weft pattern

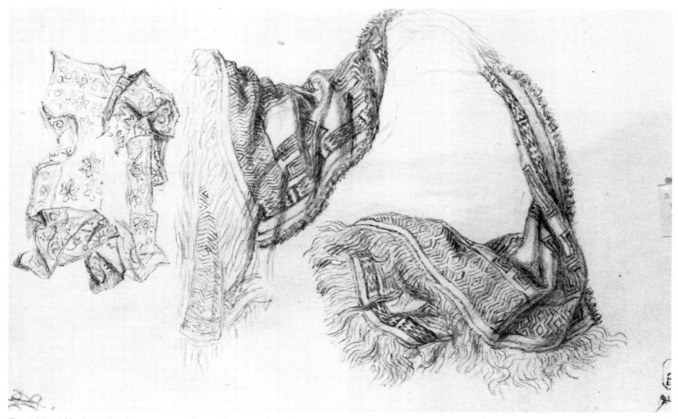

Fig. 157. Mikhailov's sketch gives an excellent indication of the drape and flexibility of the fabric in these robes

The Central Design Field

The central design field appears to be covered in rows of concentric units of the "tattoo" pattern. Two groups of black tassels hang from each unit. These tassels project from the lower right corners of the upper and lower portions of the design. In Robes IV and VIII, which also employ the "tattoo'" pattern, a single group of tassels hangs from the lower right corner. It is difficult to determine from the sketch how many rows of these concentric units were placed in the central design field.

The Fringes

The robe is surrounded on three sides by white fringes. A short black fringe can be seen adjacent to the right side of the top two-colour border.

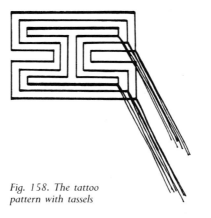

Fig. 158. The tattoo pattern with tassels

Dimensions

No dimensions have been determined for this robe.

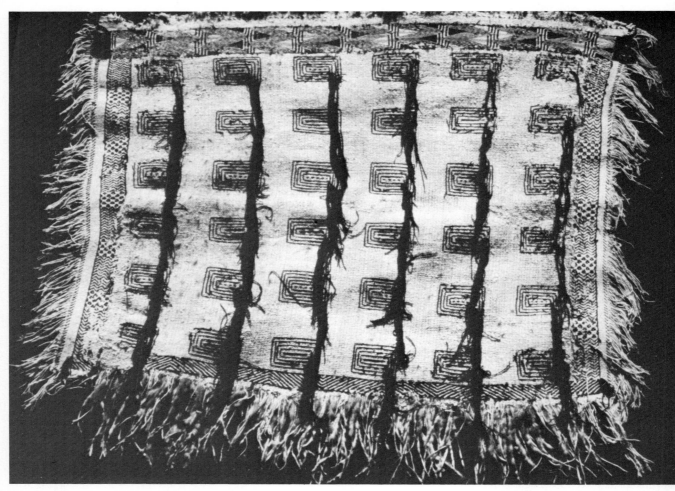

Fig. 159. The front or pattern side of the "One within Another" Fur-Sided Robe. The fur strips can be seen intermingled with wool yarns in the warp fringes

Two very special garments, Robes VI and VII in this collection, are dramatically different from all the others. In each, one side is patterned with the concentric figures typical of the first five robes. Extraordinarily, the other side of these robes is completely covered in a lush, golden brown fur pile. The fur is an integral part of the structure of the fabric, for thin strips of fur and hide are actually used, along with woollen strands, as warp yarns. The only pattern visible on the fur side of these robes is the spiral weft design of the side borders, with the adjacent sections of the top and bottom borders and the selvage bands. In this particular robe, the short tassels from the centre lines of the "one within another" figures can also be seen poking through the fur pile. The robe is amazingly soft and flexible and is, perhaps, one of the most luxurious garments ever to be worn.

Robe VI

"One within Another" Fur-Sided Robe

Collection Data

Present Location: Museum of Anthropology
and Ethnography, Leningrad, USSR.
Catalogue Number: 2520-5.

Fig. 160. The back of the robe. Only the wide spiral weft side borders show as pattern. The small tassels in the central design field are the tails of the centre lines in the concentric rectangles

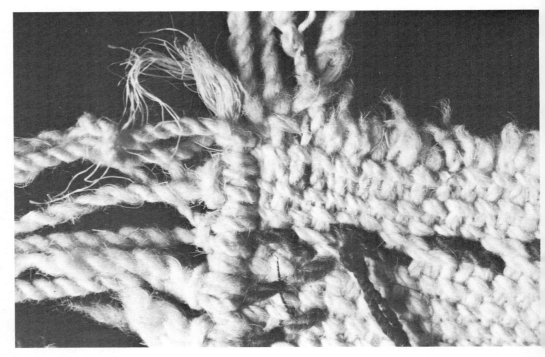

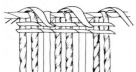

Fig. 161. The top left corner of the robe, showing the hair in the side cord

Fig. 162. A diagram of the fur and wool warp ends and the first two rows of ground twining

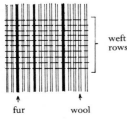

weft rows

fur wool

Fig. 163. Organization of the fur strips and wool warp ends

Materials and Condition

This robe is in very good condition. There is some disintegration in the heading, the right side fringe, and the bottom left corner of the warp fringe. Also, a few of the tassel strands are broken or missing and there is some breakage of fibres on the surface. Because the weave structure is not tight, the robe is very flexible. In the lower left corner there has been repair work done using an S-ply white yarn.

The warp ends are made of mountain goat wool with some hair mixed in and are approximately 2 millimetres in width. The fur strips vary from 2 to 3 millimetres in width. The hide side is white, and the fur side, a lustrous golden brown. The wefts are all mountain goat wool.

The Heading and the Selvage Pattern

The heading cord is 3 millimetres wide, and it is made entirely of mountain goat hair. It travels across the top of the robe, but owing to the disintegration it is not clear if it rounded the corners to travel vertically or if the side cords were added separately.

The warp is made up of two or more wool warp ends alternating with one fur strip. The fur warps are hung by folding a fur strip over the heading cord approximately 3 centimetres from the end of the

strip. The short folded end is secured in the first row of weft twining. Each fur warp end is approximately 130 centimetres long. The fur strips are placed in the warp for the width of the central design field. Wool warps only are placed on each side border.

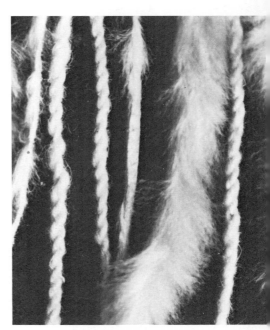

Fig. 164. Fur strip and wool warp ends

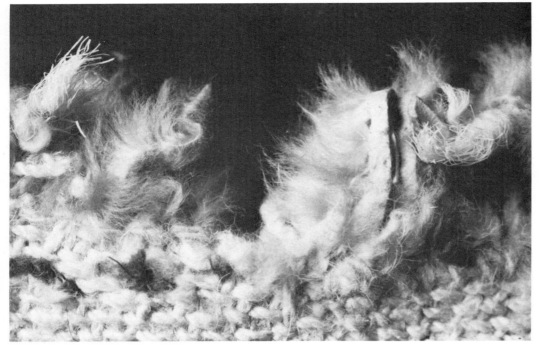

Fig. 165. The heading, showing a folded fur strip and the hair heading cord

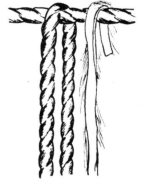

Fig. 166. Fur strip and wool warp ends

The first row of white weft twining lies directly under the heading cord and includes two wool strands and one fur strip alternately. This first row and the heading cord are wrapped with a fur strip approximately 4 millimetres in width. The second row of twining lies underneath the fur wrapping and is identical to the first. The warp is sett at six ends per centimetre.

Following these first two rows are three rows of ground twining. One weft segment in the ground twining includes either two wool warp ends or one wool warp and one fur strip.

Fig. 167. The top of the robe showing the fur wrapping and white ground twining

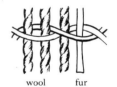

wool fur

Fig. 168. Two-strand twining over paired warp units

Fig. 169. The pattern side of the robe showing the two-strand ground twining and the wool and hide warp ends

Fig. 170. Dense fur pile covers the reverse side of the ground twining in Fig. 169

Fig. 171. The fur pile, opened up to show the ground twining

The selvage pattern at the top of the robe consists of two rows of two-colour twining in black and white designed as a diagonal. This is followed by nine rows, or 4 centimetres, of ground twining.

Down the sides of the robe, the selvage pattern is worked in spiral weft technique using all black wefts. On the left side of the robe the first four weft segments of ground twining are worked over the same warp pairs every row. The spiral weft strands on this side travel over three paired warp ends, splitting the middle weft segment. In design, the right hand angle of the diagonal is continuous for the entire length of the border.

On the right side of the robe, the ground twining works over paired warp ends for the final three weft segments. Each spiral weft strand is worked over two warp pairs. In design, the diagonal alters direction once along the length of the border.

At the bottom of the robe, the selvage band consists of three rows of white ground twining and two rows in black and white two-colour twining. The angle of the diagonal is opposite to that of the top selvage pattern. At the lower right corner of the robe, the strands from the side and bottom selvage patterns are braided together and tied off.

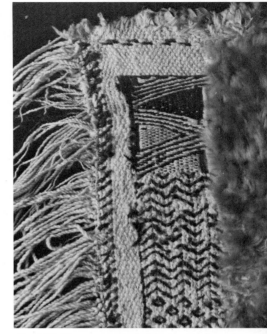

Fig. 177. The top corner of the robe seen from the fur side

Fig. 172. The top selvage pattern

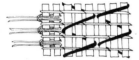

Fig. 173. The warp groups in the left side selvage pattern

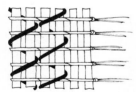

Fig. 174. The warp groups in the right side selvage pattern

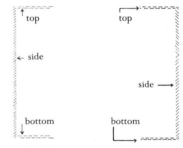

Fig. 178. The selvage patterns

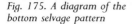

Fig. 175. A diagram of the bottom selvage pattern

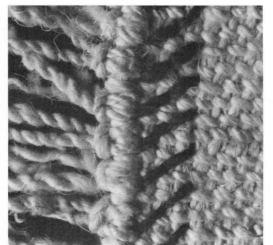

Fig. 176. The spiral weft side selvage pattern on the left side of the robe

Fig. 179. The right side selvage pattern

Fig. 180. The fur side of the robe with the pile parted to show the top two-colour pattern

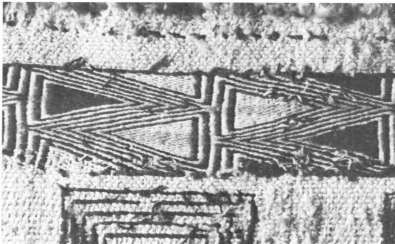

Fig. 181. The top two-colour border

The Borders

The top border is designed in units of multiple triangles and vertical zig-zag lines surrounding solid colour triangles worked in two-colour twining. The design is black and white, with black and yellow stripes running through the points of the triangles and the centre of the solid white triangles. Although the twining is compact, none of the pattern appears on the fur side of the robe. The black wefts enter on the left side of this band in a looped join and exit on the right as cut fringes.

The side borders of the robe lie directly outside the first fur warp end. They are worked in a spiral weft design of alternating bands of horizontal zig-zags, or the "mouthtrack of the woodworm" design, and "eye" lozenges. Each spiral weft travels over three warp ends.

At the bottom of the robe, directly above the bottom border, the tails of the spiral weft strands are gathered together and tied in a large overhand knot on the fur side.

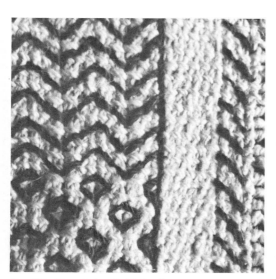

Fig. 182. The spiral weft side border

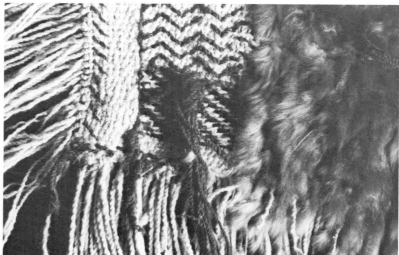

Fig. 183. The bottom right corner of the robe seen from the fur side

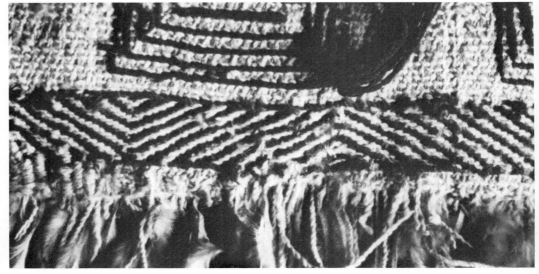

Fig. 185. The bottom border and the fringes

4 warp ends

Fig. 184. The bottom
two-colour border pattern

The bottom border is composed of groups of diagonal lines which alternate direction, much resembling the "hood of the raven" design. They are worked in two-colour twining in black and white yarns and use only one weft segment for each line.

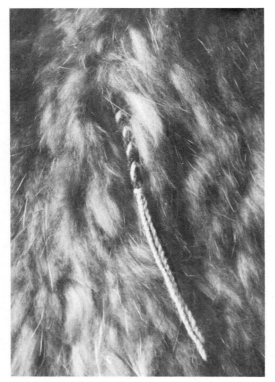

Fig. 186. The fur side of Fig. 187, showing the black and yellow tassel from the centre line

The Central Design Field

The central design field is made up of black "one within another" rectangles placed on a white ground. There are six rows, each row containing six units. In the first, third, and fifth rows from the top, the units are composed of five rectangles surrounding black and yellow counter-twined centre lines which terminate in single chevron tassels on the fur side of the robe. The second, fourth, and sixth rows have units made up of four concentric rectangles enclosing all black centre lines. These lines are made up of two rows of black three-strand twining, ending in two small braids on the fur side of the robe. The tails of the three-strand wefts used for the rectangles form black tassels approximately 30 centimetres long on the pattern side of the robe. The top of each of these tassels is braided for about 7 centimetres.

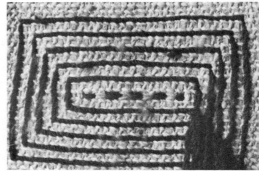

Fig. 187. A concentric rectangle unit with a black and yellow centre line

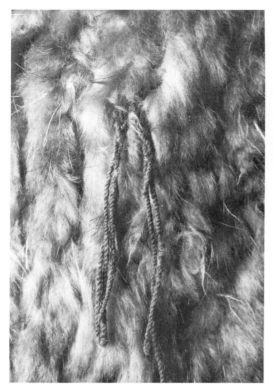

Fig. 188. The fur side of Fig. 189, showing the all black tassel

Fig. 189. A concentric rectangle unit with an all black centre line

The Footing and the Fringes

The footing consists of only one row of white two-strand twining worked over paired warp ends. On the left, the white side fringes are hitched around one weft row; the alternate row is started without a fringe. On the right the weft rows are knotted to become side fringe. Yellow side fringes appear on the right where yellow wefts are used in the top band of the geometric border. The warp fringe of this robe is composed of wool warp ends and the fur strips.

Dimensions

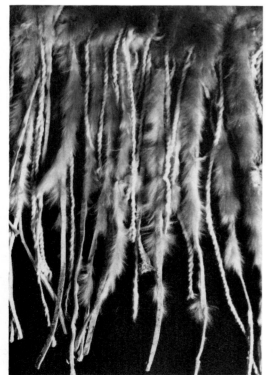

Fig. 190. The warp fringe

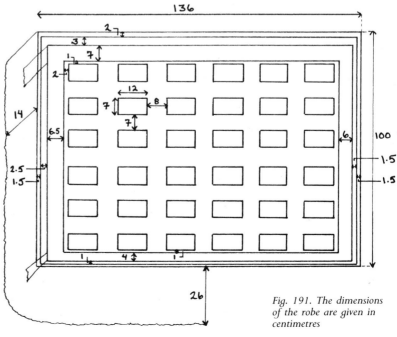

Fig. 191. The dimensions of the robe are given in centimetres

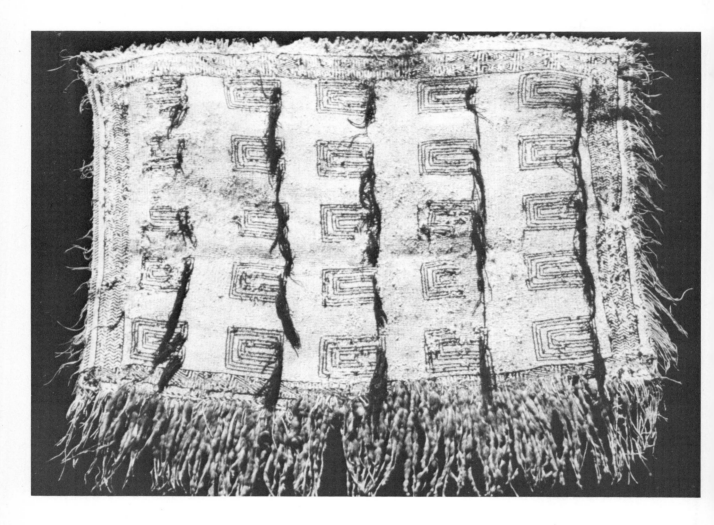

Fig. 192. The pattern side of the "Double around the Cross" Fur-Sided Robe

Only two fur-sided robes are known to exist in the world. The concentric figures on the pattern side of this robe are styled in the "double around the cross" image. It is the only robe which used these images, oriented in this particular fashion, as the primary focus of the design. Two groups of tassels fall from each concentric figure; although greatly disintegrated now, when the robe was new these must have increased both its visual and kinetic effect.

Robe VII

"Double around the Cross" Fur-Sided Robe

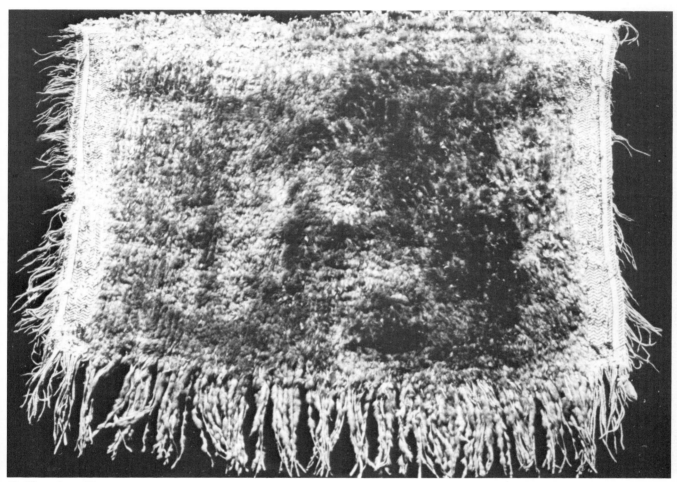

Collection Data

Present Location: Museum of Anthropology and Ethnography, Leningrad, USSR. Catalogue Number: 2520-4.

Materials and Condition

This robe is in poor condition, the fur side is considerably disintegrated, many of the tassels are missing, and there is a great deal of yarn breakage in the design elements. Repair work has been done on the top border. The side fringes and heading are sparse, and in the warp fringe many of the wool strands are broken so that the fur strips comprise most of the remaining fringe.

The warp yarns are made of mountain goat wool mixed with some hair and are approximately 2 millimetres in width. The weft is mountain goat wool. The fur strips are from 2 to 3 millimetres wide, with white hide and golden brown fur.

Fig. 193. The fur side of the robe

Fig. 194. The top left corner of the robe: pattern side

Fig. 195. The top left corner of the robe: fur side

Technique and Design

The Heading and the Selvage Pattern

The heading is mostly disintegrated and the heading cord is missing. Fur warp strips were bent over the heading cord in the same manner as in Robe VI; these strips alternate with two wool warp ends. There is no fur in the warp between the sides of the central design field and the outer edges of the robe. The warp is sett at four ends per centimetre.

Along the top of the robe, the selvage pattern is composed of two rows of two-colour twining worked in black and white. A diagonal line moves to the left in the design. Following this pattern there are ten rows of white two-strand ground twining. Segments in the ground twining are composed of two wool warp ends or one wool and one fur warp end.

The side selvage pattern is worked in spiral weft technique. The pattern wefts on the left are all added; the same wefts on the right are a continuation of the black selvage pattern wefts from the top of the robe with two wefts added to produce the complement of four needed for the pattern. On each side of the robe, the selvage pattern is designed in diagonal lines which angle from the upper right to the lower left for the entire length of the band.

Underneath the bottom border of the robe are four rows of ground twining and then a two-colour selvage pattern in black and white. The spiral wefts from the left side selvage pattern are used for this pattern and are tied off on the right with the spiral wefts of the right side selvage pattern.

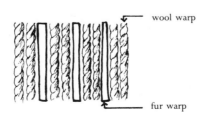

wool warp

fur warp

Fig. 196. The fur warp from the side; alternating fur and wool warp ends

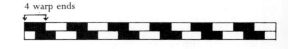

4 warp ends

Fig. 197. A diagram of the bottom selvage pattern

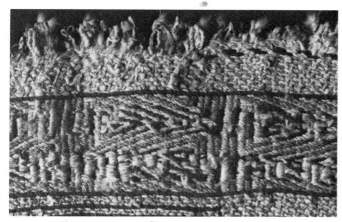
Fig. 198. The top borders of the robe

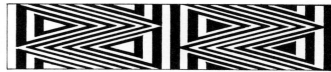
Fig. 199. The top two-colour pattern

The Borders

Along the top of the robe the black and white border is designed in units of concentric triangles and vertical zig-zags. The pattern is twined in brown and yellow stripes alternating with black and white stripes. The brown yarn was probably dyed in a hemlock bark bath without the overdye of copper and urine. The yellow and white wefts start at the left edge of the robe and finish as fringes on the right. The black and brown wefts form the standard fringes immediately adjacent to the sides of the border.

At the sides of the robe, the border is worked in row after row of black horizontal zig-zag lines done in spiral weft technique.

The bottom border is worked in a two-colour twining pattern. The colours are black and white for the upper and lower portions of the design with a brown and yellow central stripe. A single pattern unit is repeated for the entire length of the border. It is difficult to determine the number of lines in each unit precisely owing to disintegration.

Fig. 200. The spiral weft pattern in the wide side border

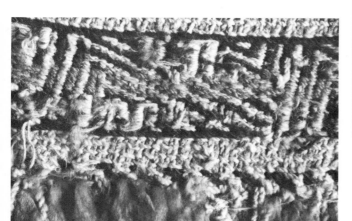
Fig. 201. The bottom border and selvage pattern

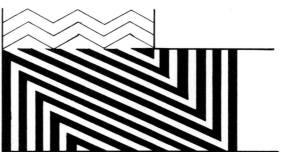
Fig. 202. The design of the bottom left corner of the robe

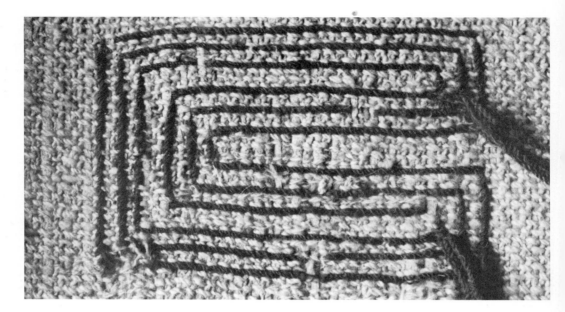

Fig. 203. One unit in the central design field

The Central Design Field

The central design field is ornamented with five horizontal and vertical rows of concentric C units, a design which Emmons called "double around the cross." The figures are worked in black three-strand twining with tassels coming from the lower corners of both of the arms on each shape, resulting in two tassels per figure. There are three concentric C's in each unit. The outer two are separated by two ground-twining rows. The innermost shape has three ground-twining rows within it. Four ground-twining rows separate the two arms of each figure.

The two sets of tassels which hang from the C are made up of three braids each. Although most of the braids are broken, some measure as long as 24 centimetres with 11 centimetres of braiding at the top.

Fig. 205. The ground twining

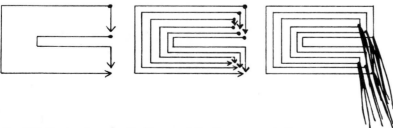

Fig. 204. Construction of a Double around the Cross concentric figure:
 • = *the beginning of the three-strand twining rows*
 ↘↓ = *the end of the three-strand twining rows and the start of the tassel braids*
Note: the three-strand twining is worked over two warp units and under one

Fig. 206. The fur pile with the ground twining exposed

90

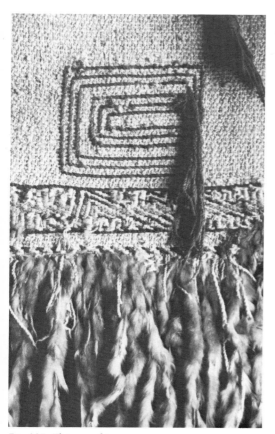

Fig. 207. The warp fringe

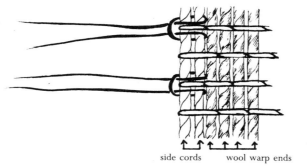

Fig. 208. The lark's head knots in the left side fringes

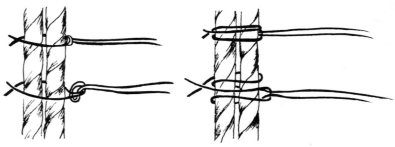

Fig. 209. An overhand knot in the right side fringe

Fig. 210. A wrapped hitch in the right side fringe

The Footing and the Fringes

There is no footing on this robe. On the left side, the side fringes are hitched around a weft row which includes the two side cords in the first weft segment. The following row does not have a fringe attached and starts over the two side cords and the first warp end.

There are two methods used on the right side of the robe to end the weft rows and create the side fringes. For the top 58 centimetres, each pair of ground wefts is tied off either by a standard overhand knot or by a wrapped hitch. These two methods alternate, but not in a regular fashion. The overhand knots, being rather large, pile up on each other producing a lumpy edge, which is presumably why an alternative method was tried. However, for the final 38 centimetres of side selvage, all of the wefts end in an overhand knot.

The warp fringe twining, which lies directly under the bottom selvage pattern, includes only the wool warp-ends. The fur warp strips are left hanging.

Dimensions

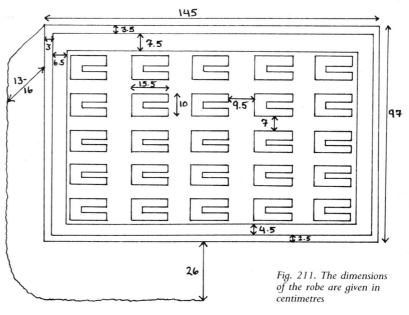

Fig. 211. The dimensions of the robe are given in centimetres

91

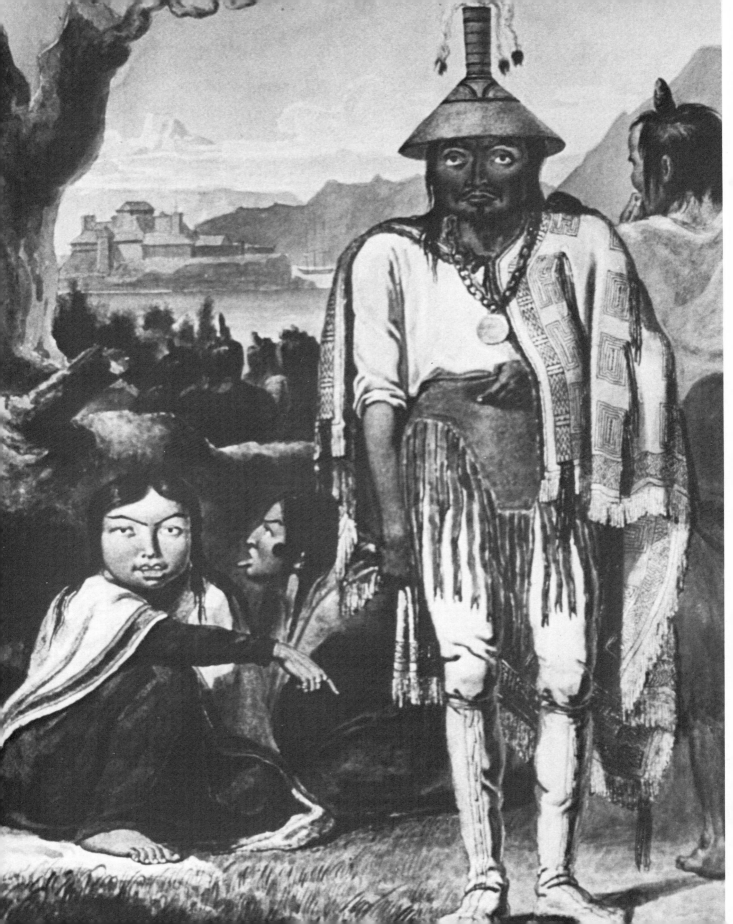

Robes VIII to XI

"Their language and dress is very similar to what we have heard and seen at Washington's [Queen Charlotte] Islands except one which was peculiar to the natives of Cahta this was a wooling mantle fine neatly wrought and evidently of their own manufacture some white others only ground work white beautifully diversified with various fancy figures and of the most lively colors of yellow, green, red, dark brown, black etca. these appeared to be wove in with the mantle and raised like the pile on velvet on others there were tassels which form'd the figures these as they walkt would naturally move which had a pleasing effect the top edge was trimmed with sea otter fur and on the bottom was a deep fringe upon the whole I think this one of the prettiest pieces of workmanship I have yet seen on the coast these people could not be induced to part with any of these garments though they were offered a very valuable consideration (Holm 1982:45).

John Hoskins, 1791
Account of the Kaigani Haida

Robes VIII to XI are visually very complex in their designs. Multiple borders in white, black, yellow, and a two-colour pattern surround the central design field. Within this the weavers placed designs which exhibit a sophisticated juxtaposition of the main colours of black and white. Streaks of yellow give life and vibrancy to the overall impact. The central design field is also adorned with long braided tassels which are not structurally a part of the woven figures. White weft fringes and a white warp fringe border three sides of the robes; a secondary black weft fringe lies adjacent to the black borders on each side. A fur wrapping finishes the top edge. In some of the robes the bottom borders and warp fringe have a slight curve.

Robe VIII, the Swift Robe, is perhaps the finest example of this type of weaving in existence. It is housed in the Harvard Peabody Museum. Robes IX to XI are all in European and Russian collections: one in Copenhagen, one in Leningrad, and one in London.

Fig. 212. Kotlean, painted by Mikhail Tikhanov with Fort Sitka in the background

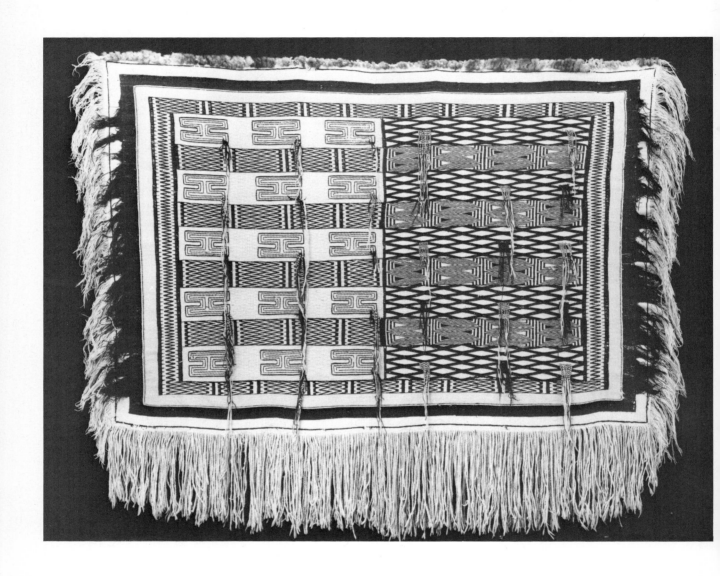

Fig. 213. The Swift Robe

Known popularly as the Swift Robe for the sea captain who collected it, this garment is the most exciting example of the Raven's Tail style of weaving. In design it combines the essence of the concentric figures with an elaborate interplay of black and white motifs. The sophistication of the design concept alone places this robe among the finest of the world's textiles. These weavings are garments, made not to be laid out flat as seen in the photographs, but to cover the body of a high-ranking person. The Swift Robe takes on an incredible dimension when worn. There is a strong design division between the two sides of the robe. If this division were placed down the middle of the chief's back, as in Bill Holm's drawing, the costume would change as he turned around. If the division were placed on

94

Robe VIII

The Swift Robe

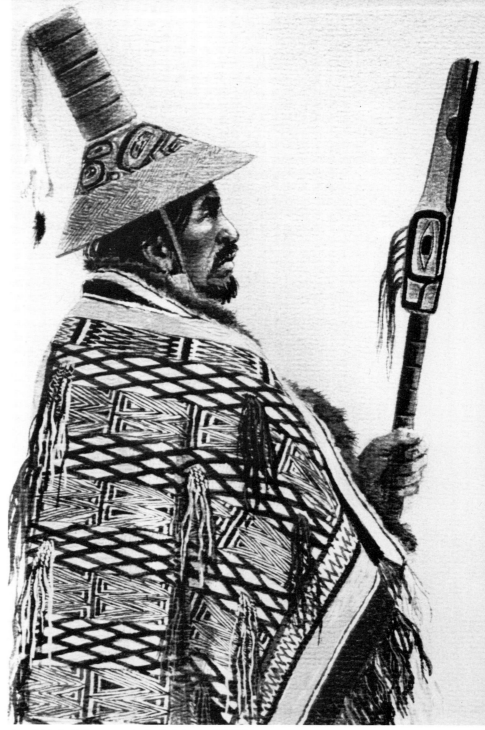

Fig. 214. A chief wearing the Swift Robe, by Bill Holm

one side of the body, from the front he would appear to be wearing one robe, and from the back an entirely different one. Within the actual designs on the robe there is an intriguing juxtaposition of black and white images; the visual transformation of the robe when worn brings to the image of the dancer this very concept of design.

Collection Data

Present Location: Peabody Museum, Harvard University, Cambridge, Massachusetts, USA. Catalogue Number; 09-8-10/76401. Photograph Number: N28168.

Historical Record: This robe was collected about 1800 by Captain Benjamin Swift of Charlestown, Massachusetts. It was donated to the Peabody Museum, Harvard, in 1909 by Lewis H. Farlow.

Materials and Condition

The Swift Robe is in excellent condition. The heading and all of the fringes are present, with a small amount of deterioration in the black side fringes. One tassel is completely missing; the others are all present although they show some breakage. There is very little disintegration in the main body of the weaving, only occasional breakage in the three-strand outlines.

The warp yarn is spun of mountain goat wool and hair. The sett is five warp ends per centimetre; there are about 690 warp ends in all. The weft yarns are of mountain goat wool, the largest wefts twining approximately ten rows per centimetre, the smallest twining approximately twenty rows. The wefts are natural white, a rich reddish brown-black, and yellow. The yellow is quite faded on the front. A fur strip adorns the top edge of the robe.

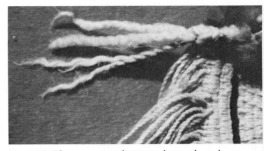

Fig. 216. The upper two horizontal strands make up the mountain goat wool heading cord; the lower two are the mountain goat hair heading cord

Technique and Design

The Heading and the Selvage Pattern

There are two fat heading cords; one is two-ply strand of mountain goat hair, the other is a two-ply strand of mountain goat wool. The two cords lie parallel across the top of the robe and are tied at each side with an overhand knot. Six rows of white ground twining are worked under the heading. Strips of fur were wound around the heading cord to finish the top edge.

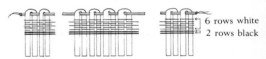

Fig. 217. The heading and selvage pattern

A black selvage pattern line travels around the perimeter of the robe. It starts underneath the white heading and consists of two rows of black three-strand twining. Along the sides of the robe, these three-strand rows lie six warp ends in from the side selvages and enclose weft rows as they are worked. Across the bottom of the robe these two black rows work from left to right and finish the bottom selvage pattern at the lower right corner.

Fig. 215. The top left corner of the robe

The Borders

Four borders surround the central design field, the outermost being white. Across the top of the robe this border is designed in a diamond pattern worked in skip-stitch twining. A half diamond starts on the left side of the top white border, followed by six full diamonds. There is no half diamond on the right.

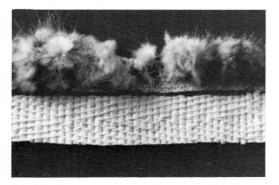

Fig. 218. Skip-stitch twining in the top white border

The skip-stitch design is worked down the side of the white border until the inner black and white two-colour border begins. At this point the white side borders are worked in ground twining.

The bottom white border is worked, once again, in skip-stitch twining. The design resembles the "hood of the raven" pattern, forming seven peaks in its path across the robe.

The top black and yellow borders are both worked in rigid weft twining over two white rigid wefts. They are separated by five rows of three-strand outlining in black, white, white, black, and yellow.

The three-strand outlines between the top black and yellow bands also continue vertically. They are the only vertical three-strand rows which are enclosed in the weft rows; they do not appear on the back of the robe.

The black and yellow "dots" on the back side of the robe from these two bands appear in parallel lines, separated by the three-strand outlines. When these two borders travel vertically, they continue in rigid weft twining. However, the black pattern wefts work over single white rigid wefts, and the yellow pattern wefts work over twisted black and white or black and yellow rigid wefts.

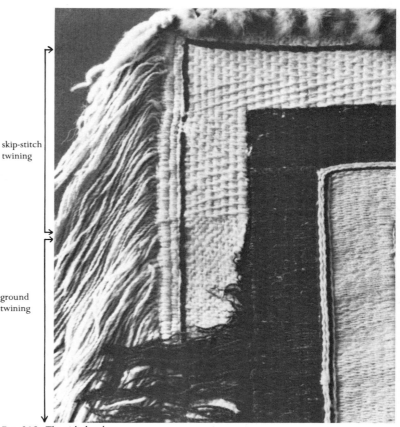

skip-stitch twining

ground twining

Fig. 219. The side borders

At the bottom of the robe, the black and yellow borders are worked in a fashion similar to their execution at the top: rigid weft twining over paired white rigid wefts. The "dots" from the rigid weft twining once again form continuous vertical lines on the back of the fabric.

Fig. 221. The back of a black border

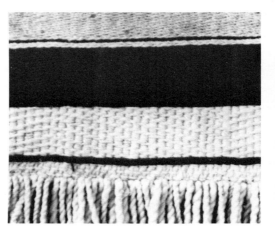

Fig. 220. The bottom black and white borders

Fig. 222. The back of a yellow border

Inside the white, black, and yellow borders lies a black and white border worked in the two-colour twining technique. At the top of the robe, this border is designed in zig-zag and bar units. These units alternate in width, the black and white unit containing four black zig-zag lines and the white and black unit containing three white zig-zag lines. There are five black and white units and four narrower white and black ones; the border starts and finishes with a wide unit. The arrangement of this design is matched, vertically, along the bottom border.

Fig. 223. *White and black and black and white units*

The two-colour side border is designed in a black zig-zag pattern on a white/yellow ground, resembling Emmons's "shadow of the tree" design. It is edged by two black bars. Worked over twenty warp ends, it is done in two-colour twining, black and white or black and yellow depending on the placement of yellow in the central design field.

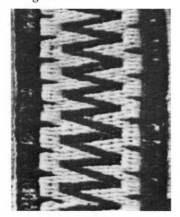

Fig. 224. *The side two-colour border*

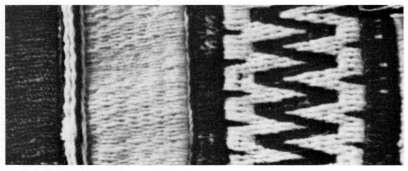

Fig. 225. *The side borders of the robe*

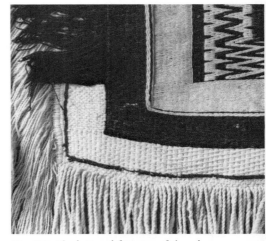

Fig. 226. *The bottom left corner of the robe*

Fig. 227. *The bottom right corner, seen from the back of the robe*

The Central Design Field

This field is divided precisely down the middle with an elaborate complex of geometric designs on the right side and bands of zig-zag and bar units alternating with concentric shapes on the left. The entire field is divided horizontally into nine broad bands. The beauty of these bands lies in the fact that although they are continuous across the entire field, their design alters at the middle division. This is particularly striking in the second, fourth, sixth, and eighth bands where the zig-zag and bar design of the left side changes to a zig-zag and triangle design on the right. All of the designs seen in this robe are found in other robes; the balance of their asemblage here is what makes this robe so stunning.

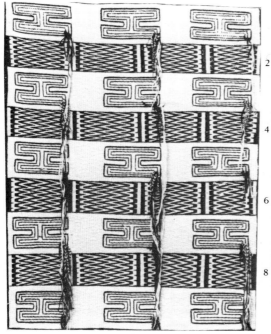

Fig. 228. The bars along the left edge alternate in colour

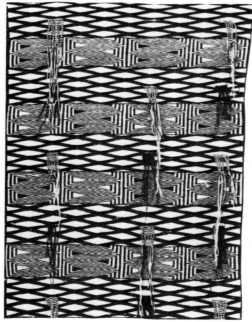

Fig. 229. The black triangles in bands 2 and 6 are white in bands 4 and 8

Bands 2, 4, 6, and 8 are worked entirely in two-colour twining. On the left side of the central design field, they are designed in zig-zag and bar units which are black and white with yellow stripes running through the points of the zig-zags.

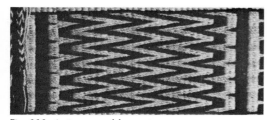

Fig. 230. A zig-zag and bar unit

There are four units in each band, (a) being the negative of (b) and (c) the negative of (d) (Fig. 231). Each line within a unit consists of two weft segments twined over four warp ends.

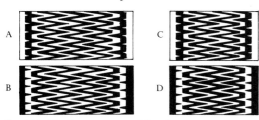

Fig. 231. The four zig-zag and bar designs

These units are distributed in the bands in the following manner:

band 2	B	A	B	D
band 4	A	B	A	C
band 6	B	A	B	D
band 8	A	B	A	C

Fig. 232. Distribution of the bar design units

Note that bands 2 and 6 are identical and bands 4 and 8 are identical. Although subtle, the juxtaposition of the four units can be easily seen by a comparison of the left hand bars in the first units of each of the four bands.

This subtle distribution of apparently similar units is repeated on the right side of the central design field in the same bands, causing white to be black and black to be white in adjacent units and alternate bands.

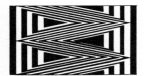

Fig. 233. Unit A: black and white

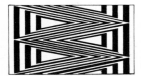

Fig. 234. Unit B: white and black

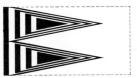

Fig. 235. Left side of the unit

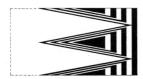

Fig. 236. Right side of the unit

Fig. 237. The arrows indicate the placement of yellow across the unit

On the right side of the central division in bands 2, 4, 6 and 8, the design changes to one of triangles and zig-zag lines

In each band there are four units, two with black central triangles (Fig. 233) and two with white central triangles (Fig 234). The units are placed alternately black, white, black, white. Furthermore, as with the zig-zag and bar units on the left side of the central division, the units alternate in colour vertically.

Placed together, these units appear as zig-zag lines with strong vertical bars between them:

Fig. 239.

The units are placed across the band as follows:

band 2	A	B	A	B
band 4	B	A	B	A
band 6	A	B	A	B
band 8	B	A	B	A

Fig. 240.

The yellow colour which streaks through the points of the zig-zags on the left continues through the units on the right. Today the impact of the yellow is reduced because of fading; when the robe was new, the addition of this colour must have made the designs shimmer.

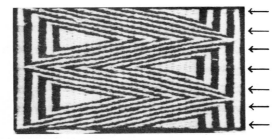

Fig. 238. The thin lines in the diagram indicate the placement of yellow through two adjacent units

Fig. 241. The left side of the central design field

On the left side of the central division, in bands 1, 3, 5, 7, and 9, three concentric "tattoo" shapes are placed on a white ground designed in a lattice work of skip-stitch twining.

The black weft from the left side borders does not travel behind these bands. Rather, it turns at the edge of the two-colour border and returns to be used again in the left black side border. The white weft from the left selvage is used for the skip-stitch twining. At the central divide, new black wefts are added to work the two-colour lattice pattern on the right side of the field.

The "tattoo" shapes are worked in three-strand twining encircling the weft rows; they therefore appear on the back of the robe. Each unit is composed of three concentric shapes. A row of white three-strand twining travels around the perimeter of each shape. The outermost "tattoo" is made of two black three-strand rows, giving strong emphasis to the outline of the form. The two inner shapes are each made of one row of three-strand twining.

100

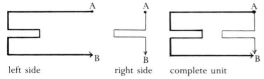

left side right side complete unit

Fig. 242. Construction of a "tattoo" unit

Each black line is entered with doubled weft strands at the top right corner (a, Fig. 242) and finishes at the bottom right corner (b). One side of the weft strands follows the path to the left and the other travels down the right side of the shape. Combined, these two directions complete the "tattoo."

Long tassels hang from the lower right corners of each "tattoo" shape. They are made of all black three-strand braids or black and white four-strand chevron braids, are braided for 4 to 8 centimetres, and are approximately 22 centimetres long. The braids are made from the tails of the three-strand wefts which work the black lines in the concentric figures. The white strands in the four-strand braids are added except for the bottom corner, which uses the white three-strand twining wefts.

There are three different treatments of the white spaces between the concentric lines within one complete "tattoo" unit. In band 1, the white weft rows are all ground twining.

In band 2, rows of compact two-strand twining over alternate warp groups of four ends are placed in the spaces between the outer two concentric figures. Ground twining fills the interior space of the innermost "tattoo."

In bands 3 to 5, the white weft is worked in compact twining similar to band 2, including the interior space of the inner form.

The central vertical stem of all the concentric shapes is worked in ground twining, with one exception: the right-hand unit in band 9 is worked in compact two-strand twining over four warp ends.

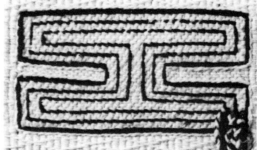

Fig. 243. A tattoo unit in band 1

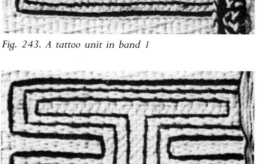

Fig. 244. A tattoo unit in band 2

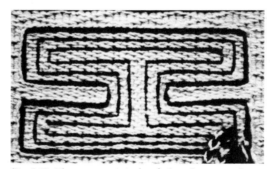

Fig. 245. The tattoo unit in bands 3 to 5

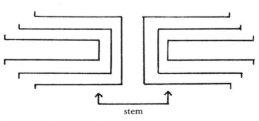

stem

Fig. 246. The stem of the tattoo units

Fig. 247. Skip-stitch twining

Fig. 248. A spruce root basket showing a skip-stitch design

101

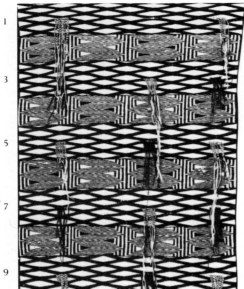
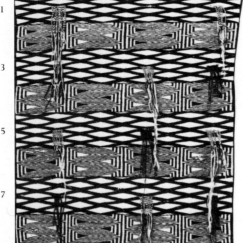

Fig. 249. Bands 1, 3, 5, 7, and 9 are a lattice pattern

Three tassels are placed in each of these bands, spaced to complement the tassels on the right. They are composed of all black braids or black and white chevron braids. There are eight braids in each tassel, each made of new weft lengths which are inserted around every other warp end for the desired width of the tassel. The braids are worked for 4 to 8 centimetres with tails approximately 22 centimetres long. The all black tassels alternate with the black and white ones both horizontally and vertically.

The Footing and the Fringes

Underneath the bottom selvage pattern line are three rows of white ground twining which form the footing.

A white fringe borders the sides and bottom of the robe. On the left side, weft fringes were added by slipping lark's head knots around the side cords after every weft row. The fringes on the right are a continuation of the weft; they are therefore either white or yellow depending on the placement of these colours in the central design field. They are knotted around the side cords.

A secondary black side fringe lies on the outside of the black side borders. It starts with the commencement of the top two-colour border and stops before the bottom yellow border begins. The reason that these fringes are not placed adjacent to the top and bottom yellow borders is that the black weft would be wasted if it were carried behind this entire horizontal band. Fringes could have been present in the top black border, but presumably it was felt that the subsequent gap produced by the yellow band was not desirable.

At the bottom of the robe is a heavy white warp fringe. The warp fringe twining is worked over three warp ends, raising two and letting one fall in each weft segment.

Fig. 250. A black and white tassel with chevron braids

It should be noted that bands 1, 3, 5, 7, and 9 are patterned entirely in black and white wefts on both sides of the central division. No yellow appears in them at all, and consequently there is no yellow in the side borders directly adjacent to them. On the right side of the central design field, these bands are patterned with a black lattice design on a white ground, the design being identical in each band. The lattice is worked in two-colour twining, appearing as a ghost of itself in the reverse side of the robe.

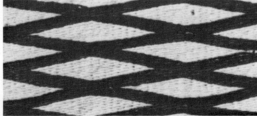
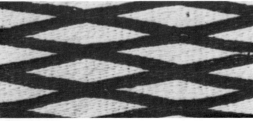

Fig. 252. The front of the lattice design

Fig. 251. An all black tassel with three-strand braids

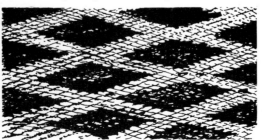

Fig. 253. The reverse side of the lattice pattern is a ghost of the front

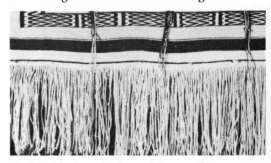

Fig. 254. The lower borders and the warp fringe

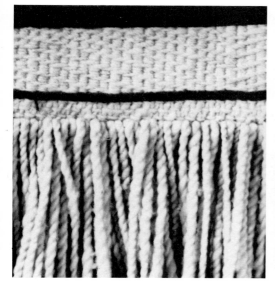

Fig. 255. The warp fringe

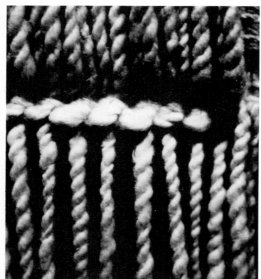

Fig. 256. Fringe twining

Fig. 257. Lark's head fringes

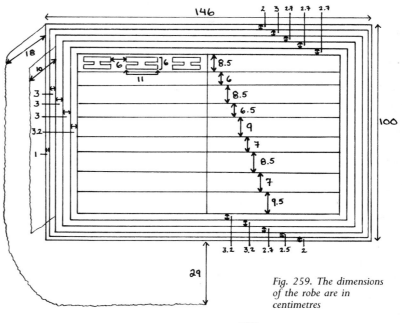

Fig. 258. Knotted fringes

Dimensions

Fig. 259. The dimensions of the robe are in centimetres

103

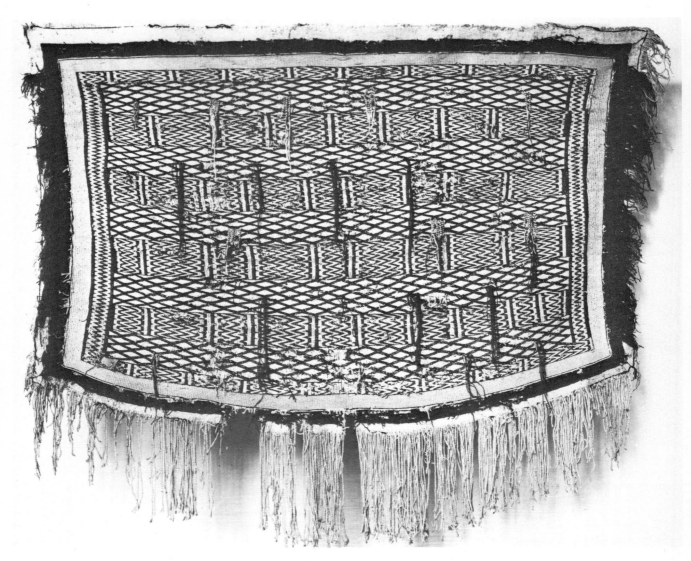

Fig. 260. The Lattice Band Robe

Bold, horizontal bands of elaborate patterning occupy the entire central design field of this robe. A black and white lattice band alternates with a band which features a zig-zag and bar design. This is the only robe which displays these patterns across the entire width of the field. The surprising addition of a linen core in one of the side cords opens interesting speculation concerning the procurement and use of non-native materials during the time when these robes were made.

104

Robe IX

The Lattice Band Robe

Collection Data

Present Location: National Museum of Denmark, Copenhagen, Denmark.
Catalogue Number: KC 119.

Historical Record: This robe was acquisitioned in 1862 by the National Museum of Denmark. It was received in an exchange from the collection in St. Petersburg-Leningrad.

Materials and Condition

There has been considerable deterioration of the heading, fringes and tassels of this robe. All of the design is present, the lower borders showing the greatest degree of damage. A supporting tape has been stitched to the back of the robe around the perimeter and down the middle to reinforce and stabilize it for display purposes.

The warp is spun of mountain goat wool mixed with hair. The weft yarns are also of mountain goat wool, with a small amount of hair included. They are coloured white, black, and yellow. Two shades of black are present: a rich brown-black and a very deep black for which iron was undoubtedly used in the dye bath. The yellow, faded on the front of the robe, is still quite strong on the back.

A spun cord of vegetable fibre is used as a core in the side cords. This cord is very tightly and evenly spun, and through analysis the fibre has been determined to be linen.

Fig. 261. Hair emerges from the top of the side cord in the heading

Fig. 263. Linen cords used in spinning the side cords extend beyond the edge of the robe

Technique and Design

The Heading and the Selvage Pattern

The heading cord is entirely missing, but it might have been the same material as the right side cords, since the remains of the cores of these cords extend quite a distance from the top of the robe. The lower side cord in Fig. 263 is composed of two sinew cores: one is a single strand of sinew and the other is a two-ply S-twist cord made of very thin sinew strands (Fig. 264). Each of these two cores are spun with mountain goat hair and then the two strands are plied together. The upper side cord is made of two strands; one is mountain goat hair spun with a two-ply S-twist sinew strand, and the other is mountain goat hair spun over a two-ply linen cord (Fig. 265). On the left side of the robe, the side cords are mountain goat hair spun over sinew cores.

The warp sett is six ends per centimetre, and the heading itself was twined as two rows of two-strand twining over paired warp ends.

The selvage pattern is a single row of black three-strand twining which travels around the entire perimeter of the robe.

Fig. 264. The lower side cord seen in Fig. 263

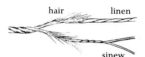

Fig. 265. The upper side cord seen in Fig. 263

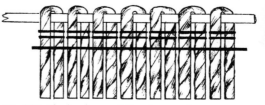

Fig. 262. The heading and the selvage pattern

Fig. 266. A piece of eagle down caught in the black border indicates that the robe was used in ceremonies

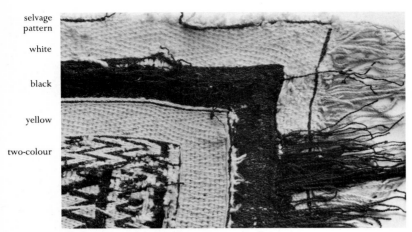

selvage
pattern

white

black

yellow

two-colour

Fig. 267. The top right corner of the robe

robe, one white weft is used for the rigid weft in each row. The rows are very tightly packed and the black pattern weft shows on the back as vertically aligned "dots" between every two warp ends. There is no fringe on the front on either side of the top black border; therefore one row of black rigid weft twining starts with a black pattern weft doubled on the left around a white rigid weft, travels the length of the band, and then is dropped on the inside just before the white side border where it is cut off in a short fringe. Adjacent to the top yellow border, the black pattern weft travels from left to right with the rigid weft and then unexpectedly returns the short distance from the right side of the black border to the left as two-strand twining over four warp ends. This method is used because there is no need for black weft either in the outer white border or in the top yellow band. Once the top yellow border is complete and the two-colour border commences, the black wefts start as looped fringes on the left, twining as pattern wefts or rigid wefts across the robe, and are dropped at the outer edge of the right black side border as fringe.

The yellow border is worked in rigid weft skip-stitch twining, patterned in concentric diamonds. Half way through the bottom band, the rigid weft is dropped and the border is completed in all yellow skip-stitch twining. There is no visual difference in the two methods on the front side of the robe.

The Borders
Four borders surround the central design field.

The outermost border is white, worked along the top in skip-stitch twining patterned in a concentric diamond design. The skip-stitch twining is worked down the sides of the robe until the beginning of the yellow border. At this point, the white side borders change to ground twining and are primarily white, with yellow stripes spaced intermittently along their length depending on the patterning in the central design field. Along the bottom of the robe, the white border is once again worked in a pattern of skip-stitch twining.

The black border is worked in rigid weft twining. At the top and bottom of the

Fig. 268. The design of the top white border

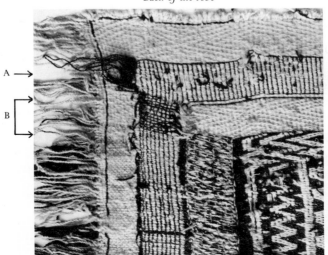

Back of the robe

Front of the robe

borders:

← white

← black

← yellow

← two-colour

central design field

Fig. 269.
A. Short black fringe on the inside of the robe
B. Black rigid weft twining combines with two-strand twining for the width of the yellow border

A →

B

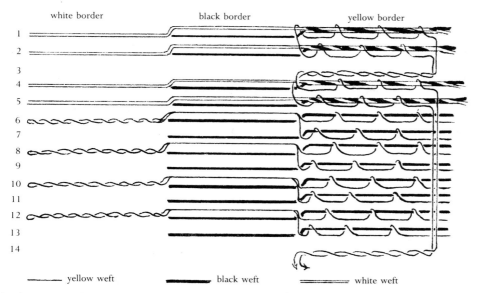

white border black border yellow border

1
2
3
4
5
6
7
8
9
10
11
12
13
14

——— yellow weft ▬▬▬ black weft ═══ white weft

Fig. 270. The sequence of twining rows in the side borders

Fig. 271. Skip-stitch twining in the top yellow border

Fig. 272. The back side of the top yellow border

When the yellow border travels vertically, it continues to be worked in rigid weft skip-stitch twining. The rigid weft is no longer only white but is made of white and black wefts from the adjacent bands. These wefts are twisted around each other as they move behind the yellow vertical border, visually forming rather mottled diagonal lines.

The sequence of twining rows in the yellow side border on the left of the robe might be as follows (Fig. 270):

Row 1: A doubled yellow weft is entered on the left of the yellow band around the two black and two white wefts from the left side borders. The black and white wefts twist together to form the rigid weft for the yellow skip-stitch twining. One half of the yellow weft is used for this row.

2: The second half of the yellow weft is used for the next row of rigid weft skip-stitch twining. The four black and white wefts from the side borders are twisted together to form the rigid weft. The row is worked from left to right.

3: The two yellow wefts from rows 1 and 2 are mated for a row of two-strand skip-stitch twining worked from right to left across the yellow band.

4: One of the strands from the preceding two-strand row is worked with the four black and white rigid wefts in skip-stitch twining from left to right.

5: The second of the two-strand twining wefts from (3) above is worked over four black and white rigid wefts in skip-stitch twining from left to right. These two yellow wefts may then be dropped alongside a warp end to be used in a later row.

6: If the pattern in the central design field calls for a yellow stripe, a doubled yellow weft is started at the left selvage. It is worked in two-strand twining through the white border, is used as a rigid weft for the black border, and one strand of it is used for rigid weft skip-stitch twining over one of the black pattern wefts from the adjacent black border.

7: The second weft strand from (6) above is used with the second black pattern weft for the next row of skip-stitch rigid weft twining.

8-13: (6) and (7) above are repeated three more times.

14: The two yellow wefts which have been enclosed in the weft twining along with the warp end at the right side of the yellow border are now used together to work a two-strand skip-stitch twining row from right to left. This moves these two yellow wefts to the left side of the border where they can once again be used for rigid weft skip-stitch twining.

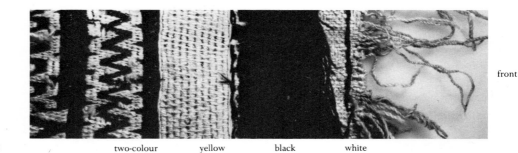

Fig. 273. The side borders

two-colour yellow black white

front

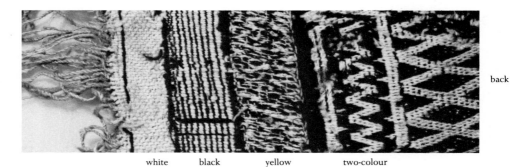

Fig. 274. The back of the side borders

white black yellow two-colour

back

The top two-colour border is designed in a zig-zag and bars pattern. The number and colour of the zig-zag lines and bars in each unit varies across the band; atypically, some have black bars on one side and white on the other. The side borders are designed as black zig-zag lines surrounded by black bars. The top border pattern is repeated across the bottom of the robe, with a slightly different distribution of the units owing to the curve.

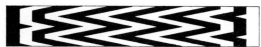

Fig. 275. A unit with a black bar on the left and a white bar on the right

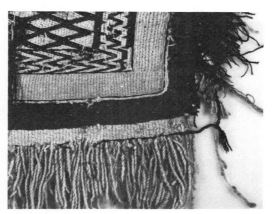

Fig. 276. The bottom right hand corner of the robe

Straight lines separate and outline the borders. Most of these rows are three-strand twining which, when travelling vertically, encircle both of the twining wefts, and therefore appear on the back side of the robe. However, between the black and yellow side borders, there are five rows of three-strand twining which are enclosed, Chilkat-style, between the two-strand wefts. They are coloured black, white, white, black, and yellow and do not show on the back of the robe. Within this group, the two white rows are worked in braided twining when they travel horizontally and in three-strand twining when they travel vertically.

At the bottom of the robe the borders are slightly curved. In the middle of the robe, the central design field is longer than at the sides; the bottom borders are also wider at the centre than they are at the sides of the robe. These increases produce a very gentle curve, which is accentuated by the warp fringe.

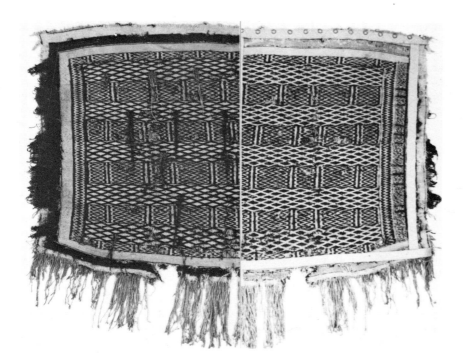

Fig. 277. The front (left) and back (right) of the robe

The Central Design Field

The central design field is composed of nine horizontal bands, five in a lattice pattern and four in the zig-zag and bars design. The lattice bands are worked in two-colour twining and only black and white wefts are used. On the front of the robe, the lattice is in black with a white background showing as diamond shapes. On the back this design is automatically reversed, the lattice appearing in white and the diamond ground in black. Double twists are used in the twining to produce the wide lattice lines and the diamonds.

Fig. 278. The lattice band, seen from the front side of the robe

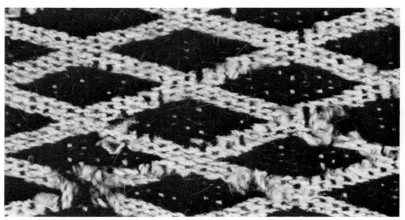

Fig. 279. The reverse of the lattice pattern

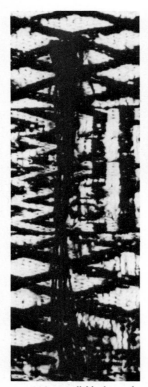

Fig. 280. An all black tassel

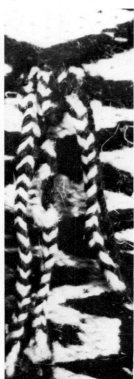

Fig. 281. The chevron braid portion of a black and white tassel

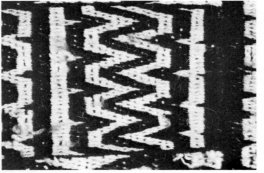

Fig. 282. The zig-zag and bar units labelled "J" in Fig. 284

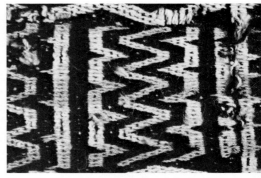

Fig. 283. The reverse side of the unit in Fig. 282

The bands designed with zig-zag and bar patterns are worked primarily in black and white with yellow placed in three stripes: across the top, the middle, and the bottom. The top band has the bars of its units slightly staggered from the bars of the bottom three bands. There are ten different sizes of zig-zag and bar units; identical units have been given a letter designation and their distribution is shown in Fig. 284.

Tassels are added to the lattice bands. When the robe was new, there may have been six or seven black and white chevron braided tassels in the first, third, and fifth lattice bands and five all black tassels in the second and fourth bands. The black tassels were placed midway between the black and white tassels in the band above. Each chevron tassel measures approximately 25 centimetres long, with 3 to 4 centimetres being braided. The all black tassels seem not to have been braided at all. They appear as two black weft strands which are simply inserted around a single warp end. Approximately seven warp ends

are used in each tassel, with one free warp end between each insertion of the wefts.

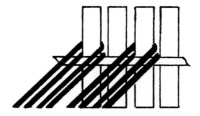

Fig. 285. Insertion of an all black tassel

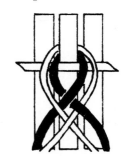

Fig. 286. Insertion of a chevron braid: black and white tassel

C	B	C	B	C	D	E	F

A	B	A	B	A	B	A	B	B
A	B	A	B	A	B	A	B	B
A	B	A	B					

| | | | | G | H | G | H | I | J |

Fig. 284. All units with the same letter identification are identical

110

The Footing and the Fringes

White fringes adorn the sides of the robe. On the left, they are all white and are added. On the right, they are the tails of the weft rows, and they are consequently yellow or white depending on the placement of the yellow stripes in the central design field.

Secondary black side fringes, adjacent to the outer edges of the black border, extend from the top to the bottom of the two-colour border.

A footing was not woven on this robe. Under the bottom selvage pattern line there is one row of white two-strand twining into which the warp fringe is worked. This row is almost entirely disintegrated, but it can be seen in one small area which includes six warp ends. The fringe is worked over two warp ends, with one warp end moving to join the next weft segment while the other remains hanging. The warp fringe is slightly stepped, repeating the curve of the bottom borders.

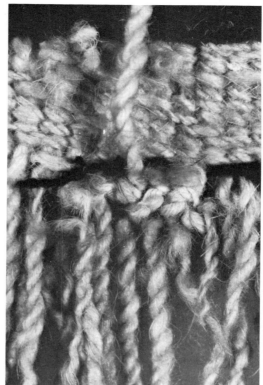

Fig. 288. The warp fringe

Fig. 287. Looped black side fringes on the left side of the robe

Dimensions

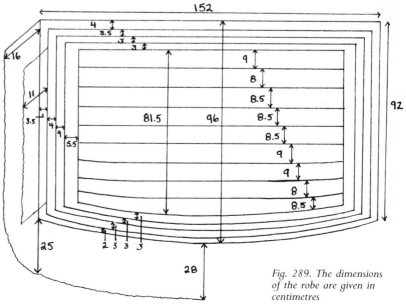

Fig. 289. The dimensions of the robe are given in centimetres

111

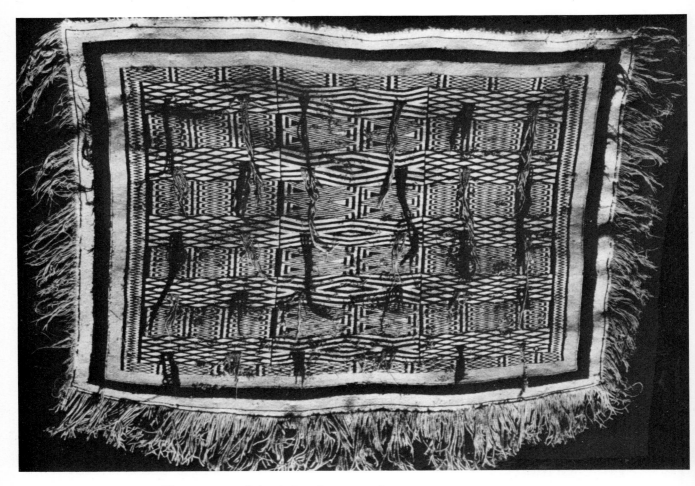

Fig. 290. The Three Panelled Robe

The crispness of the design elements and the evenness of the fabric show that the Three Panelled Robe was woven by a expert weaver. A weaver, however, is only as good as her materials; a superb spinner produced extremely fine and even weft yarns which greatly enhance the robe's overall beauty. This is the only Raven's Tail robe designed in three panels, an arrangement which became typical of the later Chilkat Dancing Blankets. It is also the only robe in the collection which uses a technique called "mock two-strand twining." This technique is found among a small number of cedar bark and wool robes collected in Nootka Sound on the third voyage of Captain James Cook.

Robe X

The Three Panelled Robe

Collection Data

Present Location: Museum of Anthropology and Ethnography, Leningrad, USSR.
Catalogue Number: 2520-7.

Materials and Condition

The main body of this robe is in good condition. The weft does show some signs of breakage, but it does not affect the overall appearance. Most of the deterioration is in the fringes and tassels. The tassels are quite broken and in places almost gone, while the black side fringe is practically non-existent. The white side fringes are present, but they also show signs of deterioration, expecially on the left side. The warp fringe is in good condition.

The warp is a strong yarn made of mountain goat wool and hair. It appears to be all wool on the surface, but there is a large amount of hair in each of the single plies. The weft is a very fine yarn spun of mountain goat wool. All of the weft yarns are small, producing eighteen rows per centimetre in the heading and fifteen to eighteen rows per centimetre in the main body of the weaving. They are coloured white, a rich black which has not faded, and a yellow which is greatly faded. Fur is wrapped around the heading cord and leather ties are sewn to it.

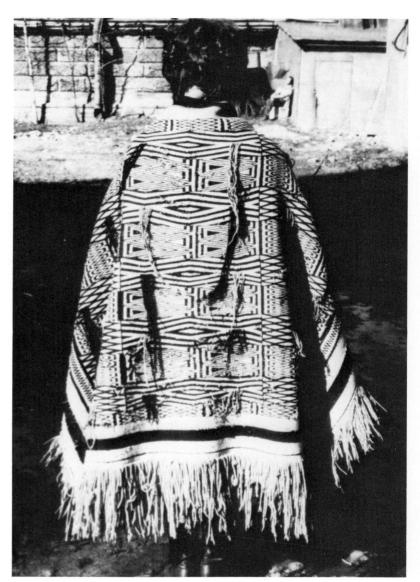

Fig. 292. The robe as it might have been worn

Fig. 291. Hair in the wool warp ends

Technique and Design

The Heading and the Selvage Pattern

The heading cord consists of two warp ends laid, but not twisted, together. At the upper corners of the robe they turn to travel vertically, becoming the side cords. On the left side they simply bend down; on the right, a knot is tied and then they hang down. A strip of fur is bound around every three warp ends and includes the heading cord but none of the weft rows. The first weft row starts on the left and ends on the right in a knot, becoming side fringe. For this row, two very small weft yarns are used together.

Fig. 293. The heading cords

Fig. 294. The heading cords and the first weft row

113

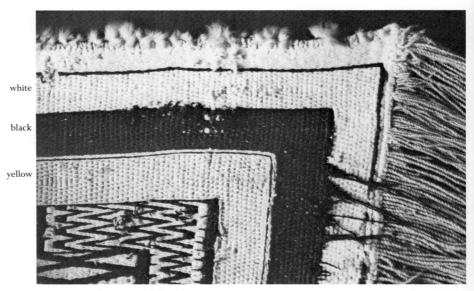

white

black

yellow

Fig. 295. The top right corner of the robe

Underneath this first row of twining there is a thin band of white. It is approximately twelve rows deep and is worked in mock two-strand twining. This is the only Raven's Tail robe which uses the technique. There are five robes, however, in which it was commonly used; these robes are illustrated in the last chapter.

Following the mock two-strand twining weave, there are two black three-strand rows which form the selvage pattern line. On the sides of the robe, these rows are worked just inside the side cords. At the bottom, they complete their outline just above the footing. Here, the top row is three-strand twining while the second row is braided twining.

The Borders

Inside the selvage pattern is a white border. At the top it is skip-stitch twining worked in a concentric diamond design. Seven diamond centres are placed across the width of the robe with a final half diamond on the left side. The skip-stitch twining continues down the sides in a diamond and herringbone design. The number of lines between each diamond varies. The bottom white border reflects the top border in design and execution.

Fig. 296. The design of the skip-stitch twining in the top white border

Fig. 297. The mock two-strand twining heading seen from the front side of the robe

Fig. 298. The reverse side of the heading (Fig. 297) showing the mock two-strand twining from the back

114

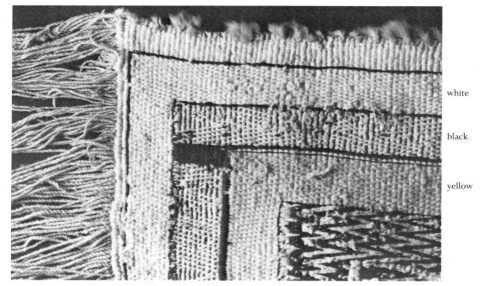

white

black

yellow

Fig. 299. The back of the top right corner shown in Fig 295. There is a small area of black two-strand twining directly underneath the top black border

Inside the white border is a black border of skip-stitch rigid weft twining. The design is similar to the white diamond border. Each black weft on the front uses one white weft from the white side border as a rigid weft.

The black side borders are worked in skip-stitch rigid weft twining in a design of alternating triangles.

The bottom black border continues in rigid weft twining, but it does not contain any patterning. The black weft appears on the back in straight rows of black dots over a white rigid weft.

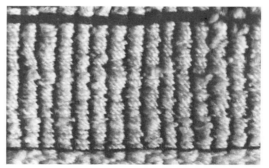

Fig. 300. The bottom black border seen from the back

Fig. 303. The skip-stitch design of the white side border

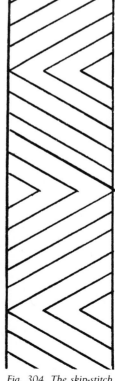

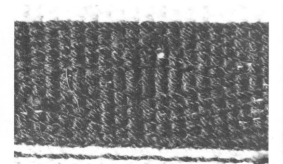

Fig. 301. The front side of the top black border showing skip-stitch rigid weft twining

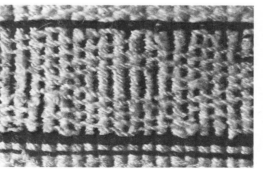

Fig. 302. The back side of the border in Fig. 301 shows rows of rigid weft "dots"

Fig. 304. The skip-stitch design of the black side border

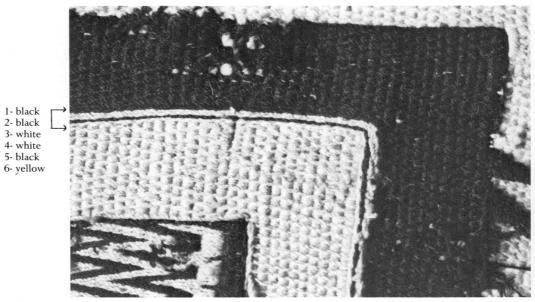

1- black
2- black
3- white
4- white
5- black
6- yellow

Fig. 305. Of the three-strand outline rows, 1, 3, and 5 are done in three-strand twining and 2, 4, and 6 are in three-strand braided twining

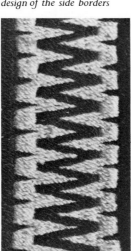

Left side Right side

Fig. 306. The skip-stitch design of the side borders

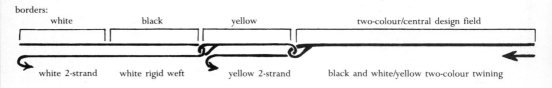

Fig. 307. The side two-colour border

Within the black border is a yellow border. At the top it is worked in skip-stitch twining, designed in diamonds similar to the top white border. The diamond designs in the black, yellow, and white top borders lie directly beneath each other except at the edges. On the sides, the yellow border continues in skip-stitch twining. The patterning on the left side of the robe differs slightly from that on the right, as illustrated in Fig. 306. The bottom yellow border repeats the skip-stitch twining design of the top yellow border.

Directly surrounding the central design field is a black and white border. Designed in zig-zag and bar units, it is worked in two-colour twining. At the sides, this border consists of a black zig-zag line against white points, edged by black bars. No yellow weft appears in this design. The black and white border at the bottom of the robe repeats the pattern of the top border.

The three-strand outlines which separate and define the top black and yellow borders are worked either in three-strand twining or three-strand braided twining. When each of these rows travels vertically, it is worked in three-strand twining.

The paths of the wefts in the borders on this robe are different from the other robes since they move back and forth in their own areas. The rows are not worked from selvage to selvage. On the left side, the white weft starts on the outside edge, twines through the white border and then becomes the rigid weft for the black border. After the black border, it interlocks with the yellow weft and returns to the outside edge. The yellow weft then interlocks with the two-colour twining of the innermost border. The two-colour border and the central design field are worked with one set of wefts. This process is mirrored on the right side of the robe.

borders:

white	black	yellow	two-colour/central design field
white 2-strand	white rigid weft	yellow 2-strand	black and white/yellow two-colour twining

Fig. 308. The paths of the wefts in the side borders

116

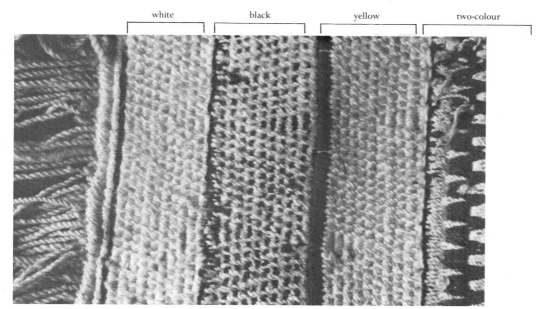

white black yellow two-colour

Fig. 309. The side borders, shown from the back of the robe

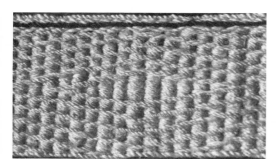

Fig. 310. The diamond design in the top yellow border

The bottom borders of this robe follow a slight curve created by adding weft rows toward the centre. The addition of these rows is made evident through examination of the patterns in the white band. The middle diamond in this band consists of five lines, while the edge diamond has only three. Measurements also show a .5 to 1 centimetre difference between the width of the centre and the outside edges of the white, black, and yellow borders.

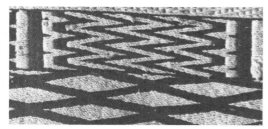

Fig. 311. One design unit in the top two-colour border

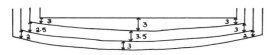

Fig. 312. Measurements of the bottom borders

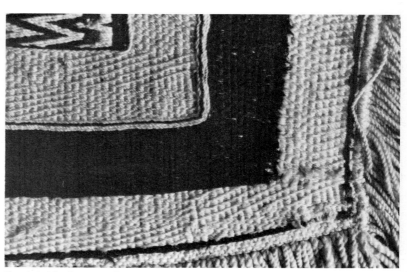

Fig. 313. The bottom right corner of the robe

117

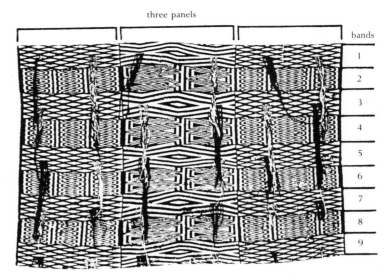

Fig. 315. The central design field showing the bands and the three panels

Fig. 316. A black and white zig-zag and bar unit

Fig. 317. The design of a central white and black unit in the zig-zag and bar bands on the right side of the robe

The Central Design Field

The central design field is divided vertically into three panels, the outer two being similar and the middle one different in design. A vertical row of black three-strand twining which encloses weft rows separates the panels. The field is also divided into nine horizontal bands. These bands visually cross the three panels, even though the design units within them change. The entire central design field is worked in two-colour twining.

The outer two panels are composed of two units: one a black lattice on a white ground and the other a zig-zag and bars design. This patterning is similar to Robe IX. The lattice design is placed in the first, third, fifth, seventh, and ninth bands and the zig-zag and bar units in the second, fourth, sixth, and eighth bands. The black lattice design is reversed on the back of the robe, appearing as a white lattice on a black field.

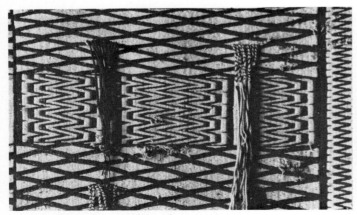

Fig. 318. Design of the outside panels

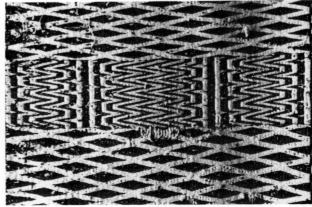

Fig. 319. The reverse side of the panels shown in Fig. 318

118

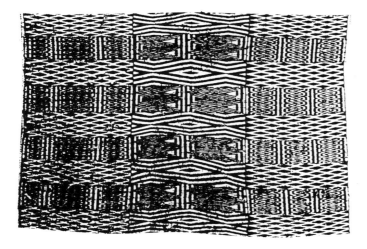

Fig. 320. The reverse of the central design field is a negative of the front

The second, fourth, sixth, and eighth bands are composed of two units of bars, triangles, and zig-zags, similar to the ones in Robe VIII, the Swift Robe. On the left of each unit there are two black triangles, on the right there is one full and two half white triangles. Yellow stripes, which coincide with the points of the zig-zags in the adjacent bands of the outer panels, run through this design.

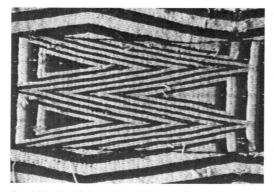

Fig. 321. One design unit in the second band

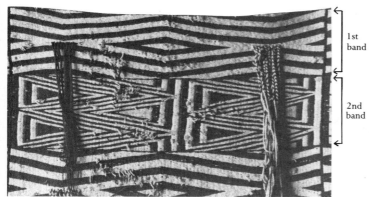

Fig. 322. The central panel of the central design field has two alternating bands

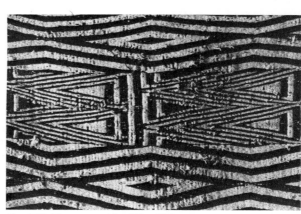

Fig. 323. The reverse side of Fig. 322

Fig. 324. A black tassel in the central panel

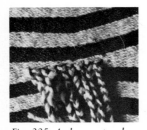

Fig. 325. A chevron tassel in the central panel

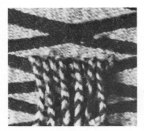

Fig. 326. A chevron tassel in an outside panel

Fig. 327. A black tassel in an outside panel

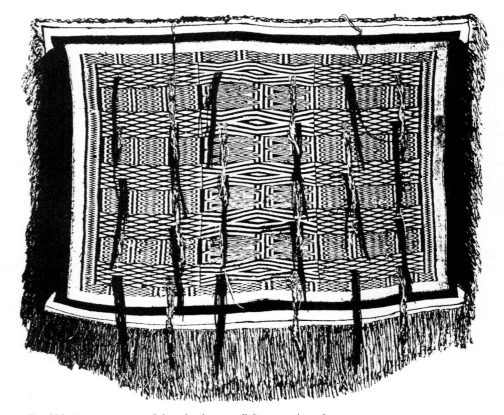

Fig. 328. A reconstruction of the robe showing all fringes and tassels

Two tassels are inserted in each of the lattice bands. The tassels are not part of the weft but instead are separate strands added around approximately ten warp ends, braided for about 5 to 6 centimetres and then left in long tails. The total length of a tassel is about 36 centimetres. In each lattice band, one tassel is composed of all black braids and one is composed of black and white chevron braids. The two types of tassels alternate places in each band and are spaced evenly, falling directly under each other.

In the central panel, the first, third, fifth, seventh, and ninth bands consist of black and white angled lines which culminate in a central diamond. Tassels which are all black, or black and white, are added on either side of the centre. These are placed in line with the tassels in the outer panels.

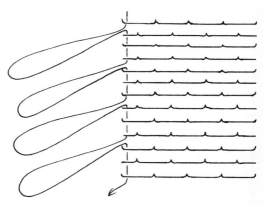

Fig. 329. The insertion of the black fringe loops in the black side border

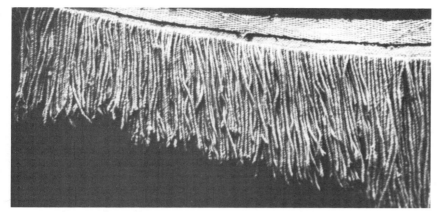

Fig. 330. The stepped warp fringe

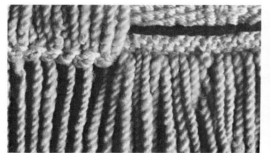

Fig. 331. The warp fringe twining

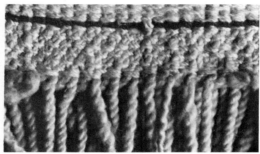

Fig. 332. The spaced twining and warp fringe seen from the back of the robe

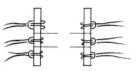

Fig. 333. Lark's head knots appear on both sides of the robe

The Footing and the Fringes

Underneath the black selvage pattern line are six rows of white ground twining which make up the footing. On both sides of the robe white side fringes are added as lark's head knots between the weft rows. There is a black side fringe placed along the outside edge of the black side borders. It is not an integral part of the black weft. The black pattern weft interlocks with the adjacent borders and is continuous row after row. The black fringe on both sides of the robe is a series of loops made of one strand of yarn (Fig. 329).

Warp fringe twining makes up the final row of weaving in the robe. This row is two-strand twining over three warp ends and two wefts are used. Of the three warp ends, one is left hanging while two are moved to the next twining segment. The warp fringe is shorter on the sides than it is in the middle and appears to be cut in steps, as is typical of the Chilkat Dancing Blankets.

Dimensions

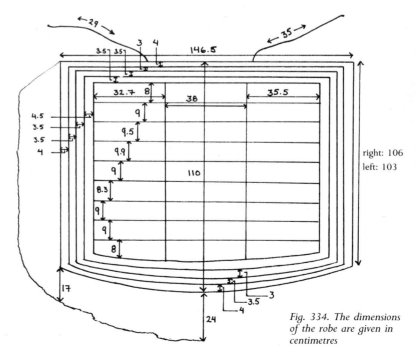

Fig. 334. The dimensions of the robe are given in centimetres

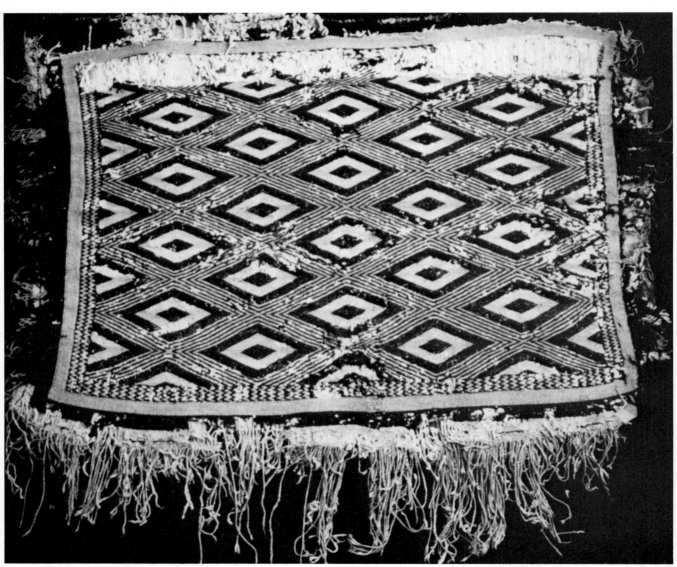

Fig 335. The Diamonds Robe

Unique in design, the Diamonds Robe shows the scope and imagination of the native weavers. Although it follows the general format displayed in the robes with multiple borders, the composition of the central field differs considerably. It is covered in rows of solid colour diamonds separated by black and white lines, and it does not have any tassels. At first viewing, the arrangement of this design might seem dull; a close examination of the complex arrangement of diamonds and diagonal lines, however, leaves one staggered by the creative ingenuity and technical ability of the designer/weaver. With a total of only fifteen robes to consider, it would be very easy to fall into the trap of categorizing the existing designs. The presence of this robe opens the probability that at one time there were many robes displaying a great diversity in styles of design.

122

Robe XI

The Diamonds Robe

Collection Data

Present Location: Museum of Mankind, London, England.
Catalogue Number: Cook-Banks Collection NWC 51.
Historial Record: No provenence was provided in the original catalogue notes for this cloak. J.C.H. King notes: "in the Peabody Museum, Harvard University, is an early print of this cloak; on the back is an inscription saying that this was collected in 1792." He goes on to discuss a variety of options put forth by scholars for the collection of this robe (p. 60).

Materials and Condition

Although still in one piece, this is in poor condition. Netting has been glued to the back to hold it together, with one small window left open. In some places two nets are glued together to the back of the textile. In the central design field, near the centre, some of the loosened wefts have been glued diagonally so that the pattern of the design reads as it should; structurally this is incorrect.

The heading and top black border are pretty well disintegrated, although the heading cord is intact. Also at the top of the robe, the yellow border remains and the two-colour border is missing. The side fringes are mostly gone, especially on the right side. The lower white border and warp fringe are also disintegrated.

The warp is spun from mountain goat wool and hair. The weft yarns are of mountain goat wool, originally dyed brown-black and yellow. The yellow wefts are very faded on the front of the robe. A strip of soft light brown fur is wrapped around the heading cord.

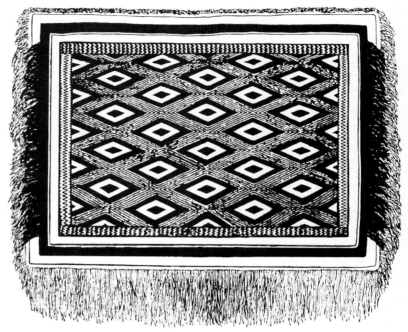

Fig. 337. A reconstruction drawing of the robe adding all fringes and the upper two-colour border

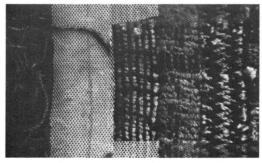

Fig. 338. One small area on the back of the robe can be seen through a window in the netting

Fig. 339. The heading cord covered with a fur strip

Fig. 336. The wool and sinew heading cord

123

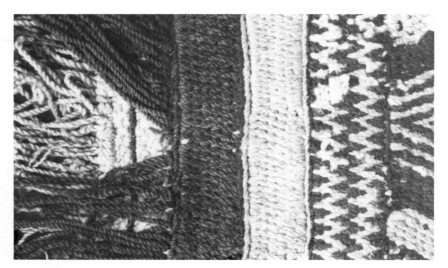

Fig. 340. The black looped side fringes are folded back to show the selvage pattern and white border

Technique and Design

The Heading and the Selvage Pattern

The heading cord is made of mountain goat wool and hair spun over a sinew cord. The cord is spun S singles, two-ply Z. It originally travelled across the top of the robe and then dropped down to become the side cords. The heading and top white border, although greatly disintegrated, can be determined from an examination of the remaining strands and a comparison with the bottom border. The heading may have consisted of four rows of white compact two-strand twining.

Underneath the heading is a selvage pattern line worked as one black three-strand braided twining row. When this row turns to travel vertically down the sides of the robe, it becomes a three-strand twining row, worked four warp ends in from the side cords. Along the bottom the selvage pattern line is once again braided twining.

The Borders

Four borders surround the central design field. From the outermost in there are three solid colour borders: white, black, and yellow. The innermost border is a black and white two-colour design. Along the top of the robe the borders are very disintegrated, only the yellow one remaining intact.

The white border may have been worked in compact two-strand twining across the top of the robe, echoing the ten rows twined in this manner which constitute the white border at the bottom. Along the sides, this border is worked in ground twining. Although basically white, it has nine yellow stripes running through it. These stripes occur according to the placement of the yellow wefts which run through the centres of the diamonds in the central design field.

The black border is also disintegrated along the top. If it was similar to the bottom black border, it was worked in rigid weft twining over a single white rigid weft. Along the sides of the robe, the black borders are worked over two rigid wefts,

Fig. 341. The black side border

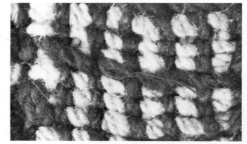

Fig. 342. The back of Fig. 341 showing rigid weft dots and two-strand rows

Fig. 343. The bottom borders of the robe. A small portion of the selvage pattern shows as a black line in the lower white border

these being white or yellow as determined by the colours in the white side borders. Black two-strand twining rows are used occasionally in the side borders, appearing on the back side as solid black lines. Along the bottom of the robe, the "dots" of the rigid weft twining appear as parallel vertical lines and are continuous through the black and yellow borders.

The entire yellow border is worked in rigid weft twining. Along the top of the robe the rigid weft is a single white strand. At the sides, it becomes a multiple of black and white strands which twist around each other giving a mottled appearance on the back. When the yellow ground-twining wefts from the left side of the robe reach the yellow border, they are used as rigid wefts and not as pattern wefts. The pattern wefts, which ride on the front only, wrap around the rigid weft on the right side of the border and return to the left in two-strand twining.

Directly surrounding the central design field is a black and white patterned border. Along the top of the robe it is completely disintegrated. It might be assumed that it was similar in design to its counterpart at the bottom, although this cannot be certain; there are robes in which the design of the top and bottom bands of this border differs. At the sides of the robe the two-colour border resembles the "shadow of a tree" design: a central black zig-zag line is flanked by two white zig-zags. Yellow wefts, placed according to the centres of the diamonds in the central design field, course through this pattern at regular intervals. The outer edges of the pattern are composed of black points which intermesh with the zig-zags, and it is outlined by black three-strand rows. The design of this border at the bottom echoes the sides; it is a series of zig-zags unbroken by bars.

Fig. 346. The two-colour side border

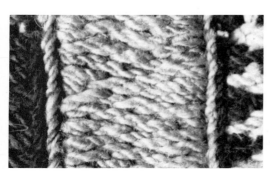

Fig. 344. The yellow side border

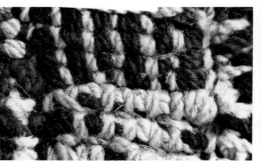

Fig. 345. The rigid weft back of the yellow border

125

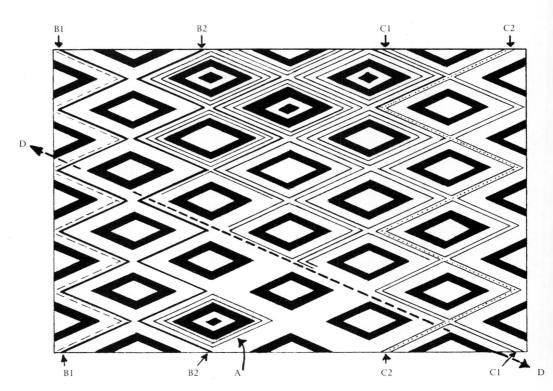

Fig. 347. This diagram illustrates the visual paths of the pattern lines in the central design field

The Central Design Field

Unlike other robes of this type, the central design field is covered entirely with a pattern of diamonds. These diamonds are black and white with a yellow stripe running through their centres. Solid coloured diamond units are separated from each other by outline diamonds and zig-zag lines.

Two black and two white outline diamonds surround each unit of solid colour diamonds units (Fig. 347, A). Two black lines zig-zag vertically around these composite units (B1 and B2). Their white counterparts (C1 and C2) zig-zag around two diamonds. The black vertical zig-zag lines do not criss-cross; in each set the white zig-zag lines cross each other between vertical rows of diamonds but not between the horizontal rows. A line (D), drawn parallel to the lower left edge of one of the black solid diamonds on the left side of the robe and extended to the right, shows that the sides of a diagonal row of diamonds are not directly aligned with each other.

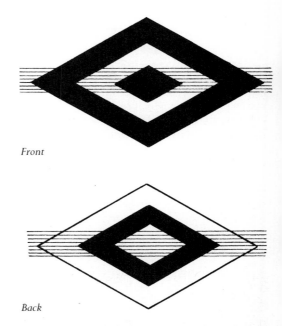

Front

Back

Fig. 348. The front and back of the diamond designs; the horizontal lines indicate the placement of yellow

126

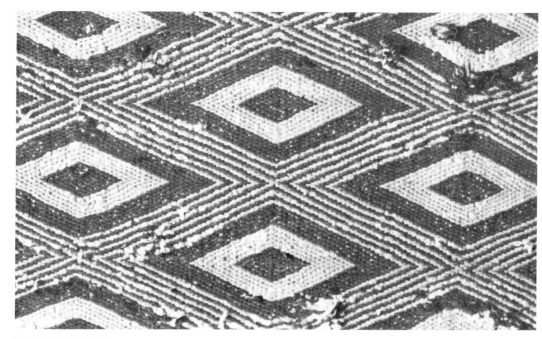

Fig. 349. Diamonds in the central design field

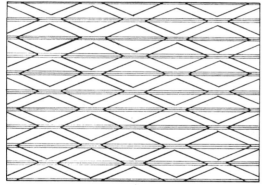

Fig. 350. The thin horizontal lines indicate the yellow stripes in the central design field

The entire central design field is worked in two-colour twining. The outline diamonds are formed by one segment of each coloured weft. On the back side of the fabric, these lines are therefore reverse in colour from the front.

The solid diamonds require double twists to maintain their colours; therefore, the unused colour takes the form of a rigid weft for a short distance behind the pattern colour. The pattern colour shows as "dots" on the reverse side of the fabric.

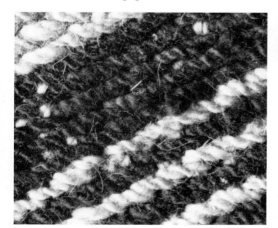

Fig. 351. The right side of a portion of the diamond design

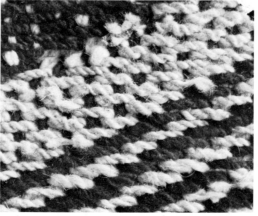

Fig. 352. The back of Fig. 351 shows rigid weft "dots" and the reversal of black and white from front to back

127

The Footing and the Fringes

The footing lies directly beneath the selvage pattern and is composed of four rows of white compact two-strand twining.

A white weft fringe borders the sides of the robe. All weft rows start around the side cord on the left and end on the right as side fringe where they are tied off in an overhand knot, a granny knot, or a hitch. When the ground-twining weft is yellow, the side fringes on the right are also yellow. The added side fringes on the left are always white. A white warp fringe worked in standard warp fringe twining completes the bottom edge of the robe.

A secondary black weft fringe lies adjacent to the outer edges of the black side borders. It begins at the commencement of the black and white top border and ends when this border finishes at the bottom of the robe.

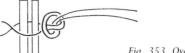

Fig. 353. Overhand knot

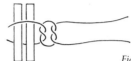

Fig. 354. Granny knot

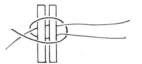

Fig. 355. Hitch

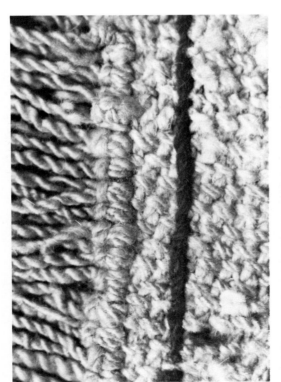

Fig. 356. The lark's head knots, selvage pattern, and spaced twining on the left side of the robe

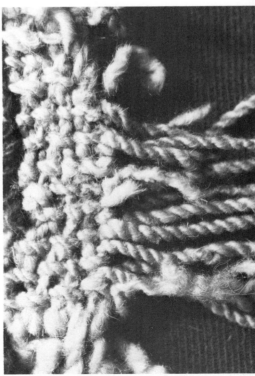

Fig. 357. The weft rows are tied off in knots on the right side of the robe

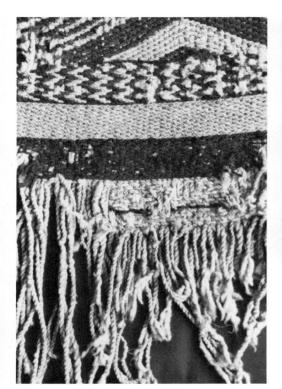

Fig. 358. The warp fringe

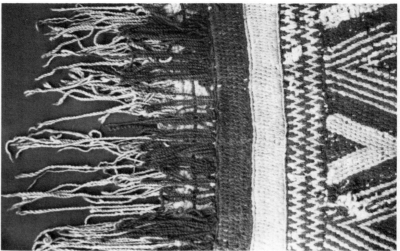

Fig. 359. The side borders and black and white side fringes

Dimensions

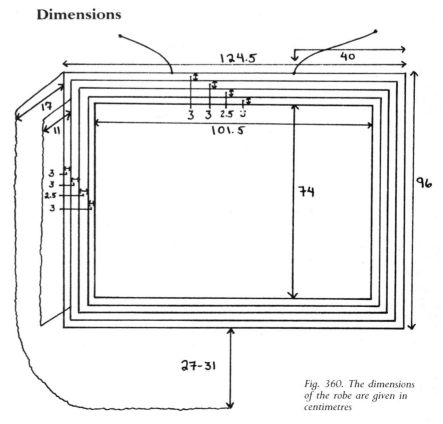

Fig. 360. The dimensions of the robe are given in centimetres

129

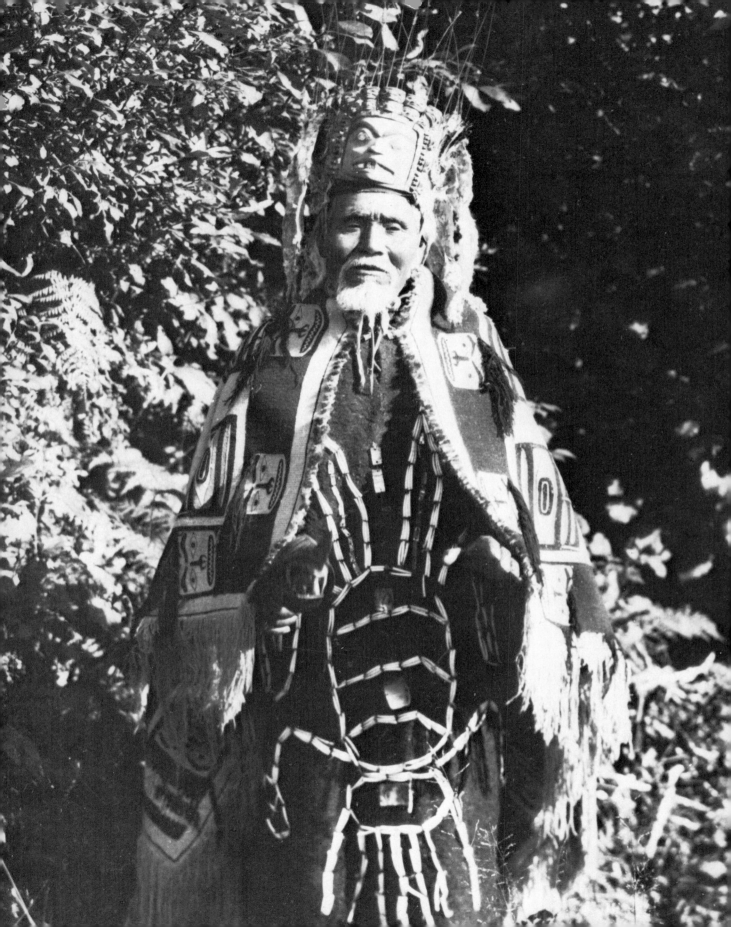

Robes XII to XV

"*This chief Mr. Whidbey represented as a tall thin elderly man. He was dressed in a much more superb style than any chief we had hitherto seen on this coast, and he supported a degree of state consequence, and personal dignity, unusual to be found amongst the chiefs of North-West America. His external robe was a very fine large garment, that reached from his neck down to his heels, made of wool from the mountain sheep, neatly variegated with several colours, and edged, and otherwise decorated with little tufts, or frogs of woolen yarn, dyed of various colours. His head-dress was made of wood, much resembling in its shape, a crown, adorned with bright copper and brass plates, from whence hung a number of tails or streamers, composed of wool and fur wrought together, died of various colours, and each terminating by a whole ermine skin. The whole exhibited a magnificent appearance, and indicated a taste for dress and ornament, that we had not supposed the natives of these regions to possess.*" (Vancouver 1801: 430-31).

Captain George Vancouver
Lynn Canal, July 1794

The last four robes are distinctive because of the placement of formline design motifs, worked in the Chilkat weaving technique, in the central design field. The robes are rectangular in shape with a curved bottom edge, and they are bordered on all sides by bands of white, black, yellow, and two-colour design. They have white side fringes and secondary black side fringes. A warp fringe hangs from the bottom and a fur strip finishes the top edge. Long black tassels, issuing from the corners of the formline motifs, adorn the central design field. The Chilkat weaving displayed in these pieces is not experimental; it has been thoroughly developed previous to its use in these robes. The use of formline design introduces a fourth colour, yellow-green, into the robes.

Of these last four robes to be presented, one is a fragment, two are illustrations, and only one is complete. Robe XII, the Lynn Canal Robe, is reconstructed from parts of a robe which are in museums in Ottawa and New York. Robe XIII exists only in a photograph. The discussion of Robe XIV, Aichunk's Robe, is taken from information presented in a Tikhanov painting. Robe XV, the Skatins' Robe, is a complete garment which now resides in a Toronto museum. In design this last robe appears to be very different from the others; it is included because technically it belongs to this unique style of weaving.

Fig. 361. Tsimshian chief Peter Ni.sy,qt in full regalia wearing the Skatins Robe

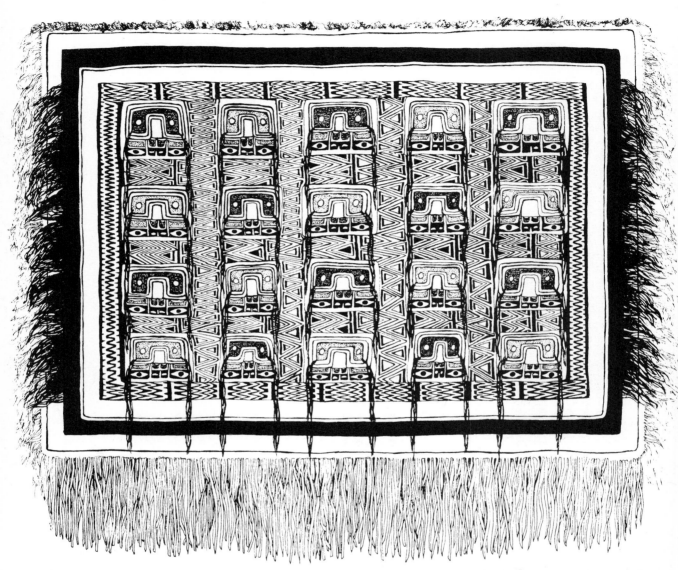

Fig. 362. A drawing of the Lynn Canal Robe reconstructed from a tunic and a pair of leggings

The Lynn Canal Robe is the only robe in the collection which has taken part in the native tradition of cutting a woven garment into pieces and distributing them to worthy recipients in the ceremony called the "potlatch." Owners of the severed pieces would then fashion them into new garments, to be worn with pride at future gatherings. Three pieces of this robe remain. One half of the original robe was made into a tunic, and a portion of the other half was made into a pair of leggings. The whereabouts of the remaining pieces of the robe are not known. The

drawing which reconstructs the original robe has been created from an examination of what exists. The placement of the concentric figures, along with the added Chilkat motifs, is in the tradition of the first seven robes. The multiple borders, the secondary black side fringe, and the zig-zag and triangle designs flow from the style used in Robes VIII to XI. The only unanswered question concerns the lower border, which might have been straight, as shown here, or slightly curved, as in Robe XIII.

132

Robe XII

The Lynn Canal Robe

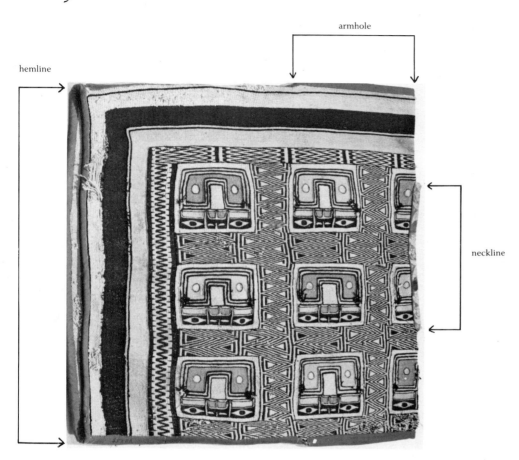

armhole

hemline

neckline

Fig. 363. This tunic has been made from half of the robe

Collection Data

Tunic

Present Location: Museum of Civilization, Ottawa, Ontario Canada.
Catalogue Number: VII-X-55.
Photograph number: J19411-3, 4, 72-2978.
Historical Record: This tunic was collected by I. W. Powell in 1873 on Lynn Canal. It reached the National Museum in 1879.

Leggings

Present Location: Museum of the American Indian, Heye Foundation, New York, New York, USA.
Catalogue Number: 4177 a and b.

Materials and Condition

The fabric of the tunic and the leggings is in good condition, showing relatively few areas of disintegration, with the exception that the black side fringe and the tassels are almost completely missing. The white side fringes are also not present owing to the construction of the new garments.

The photograph has been turned so that the tunic can be viewed as a robe. In this position, the neckline of the tunic appears on the right side and the armholes are arranged at the top and the bottom. The lower opening of the shirt can be seen on the left. The armholes and lower opening have been bound with strips of red wool cloth, the neckline with a cotton print.

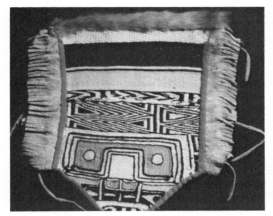

Fig. 364. The front of legging B

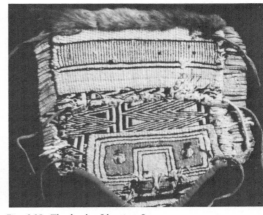

Fig. 365. The back of legging B

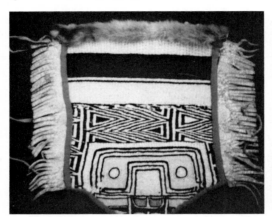

Fig. 366. The front of legging A

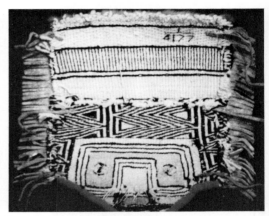

Fig. 367. The back of legging A

The leggings are each made of two pieces joined horizontally. The upper portion, including the white, black, yellow and a part of the two-colour borders, is cut from the bottom border of the robe. The lower half of the leggings includes a section from the central design field. The fur which is on the leggings is a wide strip sewed over the top edge to bind and finish it and is not a part of the original robe.

The warp is made of mountain goat wool and hair. The weft yarns are of mountain goat wool, dyed black, yellow, and yellow-green. The yellow and yellow-green are very faded on the outside, but the colour is vividly retained on the inside of the tunic.

Fig. 368. The heading and selvage patterns

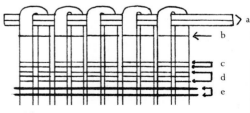

a = 2 heavy warp yarns
b = 1 row white 2-strand twining
c = 2 rows over paired warp ends
d = 3 rows over alternate warp pairs
e = selvage pattern

Fig. 369. A diagram of the heading and selvage

134

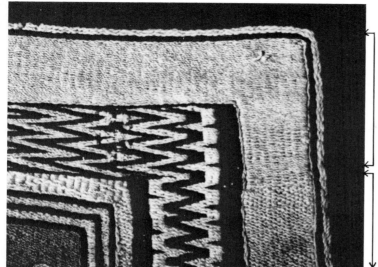

Fig. 370. The top right corner of the robe

rigid weft twining

2-strand twining

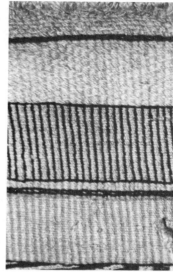

Fig. 371. The back of the top borders

Technique and Design

The Heading and the Selvage Pattern

The heading cord consists of two heavy warp yarns. There is no fur present. The heading is tucked into the seam of the cloth binding. Immediately under the heading cords there is one row of white two-strand twining. This is followed by a .5 centimetre space and then two rows of two-strand twining over paired warp ends. Three rows of two-strand twining over alternate warp pairs, slightly spaced, finish the white portion of the heading.

A black selvage pattern line starts under the heading, runs vertically down the sides of the robe, and completes its circuit underneath the bottom white border, directly above the footing. It is composed of two rows of three-strand twining.

The Border

Multiple borders are organized around the central design field. The outer border is white, followed by a black and then a yellow border, and finally a two-colour border. Along the top of the robe, the white border is worked in a diamond design of skip-stitch twining. When this band turns to travel vertically, it continues to be worked in skip-stitch twining on the left for a short distance and then changes to compact two-strand twining. Along the bottom of the robe, the white border is once again worked in skip-stitch twining and is designed as a series of horizontal zig-zag lines.

At the top of the robe, the black border is worked in compact rigid weft twining over single white rigid wefts. The white wefts originate from the left white side border. The top yellow border is also worked in compact rigid weft twining over single white rigid wefts. As these borders turn the corners and travel vertically, rigid weft twining alternates with compact two-strand twining. This alternating is in rhythm with the placement of the formline design units in the central design field. When there are no formline units in the horizontal path of the weft across the robe, the weaver twines across the entire robe from left to right, utilizing the rigid weft twining technique.

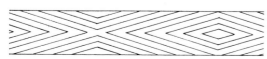

Fig. 372. The design of the top white border

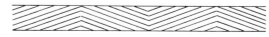

Fig. 373. The design of the bottom white border

135

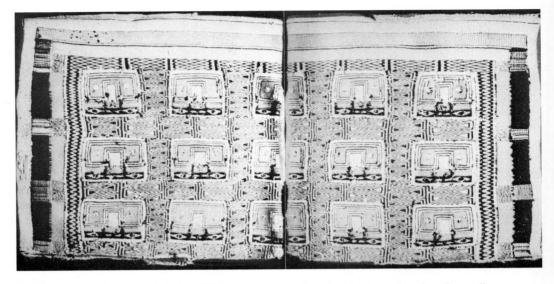

Fig. 374. Areas of rigid weft twining in the black border can be easily seen on the back of the robe

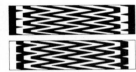

Fig. 375. The zig-zag and bar units in the two-colour border

In the rows in the central design field which contain Chilkat weaving, the wefts cannot travel in an uninterrupted path from left to right; therefore, compact two-strand twining can be used in conjunction with the interlock and dovetail joins.

For the black side borders, the rigid wefts continue to be the white wefts from the outer white border. The rigid wefts for the yellow border are composed of the white and black strands from the outer two adjacent borders.

Along the bottom of the robe, the black and yellow borders are worked in compact rigid weft twining over white rigid wefts. The "dots" from the pattern wefts form continuous vertical lines between the two borders.

Black, white, and yellow three-strand rows surround and separate the borders. Between the black and white borders is a row of black three-strand twining. Between the black and yellow borders are six rows of braided twining in black, white, white, black, black, and yellow. The

yellow border is outlined with a yellow row of braided twining and the two-colour border is outlined by a row of black braided twining.

Inside the white, black and yellow borders lies a black and white border of two-colour design. At the top of the robe, it is a sequence of alternating positive/negative zig-zag and bar units. The unit at the right corner of the top border is slightly larger than its mates. Along the sides of the robe, the two-colour border is worked in a pattern which resembles the "shadow of the tree" design. The black zig-zag line which runs down the centre of the design is two warp segments wide and has blunt points because of the repetition of the outermost row of the point. Black bars lie on either side of the zig-zag line. At the bottom of the robe, the two-colour border is worked in a black and white zig-zag and bars pattern similar to the top border. This can be determined from the small fragment of it present in the legging.

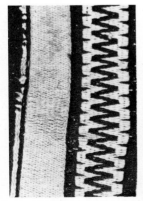

Fig. 376. The two-colour side border design

Fig. 377. The bottom borders, seen from the front

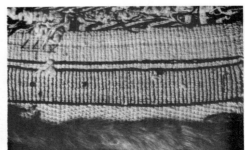

two-colour

yellow

black

white

Fig. 378. The back of the bottom borders in Fig. 377

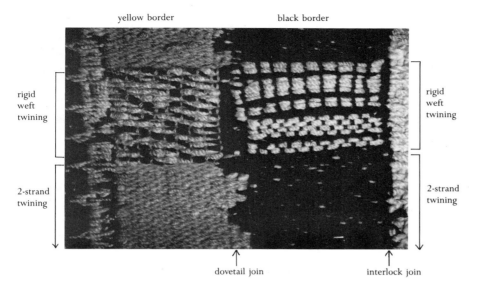

yellow border · black border

rigid weft twining

2-strand twining

rigid weft twining

2-strand twining

↑ dovetail join · ↑ interlock join

Fig. 379. The black and yellow borders from the back of the robe

The Central Design Field

The central design field is elaborately organized with rows of formline and concentric design units placed on a ground of two-colour design. These rows alternate with rows composed entirely of two-colour design. The formline units are placed in five rows of five each. In each of these units, the upper portion is coloured with yellow or yellow-green. The colouring of these units alternates both horizontally and vertically. Long black tassels once hung from both of the outer lower corners of the concentric portion of the motifs.

The formline motifs placed in the central design field are rectangular in shape. The units are connected to the surrounding two-colour field by drawstrings.

Within each motif, a narrow white band surrounds the design. Along the top and bottom this band is worked in skip-stitch twining. Along the sides it is worked in compact two-strand twining. White rows of three-strand twining outline both sides of this band.

The upper portion of the design is a combination of black lines which form a concentric "double around the cross" shape, with interior circles on a coloured ground. The black lines are worked in three-strand twining, enclosing the weft rows when they travel vertically and therefore appearing on the reverse side of the fabric. The vertical three-strand twining used in the circles follows the Chilkat tradition of working between the horizontal wefts; these lines do not show on the

back. The ground in the middle of the motif, between the two sides of the concentric shape, is worked in compact two-strand twining and is joined to the coloured area with an interlock join.

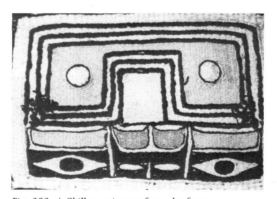

Fig. 380. A Chilkat unit seen from the front

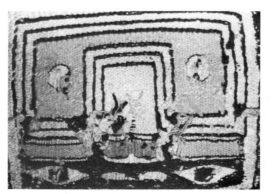

Fig. 381. The reverse side of a Chilkat unit

Fig. 382. Placement of the drawstrings

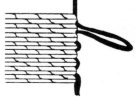

Fig. 383. A drawstring loop

137

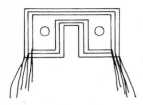

Fig. 384. The upper portion, or concentric design

Fig. 385. The lower portion, or formline design

Pendant from the lower corners of the concentric shapes were long black tassels. Although these are no longer present, evidence of them exists in the remaining short ends.

The lower portion of the formline design units is executed in Chilkat weaving technique. In design, two eyes lie underneath U shapes, depicting a stylized upside down face. All joins are interlocks, and all of the elements of the design are outlined in rows of three-strand braided twining. In the first horizontal row of formline motifs, there appear a number of added warp ends. The rectangular units themselves curve in at the top, whereas the units in all other bands have straight sides. The number of added warp ends in the top row varies from four to fifteen; some of the ends are added in the design unit itself, others in the yellow border above.

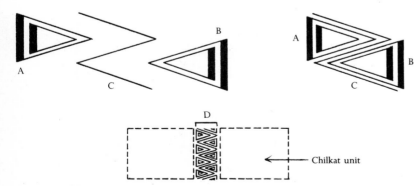

Fig. 386. The two-colour pattern

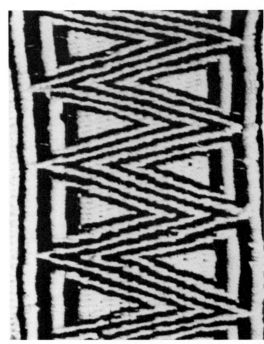

Fig. 387. The two-colour pattern between Chilkat units

The area between the formline motifs in each horizontal row is worked in black and white two-colour twining. It is elaborately designed with a series of zig-zag lines and triangles. Vertically, the design consists of two rows of concentric triangles with heavy black bases facing each other and separated by black and white zig-zag lines. The inner triangles have solid white centres.

Bands of two-colour patterning lie between the rows of formline motifs. In design, they consist of positive/negative units of black and white triangles and zig-zag lines. Discussion of a design similar to this one appears in Robe VIII. The units alternate in colour across the band but do not change their position in each succeeding band. Therefore, all the units with black centered triangles are vertically aligned. These two-colour bands are designed and worked separately from the rows with the formline motifs. Although the units with white triangles are planned so that they are aligned vertically with the white triangles in the two-colour design between the formline motifs, this alignment is not always accurate.

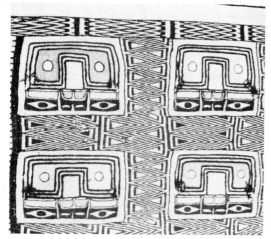

Fig. 388. Chilkat units in the two-colour ground

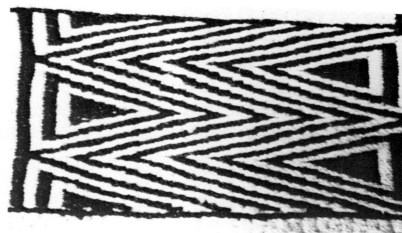

Fig. 389. One unit in a two-colour band

Dimensions

The Footing and the Fringes

Underneath the bottom selvage pattern are a few rows of white ground twining. The fringe twining row and the warp fringe have been cut off.

The lower edge of the tunic, which is in fact the side of the robe, is bound in red wool cloth, the white side fringes having been cut off. A secondary black side fringe lay adjacent to the black border when the robe was new. This fringe started at the beginning of the top two-colour border and ended at the completion of this border at the bottom of the robe. On one side, the black fringe was inserted as a lark's head knot between weft rows on the outer two warp ends of the black border. The black three-strand outline row covered the entry of these fringes.

Fig. 390. The entry of the lark's head fringes

Fig. 391. The dimensions of the robe are given in centimetres

139

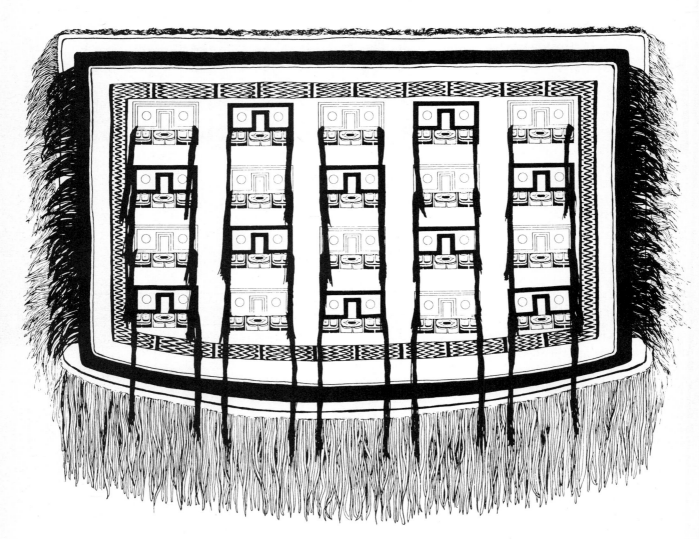

Fig. 392. A drawing of
the Single Eye Robe
based on the photograph
in Fig. 395

This exquisite robe exists, to date, only in
a photograph which was donated to the
Tongass Historical Society by Dorothy
Gould Young, a relative of the Reverend J.
Loomis Gould, the first Presbyterian
missionary to the Haida people in
Howkan, Alaska, 1884-1902 (personal
communication, Suellen Liljeblad, Senior
Curator of Collections, Tongass Historical
Museum). Because the whereabouts of the
actual robe are unknown, the photograph is
extremely valuable as another example of
the variety of techniques and design
combinations which were used by the

northern weavers. This robe must be
imagined in colour. White, black, yellow,
and black and white borders surround a
basically white design field. Upon this
field are placed concentric figures, the
interiors of which might have alternated in
colour between yellow and green. Under-
neath the concentric forms is a discrete
formline image featuring a single eye. Long
black tassels hang from both of the lower
corners of each of the units. The black of
these tassels and the white background
must have vividly accentuated the richness
of the yellow and green forms.

140

Robe XIII

The Single Eye Robe

Collection Data

Present Location of the Photograph: Tongass
Historical Society, Inc. Ketchikan, Alaska,
USA.
Negative Number: PB.77 9.930 T.H.S.
75.5.11.5 Mics.

Design

The Heading and Selvage Band and Borders

The heading and selvage bands are white.
The selvage pattern is a black line which
travels around the perimeter of the robe.
White, black, and yellow borders surround
the central design field. The black and
yellow borders are separated by a white
line. Inside the yellow border is a fourth
border designed in two-colour twining
patterns. Black and white and white and
black units of zig-zag line designs alternate
across the top and bottom of the robe.
Down the sides, the two-colour twining
pattern resembles the "shadow of the tree"
design. As can be seen in the photograph,
the bottom borders of the robe are curved.
The width of these borders is considerably
smaller at the sides of the robe than it is
in the centre; this increase would account
for the lower curve.

Fig. 393. Design of the two-colour side border

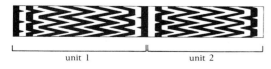

unit 1 unit 2

Fig. 394. Design units in the top and bottom borders

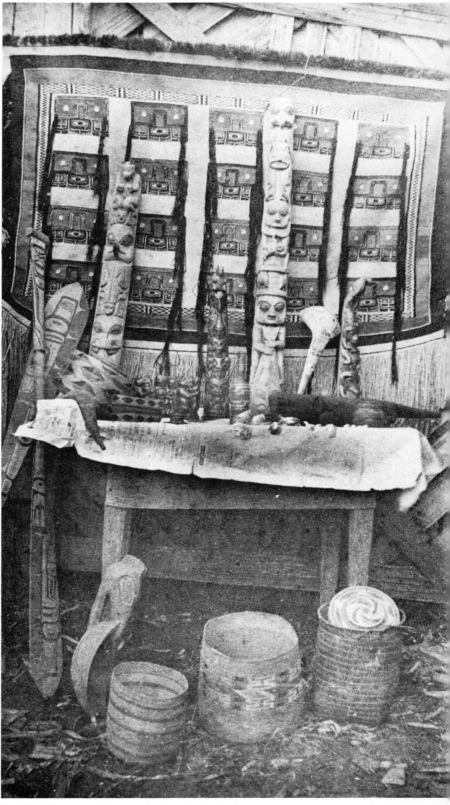

Fig. 395. The original photograph of the Single Eye Robe

141

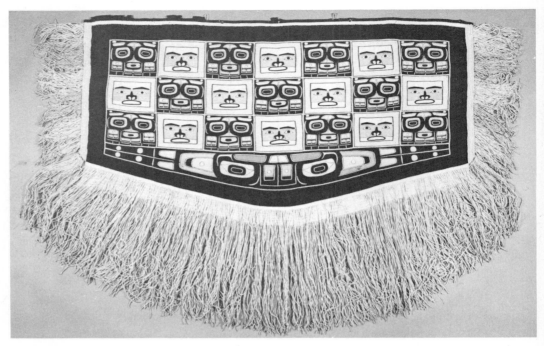

Fig. 396. An unusual Chilkat Dancing Blanket showing a formline motif similar to the one in the Single Eye Robe

Fig. 397. A Chilkat unit

Fig. 398. Concentric figure above the band of formline design

The Central Design Field

The central design field is designed with four horizontal rows containing five units placed on a white ground. It is impossible to tell from the photograph whether the ground was designed with a skip-stitch pattern as it is in Robes XIV and XV.

In the Chilkat units, a figure with three concentric lines enclosing two circles lies atop a small band of formline design. Long black tassels hang from both of the outside lower corners of the concentric figures. In row one of the Chilkat units, the concentric figures in the second and fourth units appear to be solid black while the first, third, and fifth figures follow the usual black and white spacing. In the second row, this order is reversed, with the first, third, and fifth figures

being solid black. It is possible that the interior colour surrounding the small perfect circles also alternates between yellow and yellow-green as in Robe XII.

The units are a combination of concentric figures bordered on the bottom with a thin band of formline weaving. The concentric design takes the form of a "double around the cross" image and is composed of three black lines ending in long black tassels at both of the bottom corners. In the top row the first, third, and fifth units appear to follow the traditional black and white spacing for concentric lines, while the second and fourth units seem to be solid black. This order alternates in the following three rows. It is possible that the interior colour surrounding the perfect circles within these forms also alternates between yellow and green as in the Lynn Canal Robe.

A single eye is placed in the middle of the formline figure, flanked by a black U shape containing two inner U's. These inner U's could be coloured either yellow or green, depending on the colour within the concentric figure above. It is interesting to compare this particular design with one found in the lower portion of a formline face which alternates with human faces on a much later Chilkat Dancing Blanket (Fig. 396).

142

W = white band C = Chilkat band

Fig. 399. Placement of bands in the central design field

Fig. 400. The side fringes

The Footing and the Fringes

The footing on this robe is a very narrow band of white lying directly beneath the black line of the selvage pattern. White weft fringes border the sides of the robe, and a complementary white warp fringe finishes the bottom edge. There is a hint, in the photograph, that the warp fringe may have been stepped as in the Chilkat robes. A secondary black fringe lies directly adjacent to the outer edges of the black side borders.

Dimensions

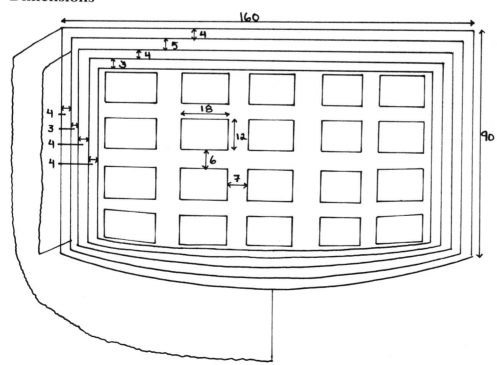

Fig. 401. The dimensions of the robe are given in centimetres

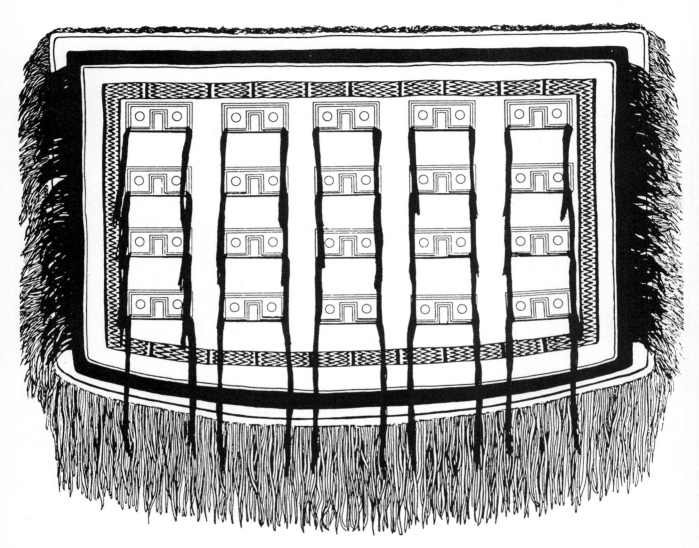

Fig. 402. A drawing of
Aichunk's Robe based on
information taken from the
Tikhanov painting

This robe is illustrated in a painting by
Russian artist Mikhail Tikhanov done in
the year 1818 of a native man called
Aichunk. The painting is a double
portrait, front and profile views, showing
Aichunk from the waist up. Aichunk,
according to the Shur and Pierce article in
which the portrait is published (*Alaska
Journal* [Winter 1976]), is a "toion" or
chief from the Alaska Peninsula. Informa-
tion has been gathered from the painting,
and since only the top half of the robe is

shown, an educated projection has been
made as to what the complete robe might
have looked like. Because the interior space
in all of the concentric figures was
coloured yellow, the visual impact of yellow
and black would have been very strong.
This painting, the one of Kotlean, and the
photograph of Peter Ni.sy,qt wearing
Skatins' Robe, give the only indications we
now have of how the robes might have
been worn.

Robe XIV

Aichunk's Robe

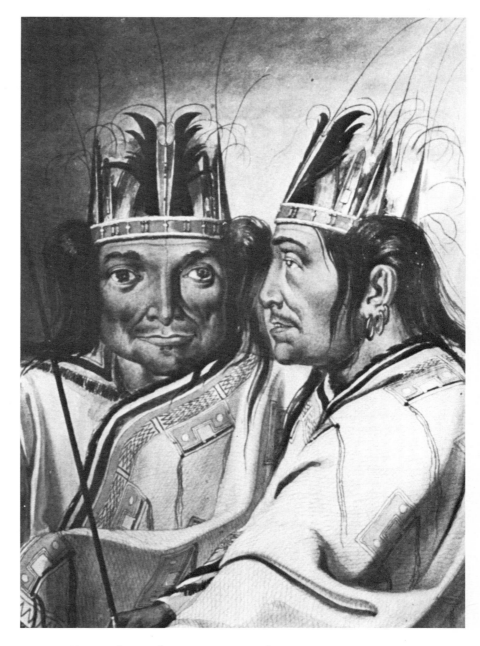

Fig. 403. "Aichunk" painted by Mikhail Tikhanov, 1818

Collection Data

Present Location:
Original Painting: Museum of the Academy of Art, Leningrad, USSR.
Colour transparency: Leonid Shur Collection, University of Alaska, Fairbanks, Alaska, USA.
Black and white print: *Alaska Journal* 6 (Winter 1976), 42.

Historical Record: For an account of artist Mikhail Tikhanov, refer to the article by Shur and Pierce entitled "Artists in Russian America: Mikhail Tikhanov" in the *Alaska Journal* issue noted above and to the Historical Record given for Robe IV.

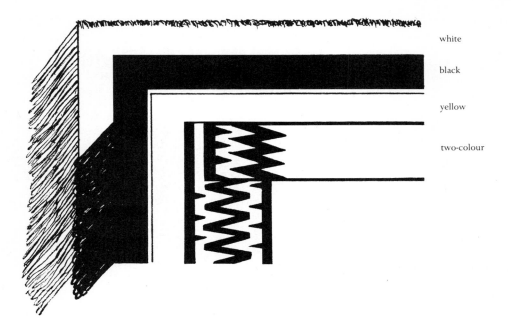

Fig. 404. The top borders of the robe

Design

The Borders

Although the heading is not shown in the illustration, it appears that the top of the robe is wrapped in fur. Underneath this wrapping lie borders in white, black, yellow, and two-colour patterning. A white and then a black line lie between the black and yellow borders.

The two-colour border is patterned in zig-zag and bar units. These units appear to vary in width, the two units in the painting which are completely visible have six and nine zig-zags between two bars. It is impossible to know whether Tikhanov was painting this border precisely or just giving an impression of it.

There is a curious discrepancy in the illustration of the side borders. The top right corner of the robe, seen tucked around Aichunk's neck in the frontal view, shows that the white, black, and yellow borders all turn the corner and travel vertically down the side of the robe. This is confirmed in the profile view directly above the right hand. However, in the front view, the left side borders of the robe are painted as having only white, black, and two-colour borders, the yellow border being absent. The illustration is even more confusing because it is difficult to judge whether the white and black areas which appear on the sides are fringes or woven borders. That a black side fringe did exist is indicated in the upper right corner, frontal view, and above Aichunk's right hand, profile view. However, in both cases it is not attached to the black border.

Given the information presented in the painting and with knowledge of the other robes and the traditional methods of designing the borders, it is probable that the robe had white, black, yellow, and two-coloured borders and also a white side fringe and a secondary black fringe along the sides of the black border. The two-colour side border is patterned in the "shadow of the tree" zig-zag design. As in Tikhanov's painting of Kotlean, Robe IV, the side fringes are very short.

Fig. 405. The two-colour side border

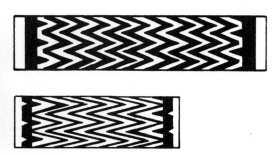

Fig. 406. The zig-zag and bar units

146

The Central Design Field

The ground of the central design field is patterned in a skip-stitch design. This is clearly illustrated in the painting, although the actual design might be questioned. As painted, it is a criss-cross of diagonal lines over the entire surface.

Placed in rows in the central design field are units which combine the essence of the concentric figures with perfect circles. These units are similar to the upper portion of the units in Robes XII and XIII. The unit is composed of a yellow shape bordered by black lines. Inside the yellow shape are two white circles. Three black lines on a white ground lie both outside and inside the yellow shape. These lines are not connected. A solid black bar is found underneath the yellow shape. Long black tassels hang from both of the lower corners. These tassels are probably accurately painted as thin lines; they are the tails of one, or possibly two, of the black lines which travel vertically down the sides of the unit. The painting indicates that these tails were braided a short distance and then left free.

The design units are arranged in horizontal and vertical rows across the central design field. Each row is placed directly below the one above. In the painting, only three units can be seen in any one row. In the profile view, one unit appears near the right shoulder. Judging from the frontal view, perhaps five units were placed across the top. There is wide spacing of skip-stitch ground between each row of design units. As the painting does not show the entire robe, the number of rows of these units, both horizontally and vertically, can only be surmised.

Fig. 407. The ground of the central design field

Fig. 408. A unit of the central design field

Dimensions

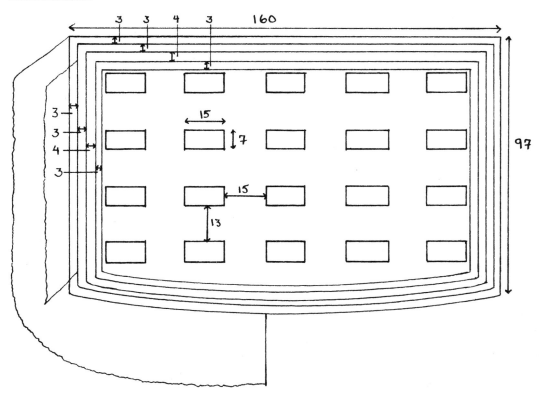

Fig. 409. The dimensions of the robe are given in centimetres

147

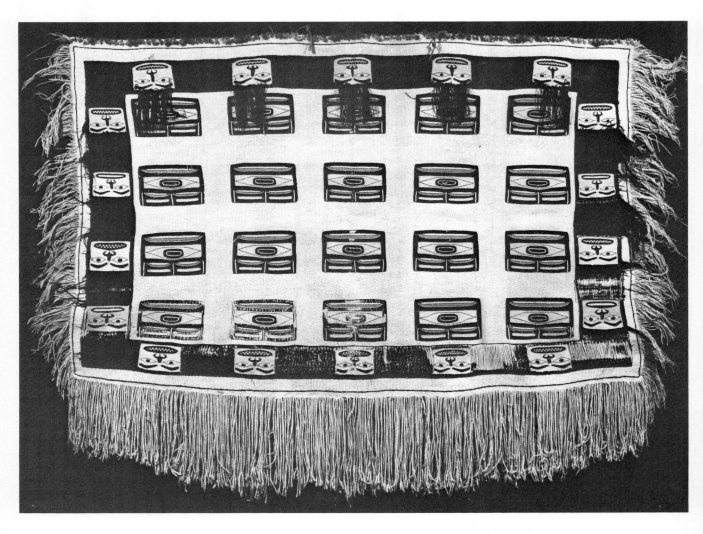

Fig. 410. The Skatins' Robe

From the patterns on this robe, it may seem strange to classify it as one of the Raven's Tail robes; technically, however, it is closely related to the seven robes which precede it. In design it appears to be a Chilkat Robe, for it contains none of the striking two-colour patterns which characterize the Raven's Tail robes. However, it is made only of mountain goat wool and hair with no cedar bark included in the warp, and it has been woven in single rows worked from left to right in the areas where there are no Chilkat design units. It has been conceived in the format of a

Raven's Tail robe, being basically rectangular in shape with long side borders from which extend white fringes and secondary black fringes. The units of Chilkat formline design are plotted on a white ground worked in a pattern of skip-stitch twining which is subtly similar to the main design of the Diamonds Robe. Tassels do not appear in the central design field, but it is interesting to speculate on the similarity between the cascading hair of the human faces in this robe and the placement of the tassels on the lower edges of the concentric figures in other robes.

148

Robe XV

The Skatins' Robe

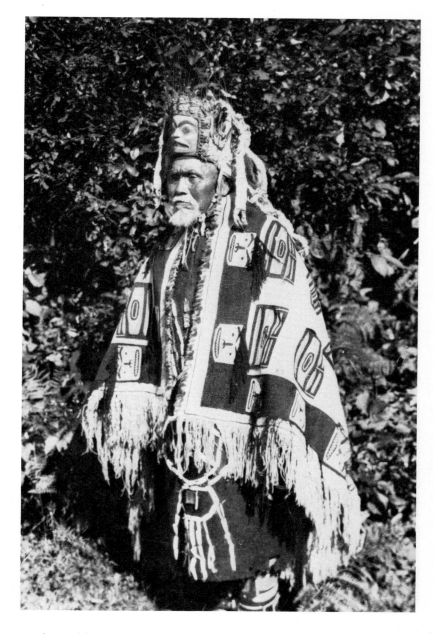

Fig. 411. The Skatins' Robe worn by Tsimshian chief Peter Ni.sy,qt

Collection Data

Present Location: Royal Ontario Museum, Toronto, Ontario, Canada.

Catalogue Number: HN 821 (927.37.142).

Historical Record: The robe was purchased by Marius Barbeau from Alfred Skatins, Gitlaxdamks village, in 1927. Barbeau's notes in the Royal Ontario Museum state that the robe "belonged to former Skatins. Present owners do not know when it was acquired by the former Skatins; it seems fairly long ago. These blankets were made by the Tsitge.t (Tlingit), of mountain goat wool. Used by Skate.n in the feasts; used for the last time about 30 years ago. The figures on it are not crests but conventional designs. Dr. Newcombe made an offer for it to the former owners years ago, but it was declined."

149

Fig. 412. The heading and the selvage pattern

Materials and Condition

The robe is in good condition, even though there is a certain degree of deterioration in the last row of the central design field and the lower border. In this border, the fringes which seem to represent hair, attached to the foreheads of the faces in the black border, are no longer present. The black side fringes are practically all missing.

The warp yarn is made of mountain goat wool with a large amount of hair included. It is spun S singles, plied Z, and consists of two-, three- and four-ply strands placed irregularly across the width of the warp. All strands are approximately three millimetres in width. There are eight hundred warp ends in this robe.

The weft is of mountain goat wool, dyed in the traditional manner. The faces in the black border, although considerably faded, appear to have been painted blue on the front of the robe; they are white on the back. The warp is sett at five ends per centimetre.

Fig. 413. The warp yarns

Technique and Design

The Heading and the Selvage Pattern

The heading cord is a doubled white warp end which starts on the left, about 2 centimetres from the edge of the robe as a loop. The two strands cross the robe and become the side cords on the right side. The first row of white two-strand twining starts on the left, turns on the right, working over the same warp pairs to the left, and then ties off on the left in a knot, becoming the side fringe. The fur strip which finishes the top edge of the robe is wrapped around the heading cord and these first two rows of twining. Following the fur wrapping are six rows of white ground twining.

The selvage pattern consists of a single black line which runs around the perimeter of the robe. Two black three-strand rows make up this pattern; the top one is three-strand twining and the bottom one is braided twining.

The Borders

A white border lies directly inside the black selvage pattern line. Along the top of the robe, it is designed in a series of diamonds worked in skip-stitch twining. There are seven full diamonds across the top, with a half diamond on each side.

Fig. 414. The design of the top white border

Down the sides of the robe, the white border is worked in skip-stitch twining for part of the way and then changes to compact two-strand twining.

Across the bottom of the robe, the white band is once again worked in skip-stitch twining. The design differs from the top band in that, vertically, it shows a complete diamond and a half diamond. The bottom white border is 3.4 centimetres wide in the middle and 2 centimetres wide at the sides, producing a slight curve to the bottom edge of the robe.

Fig. 415. The design of the bottom white border

A very wide black border surrounds the central design field of this robe. It is 9.5 centimetres deep across the top and bottom, and 13 centimetres wide at the sides. It is decorated with formline design human faces, placed upside down to the weaver, with long black "hair" fringes hanging from the top of the foreheads. There are five faces along the upper and lower borders and four faces on each side, all worked in standard Chilkat twining technique and connected to the black border with drawstrings or an interlock join.

The faces at the top and bottom have teeth designed in a checkerboard style. The first and third faces down the sides also have checkerboard teeth, while the second and fourth faces have no teeth at all.

Of the faces with teeth, those along the top border are worked in two-colour twining over paired warp ends. All the rest of the teeth are worked in two-colour twining over alternate warp pairs.

The "hair" fringe which hangs underneath the forehead of each face is not an integral part of the twining. It consists of added strands of black weft, attached to the twining weft.

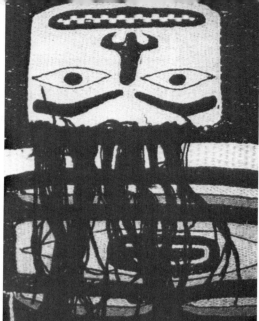

Fig. 417. The hair fringe

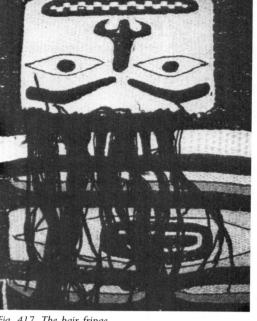

3-strand row

Fig. 418. Insertion of the hair fringe

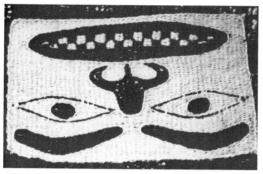

Fig. 419. A face with checkerboard teeth

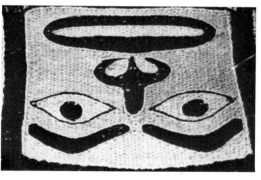

Fig. 420. A face with no teeth

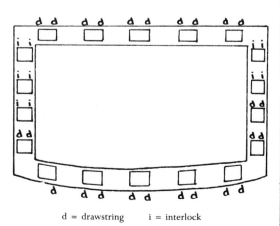

d = drawstring i = interlock

Fig. 416. The placement of the designs in the black border

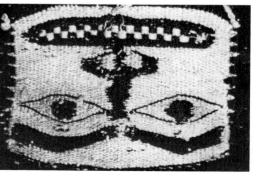

Fig. 421. Teeth woven over paired warp ends, seen from the back of the robe

151

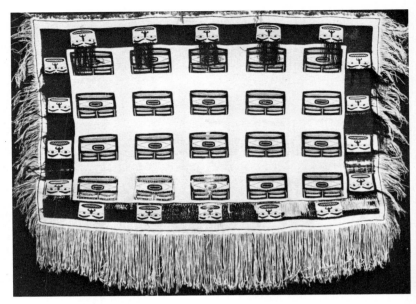

Fig. 422. The bands in the central design field

The black border itself is worked mostly in two-strand twining. Rigid weft twining is used in the spaces between the Chilkat units in the side borders. This use, however, is not regular; it occurs on the left side facing the back of the robe between each of the faces, but not on the right. The rigid weft itself is white, and it is a continuation of the white side border wefts. After working as rigid wefts, these white strands form the skip-stitch pattern of the central design field.

The Central Design Field

The white ground of the central design field is worked in diamond designs in skip-stitch twining. The pattern is similar to the organization of the diamonds and lines in Robe XI, with the alignment being offset by two diagonals.

Set into this ground are four bands of five units each which are woven in Chilkat weaving technique. These units are identical in the bottom three bands. The top band shows a slight variation in the exclusion of the white line below the upper green form. The units are designed in yellow, yellow-green, black, and white. The yellow is placed in the area around the eye shape and in the two lowest horizontal shapes. The yellow-green lies underneath the top white crescent and underneath the two crescents below the eye. A row of white three-strand braided twining outlines the periphery of each unit.

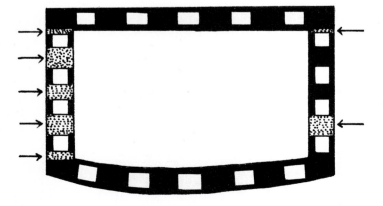

Fig. 423. Placement of the rigid weft twining in the black side border

Fig. 424. Skip-stitch twining in the central design field

152

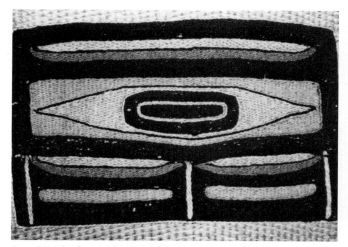

Fig. 425. The design of the Chilkat unit in the first band

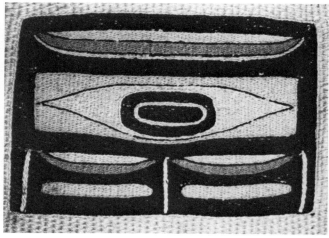

Fig. 426. The design of the Chilkat unit in the remaining bands

The Footing and the Fringes

Beneath the bottom black selvage line the footing consists of rows of ground twining which correspond to the rows of ground twining in the heading.

Along the sides of the robe white fringes are added on both sides with a lark's head knot. These fringes enclose the weft turn of the white twining.

A secondary black fringe at one time ran the complete length of the black side borders.

The warp fringe is slightly curved, although a definite stepping of the warp ends is not apparent. The warp fringe twining was worked over two warp ends, with a single warp end being raised in each weft segment.

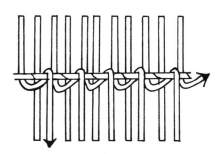

Fig. 428. The warp fringe twining

Dimensions

Fig. 427. The black side fringe

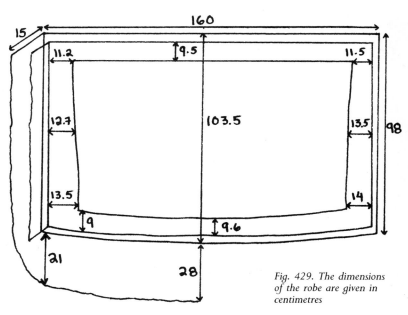

Fig. 429. The dimensions of the robe are given in centimetres

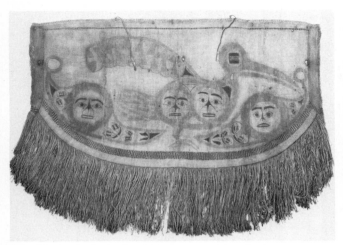

Fig. 430. A cedar bark robe with a woven two-colour border. (British Museum)

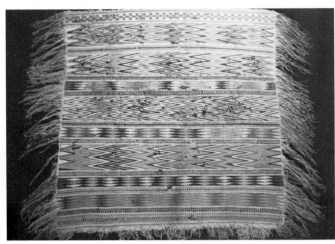

Fig. 431. A Salish robe. (Perth Museum and Art Gallery)

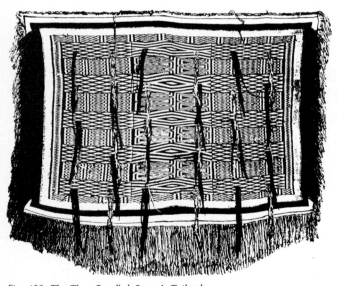

Fig. 432. The Three-Panelled Raven's Tail robe

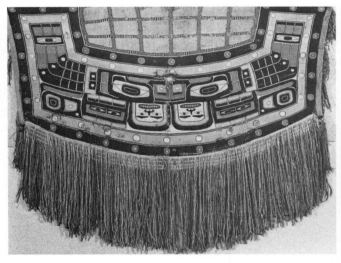

Fig. 433. A Chilkat Dancing Blanket with a central bib which is reminiscent of the Raven's Tail tradition. (Portland Art Museum)

A Tale of Transition

Four major styles of ceremonial robes come from the native people of the Northwest Coast. In the south, the West Coast weavers created Cedar Bark robes, some of which sported dramatic zig-zag borders. The geometric designs on the colourful Salish robes speak to their northern cousins, the black and white Raven's Tail robes. The Chilkat Dancing Blankets with their heraldic proclamations are the only robes woven in a curvilinear design style; they are also the only robes which were not designed by the weaver. The question is often asked, "Why did the northern weavers change from their geometric format to the curvilinear one?" Knowledge of the Raven's Tail and Cedar Bark robes leads to an understanding of the technical possibility of this transition. A more searching question might be, "When did the curvilinear style of design develop?"

Six robes exist which speak to the question of technical transition. How do they relate to the major styles of robe design on the coast? Are they experimental, transitional, or peripheral? Three were collected in 1778 at Nootka Sound on Cook's third voyage and presented to the National Museum of Ireland by Captain James King, Figs. 435, 436, 437. King, the astronomer with Captain Cook on this voyage, took command after Cook's death in Hawaii.

The provenence of the "Zig-zags and Eyes" robe, Fig. 434, now in the Museum of Mankind, British Museum, in London, has not been recorded, although there is considerable likelihood that it might also be a Cook piece. Another robe, now in the Museum für Völkerkunde in Vienna, Fig. 438, was collected on the same expedition and found its way there after the sale of the collection in the Leverian Museum in London. As a group, these five robes are presented here because they are the only other robes known to use mock two-strand twining. This unusual technique may hold the clue to the thought processes which the weavers of Raven's Tail robes went through when they took up the challenge of weaving formline designs.

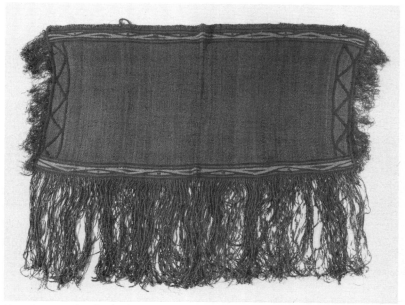

Fig. 434. A wool and cedar bark robe with zig-zag side borders and a stylized "eye" design. All the wool in the main body of the robe has disappeared. (British Museum)

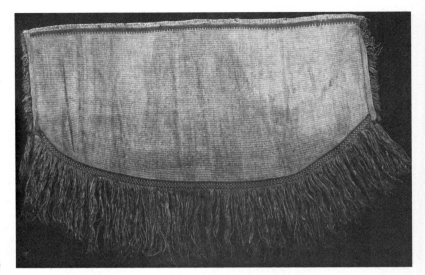

Fig. 435. A cedar bark robe with a two-colour checkerboard border. (National Museum of Ireland)

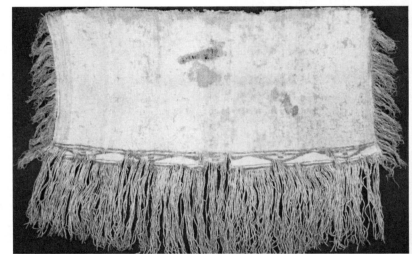

Fig. 436. A wool and cedar bark robe with a stylized "eye" design. (National Museum of Ireland)

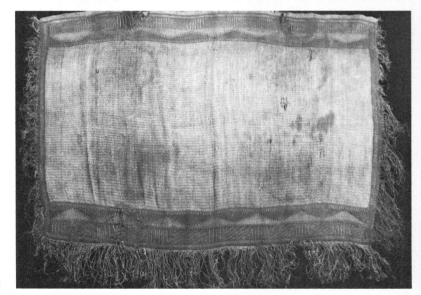

Fig. 437. A wool and cedar bark robe with designs from both the Raven's Tail and Salish traditions. (National Museum of Ireland)

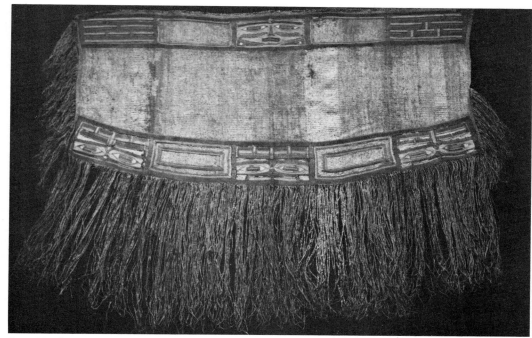

Fig. 438. The "Vienna Robe," made of wool and cedar bark. (Museum für Völkerkunde)

One robe in particular, popularly called the "Vienna Robe," tantalizes the student of cultural transition. It is exciting to speculate about whether the weaver of the Vienna Robe was a leader in the transformation of Raven's Tail weaving to Chilkat weaving, or if she was gathering knowledge from the weavings of other tribes. In either case, her work displays the technical challenge and a movement towards its solution.

In the Vienna Robe, the face in the top border is an obvious attempt at depicting curvilinear lines, Fig. 439. It fails to achieve the perfect curve because no weft element ever completely encircles a form.

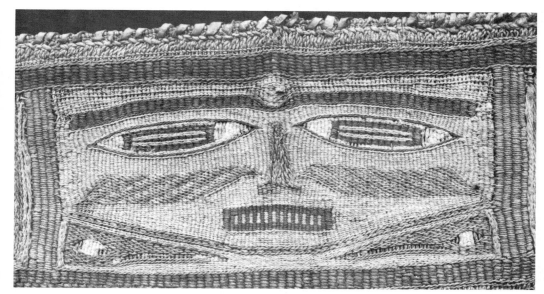

Fig. 439. The central upper face on the Vienna Robe

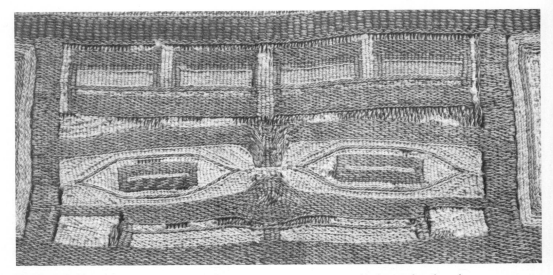

Fig. 440. A design unit in the lower border of the Vienna Robe in which mock two-strand twining is used

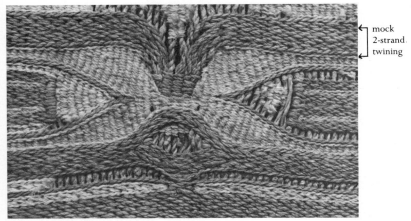

← mock 2-strand. twining

Fig. 441. The mock two-strand twining becomes three-strand braiding as it rounds the top of the ovoid

Fig. 442. A braided twining line completely surrounds the inner ovoid in the central face of the lower border

However, in the lower border, the weaver obviously was making experimental leaps. The width of the primary formline around the top of the eyes in the face at the lower right is created with rows of mock two-strand twining. Because this technique uses three weft strands for every two rows of compact twining, the weaver could braid these strands vertically to create the inner sides of the ovoid, as seen in Fig. 441. The use of three-strand wefts which travel both horizontally and vertically to create figures is a technique found in many of the Raven's Tail robes. However, all of the Raven's Tail figures were created as line drawings rather than solid colour forms, and none of them were curvilinear. The turning of the mock two-strand twining rows in the Vienna Robe was not totally successful as a technique for weaving a curved form, but the thinking behind it was a vital step towards the solution. The movement of weft strands out of the warp, and the weaving of these strands vertically by using the underlying horizontal wefts as their base, is the kernel of genius behind Chilkat weaving. In Fig. 442 success is near. In the central face of the bottom border, an outline row actually leaves the warp and travels through the weft around the side of the right eye ovoid and then resumes its passage through the warp underneath the shape. Compared with the squared "pupils" of all of the eyes and the circles with pinched sides in the face in the upper border, Fig. 439, the movement of this single row is a victory in the curvilinear transition.

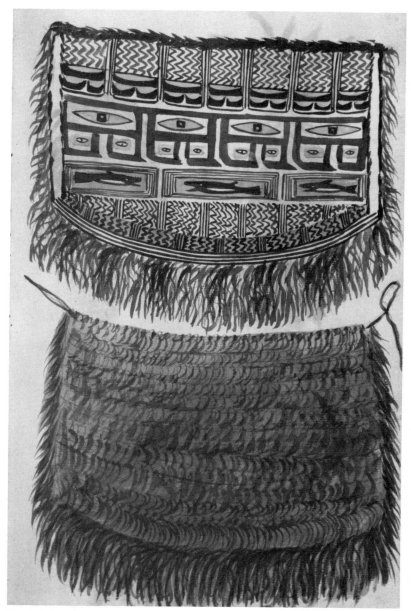

Fig. 443. The front and the back of the robe sketched by Sarah Stone in 1783. (Courtesy Bishop Museum)

The sixth robe is seen in an illustration painted in 1783 by Sarah Stone from material in the collection of Sir Ashton Lever. According to Bill Holm, "Since nothing but Cook material had come to England from the Northwest Coast by that time it is accepted that every such piece in the Stone drawings came from Cook's third expedition. Quite a few of the pieces represented are still around in various collections, and at least two, and maybe more, have been identified as Cook pieces since the publication of the sketch books in 1968" (Holm, personal letter, 24 January 1987). The date of the sketch, along with the design of this robe, add to the mystery of the Chilkat transition: is it a Raven's Tail robe with Chilkat motifs, a Cedar Bark robe with Chilkat motifs, or a Chilkat robe with Raven's Tail motifs? A final, and even more intriguing question: is it fur-sided? If this robe still lives today, hidden away and unrecognized, its rediscovery might tell the tale of transition.

At one point in the past, probably near the beginning of the nineteenth century, the weavers of the Raven's Tail robes ceased to weave the patterns of their ancestors. Technical success led to tranformation: it was now possible to contain human bodies in curvilinear designs. Formline motifs dominated the minds of the male artists who filled the world with painted and carved forms. The attraction of these designs and the stories they held within them provided a strong impetus for total change.

The world is never static; techniques do not die. They may disappear and lie dormant in the collective world of ideas, to be revived once again when their time has come. Now, the past has been relived in the re-creation of a Raven's Tail robe, and today's weavers are using the techniques to tell a new tale of transition. Herein lies the great strength of this style of weaving: once learned, it cries for contemporary expression. Through the centuries and across cultures the designs are gathering; it is time for the rebirth of Raven's Tail weaving.

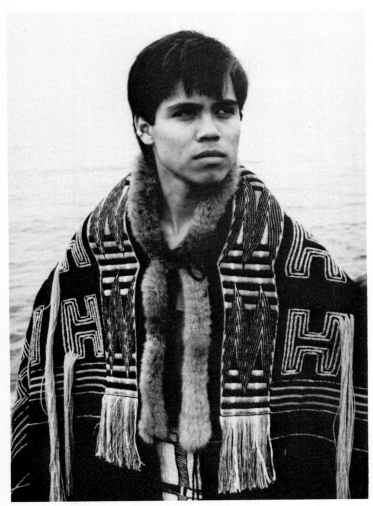

Fig. 444. Evan Adams wearing the Midwinter Robe

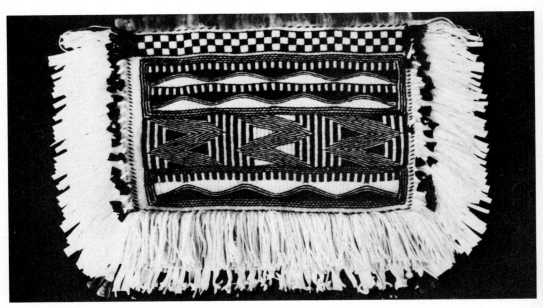

Fig. 445. A ceremonial apron woven and danced by Evan Adams, Coast Salish, 1985

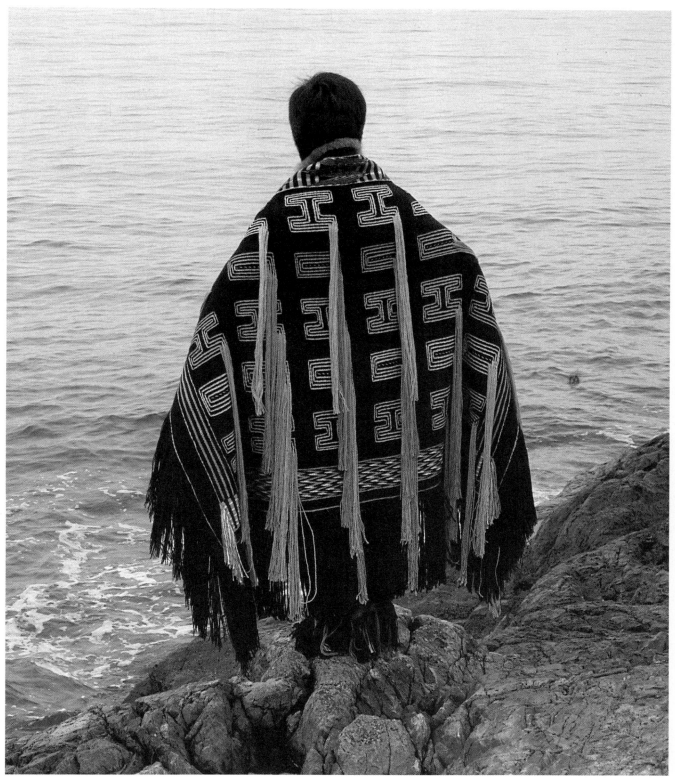

Fig. 446. The Midwinter Robe is the newest Raven's Tail Robe. It was woven by Cheryl Samuel with Evan Adams, in 1986, of wool and silk yarns in the colours of the winter beach.

Acknowledgements

No one person can do a work of this nature alone. The team of people which it takes to gather in information, consider it, and then present it becomes extensive when one must travel the world to find the original materials. The amount of effort it takes to feed, house, love, and bolster the moral of a fanatic writer-weaver is equally enormous; may I start by thanking, with all my heart, Edgar Samuel for his unfailing support. As those who have also written books will know, his most important piece of advice was "stop rewriting." Further thanks must go to my daughter, Silvina, for putting up with a Mama who always seems to be working on *the* book.

The original manuscript for this book was produced for the Museum of Civilization with the intention of publishing it as a monograph in the Mercury Series publications. The Museum provided me with a travel grant which I used partially for research on *The Chilkat Dancing Blanket* and partially on analysing some of the North American Raven's Tail robes. I intend to present the extensive, if often cumbersome, first manuscript of this book to the Museum of Civilization, Ottawa, with many thanks for their patience.

Working with Jane Fredeman, Senior Editor of the University of British Columbia Press, has been an extraordinarily comfortable experience. I have greatly appreciated her intelligent criticisms, her willingness to let the writing be mine, and the spontaneous interest she has shown by putting me in touch with Canadian scholars working on this early period of cross-cultural contact.

A book which is seven years in the writing covers a considerable span in one's life. Events occurred which clouded my initial passion; unbelievably, there were times when I wondered why I stayed involved. Encouragement from people around me and a genuine love of the robes have kept me going. People have been a great source of inspiration. My friendship with Ann Meerkerk has continued to give me great strength, while Delores Churchill, through the example of her own life and beliefs, has kept my fingers weaving. Evan Adams, Robert Davidson, Dorothy Grant, and Edna Jackson continue to offer encouragement, understanding, and confidence. The drive, vigour, and searching mind of Dorothy Burnham inspires me to keep learning. Carolyn Osborne, through her sharing, has made me very aware that knowledge is not a private possession. The incredibly swift, unselfish response of Thor Heryerdahl in procuring the photograph of the Tattoo Robe heralds a world of people, even strangers, working together. And finally, Edmund Carpenter, through his intuition and his generosity, has opened doors in my mind which will lift me through this project into the future.

Thanks also go to those who helped me in my research and during the production of the manuscript. Christine Olsen worked on the Kruzof Island Robe; Chris Peet helped with the Skatins' Robe. Identification of the linen strands in Robe IX, the Lattice Band Robe, was initially made by Mary Lou Florian, Conservation Analyst at the Royal British Columbia Museum, and verified by Jane Good, Textile Technologist with the Textile Analysis Service of the University of Alberta. Sara Porter's drawings add magic to the words and were an inspiration when I found I had to draw my own. Rudi Carolsfeld spent endless hours plotting the Raven's Tail designs, while Robin Hopper shared with me the invaluable world of his computer. Robin Wright photographed my slides. Katie Pasco has continued to send support and encouragement through her unflagging faith that this book would one day be born.

Certain museums and universities, through the people who work in them, have been of great assistance. Sincere gratitude goes to:

Burke Museum, University of Washington: Bill Holm

Museum of Civilization: George MacDonald, Annette McFadyen Clark

Museum of the American Indian: Brenda Holland

American Museum of Natural History: Phillip Gifford

Royal British Columbia Museum: Peter McNair, Marilyn Chechik, Dan Savard, Alan Hoover, Mary Lou Florian

Peabody Museum, Harvard University: Edwin Wade

Royal Ontario Museum: Kenneth Lister

Museum of Anthropology and Ethnography, Leningrad: Rosa Lyapunova

Academy of Sciences, Moscow: Julian Bromley

State Russian Museum: Director V.A. Lenjashin

Embassy of the USSR, Ottawa: Minister-Counsellor Alexi Makarov

Museum and Art Gallery, Perth: Susan Payne

Museum of Mankind, British Museum: Jonathan King

Museum für Völkerkunde, Vienna: Christian Feest

National Museum of Denmark: Else Östergärd, Niels Erik Jehrbo

National Museum of Ireland: Mary Cahill

University of Alaska Archives: Marvin Falk

Textile Analysis Service, University of Alberta: Jane Good

University Museum, University of Pennsylvania: Pamela Hearne

Tongass Historical Society: Lisa Steinbrueck, Suellen Liljeblad

Smithsonian Institution: Adrienne Kaeppler, William Sturtevant

Bibliography

Burnham, Dorothy K. *The Comfortable Arts: Traditional Spinning and Weaving in Canada.* National Gallery of Canada. Ottawa. 1981.

Cook, James. *The Journals of Captain James Cook on His Voyages of Discovery. The Voyage of the "Resolution" and "Discovery," 1776-1779.* Edited by J.C. Beaglehole. Volume 2. Cambridge. 1967.

Cook, James, and James King, *A Voyage to the Pacific Ocean . . . in the Years 1776-1780.* 3 Vols. London. 1784.

Drucker, Phillip. *The Indians of the Northwest Coast.* New York, 1963.

Emery, Irene. *Primary Structures of Fabrics.* Washington, D.C., The Textile Museum, 1966.

Emmons, George T. *The Chilkat Blanket.* Memoirs of the American Museum of Natural History. Whole Series, Vol. 3. Anthropology, Vol. 4, 1907.

Emmons, George T. "The Meeting of La Pérouse and the Tlingit." *American Anthropologist* 13 (April-June), 294-98. 1911.

Emmons, George T. *The Basketry of the Tlingit.* American Museum of Natural History Memoirs, Vol. 3, 1903.

de Laguna, Frederica. *Under Mt. St. Elias: The History and Culture of the Yakutat Tlingit.* Vol. 7. Smithsonian Institution Contributions to Anthropology. Washington, D.C., 1972.

Griffin, George Butler. *The California Coast. Journals of Juan Crespi and Tomás de la Peña.* Re-edited with preface by Donald C. Cutter. American Exploration and Travel Series, no. 57. Norman, 1969.

Gunther, Erna. *Indian Life on the Northwest Coast of America, as seen by the Early Explorers and Fur Traders during the Last Decades of the Eighteenth Century.* Chicago, 1972.

Holm, Bill. *Northwest Coast Indian Art: An Analysis of Form.* Seattle. 1965.

Holm, Bill. "A Wooling Mantle Neatly Wrought: The Early Historic Record of Northwest Coast Pattern-twined Textiles—1774-1850." *American Indian Art Magazine,* Winter 1982.

Hoskins, John. *Voyages of the Columbia to the Northwest Coast: 1787-1790, 1790-1793.* Edited by Frederic W. Howay. Massachusetts Historical Society, Boston. 1941.

Kaeppler, Adrienne L. *Artificial Curiosities: An Exposition of Native Manufactures Collected on the Three Pacific Voyages of Captain James Cook.* Honolulu, 1978.

Kaeppler, Adrienne L. *Cook Voyage Artifacts in Leningrad, Berne and Florence Museums.* Honolulu, 1978.

King, J.C.H. *Artificial Curiosities from the Northwest Coast of America: Native American Artifacts in the British Museum collected on the Third Voyage of Captain James Cook and acquired through Sir Joseph Banks.* British Museum Publications. 1981.

Kissel, Mary Louise. "The Early Geometric Patterned Chilkat." *American Anthropologist* (1928).

la Pérouse, Jean-François Galup de. *The Voyage of la Pérouse Round the World, in the years 1785-1788.* Vol. 1. Translated from the French by M. L. A. Milet Mureau. London, 1798.

Lisianskii, Iurii Fedorovich. *A Voyage Round the World in the Years 1803-1806.* Translated from the original Russian into English by Lisiansky. 1814. Reprint. Ridgewood, New Jersey.

Osborne, Carolyn. "The Yakutat Blanket." In *Archaeology of the Yakutat Bay Area, Alaska.* Bureau of American Ethnology, Bulletin 192. Washington. 1964.

Paul, Frances. *Spruce Root Basketry of The Alaska Tlingit.* U.S. Department of the Interior, Bureau of Indian Affairs, Division of Education. Lawrence, Kansas, 1944, with an Appendix by Nora Florendo Dauenhauer, 1981.

Samuel, Cheryl. *The Chilkat Dancing Blanket.* Seattle, 1982.

Samuel, Cheryl. "From Baskets to Blankets." *Threads Magazine,* Issue #5 June/July 1986.

Samuel, Cheryl. "The Knight Island Robe," in Kaplan, Susan, and Barsness, Kristin. *The Raven's Journey.* The University Museum, University of Pennsylvania, Philadelphia, 1986.

Shur, L.A., and R.A. Pierce. "Artists in Russian America: Mikhail Tikhanov (1818)." *Alaska Journal* (Winter 1976).

Shur, L.A., and R.A. Pierce. "Pavel Mikhailov, Artist in Russian America." *Alaska Journal* (Autumn 1978).

Stone, Sarah. *Arts and Artifacts of the 18th Century: Objects in the Leverian Museum as Painted by Sarah Stone.* Honolulu, 1968.

Wagner, Henry R. *Journal of Tomás de Suria, of His Voyage with Malaspina to the Northwest Coast of America 1791.* Glendale, 1936.

Willoughby, Charles C. "A New Type of Ceremonial Blanket from the Northwest Coast." *American Anthropologist* 12 (1910).

Museums

Canada

Museum of Civilization
National Museums of Canada
Esplanade Laurier
300 Laurier Avenue West
Ottawa, Ontario K1A OM8

Royal Ontario Museum
100 Queens Park
Toronto, Ontario M5S 2C6

Denmark

National Museum of Denmark
Department of Ethnography
Ny Vestergade 10
DK—1471 Copenhagen K

Great Britain

Museum of Mankind
The Ethnography Department
The British Museum
6 Burlington Gardens
London W1X 2EX
England

Ireland

National Museum of Ireland
Kildare Street
Dublin 2
Eire

United States of America

American Museum of Natural History
Central Park West at 79th Street
New York, New York 10024

University Museum
University of Pennsylvania
Philadelphia, Pennsylvania 19104

Leonid Shur Collection
Archives
University of Alaska
Fairbanks, Alaska 77701

Peabody Museum
Harvard University
11 Divinity Avenue
Cambridge, Massachusetts

Tongass Historical Society, Inc.
629 Dock Street
Ketchikan, Alaska 99901

Museum of the American Indian
Heye Foundation
Broadway at 155th Street
New York, New York 10032

Bishop Museum
1525 Bernice Street
P.O. Box 9000A
Honolulu, Hawaii 96817 0916

Union of Soviet Socialist Republics

Museum of the Academy of Art
Universitet Quai 17
Leningrad 1991164

Museum of Anthropology and Ethnography
Academy of Sciences
Universitetskaya nab. 3
Leningrad B-164

State Russian Museum
Inzhenernaya ul. 4
Leningrad 191011
USSR

Illustration Credits

All of the photographs were taken by Cheryl Samuel with the exception of the following:

Bishop Museum: fig. 443

British Museum: fig. 430

Field Museum: fig. 1

Museum of Civilization: figs. 361, 363, 396, 411

National Museum of Denmark: fig. 260

Carolyn Osborne and the University Museum, University of Pennsylvania: figs. 123, 124, 125, 127, 130, 133, 134, 135, 136

Peabody Museum, Hillel Burger: pp. 12, 16, figs. 213, 218, 219, 220, 224, 225, 226, 228, 229, 241, 243, 244, 247, 249, 250, 251, 252, 254, 255

Portland Art Museum: fig. 433

Royal British Columbia Museum: p. 17, fig. 2

Royal Ontario Museum: p. 13, fig. 410

Edgar Samuel: p. 10

Leonid Shur Collection, University of Alaska: figs. 139, 147, 151, 212, 403

State Russian Museum: figs. 154, 157

Tongass Historial Society: fig. 395

All of the drawings were done by Cheryl Samuel with the exception of the following:

Ian Bateson: figs. 227, 253

Rudi Carolsfeld: figs. 79, 80, 128, 199, 202, 223, 238, 239, 275, 303, 347, 350, 375, 393, 394, 406

George Emmons, *Basketry of the Tlingit*: pp. 20-23

Bill Holm: fig. 214

Sara Porter: pp. 18, 19, 24, 25, figs. 4, 65-68, 73, 83

Sara Porter, revised by Cheryl Samuel: fig. 104